Portraits of the Presidents: The National Portrait Gallery

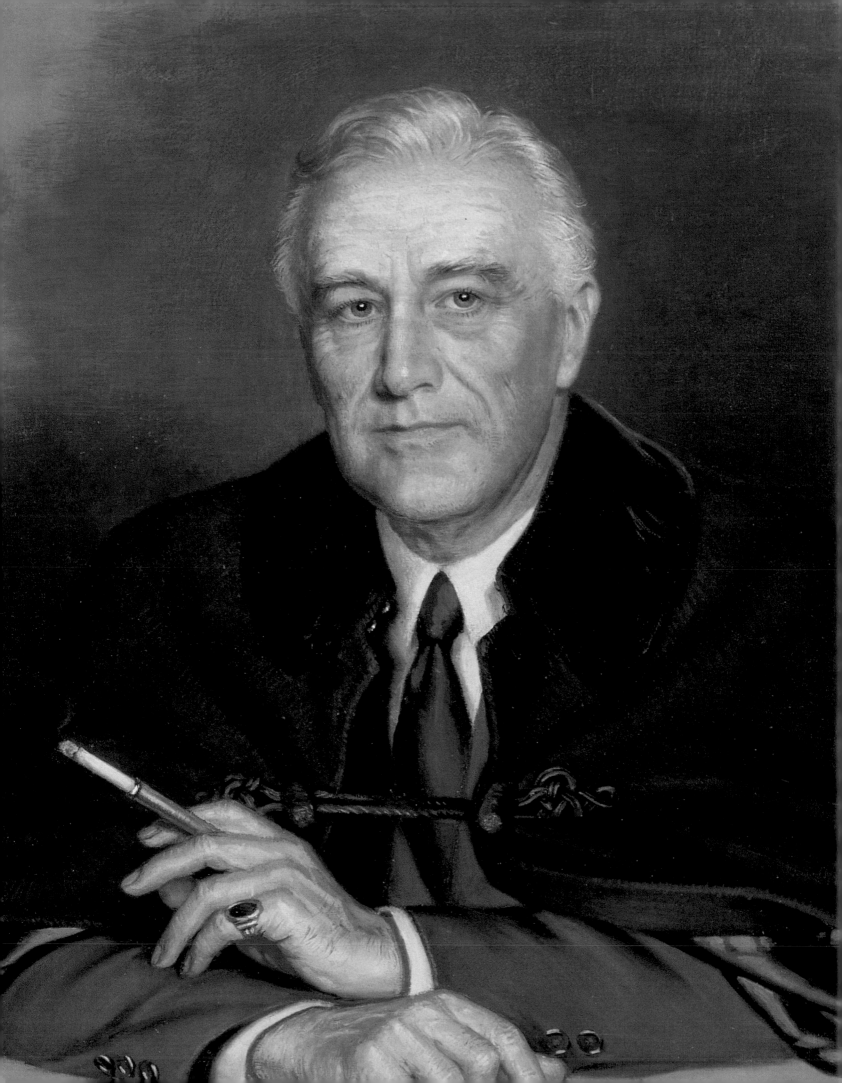

Portraits of the Presidents
The National Portrait Gallery

Frederick S. Voss

National Portrait Gallery, Smithsonian Institution, Washington, D.C.

In association with

Rizzoli International Publications, Inc.

This publication was produced in conjunction with the exhibition "Portraits of the Presidents," organized by the National Portrait Gallery, Smithsonian Institution, Washington, D.C.

This publication is supported in part
by the National Portrait Gallery's
Paul Peck Fund for Presidential Studies.

Exhibition Itinerary:
George Bush Presidential Library and Museum
College Station, Texas
October 6, 2000–January 15, 2001

Harry S. Truman Library and Museum
Independence, Missouri
February 16–May 20, 2001

Gerald R. Ford Presidential Museum
Grand Rapids, Michigan
June 22–September 23, 2001

Ronald Reagan Presidential Library and Museum
Simi Valley, California
October 26, 2001–January 21, 2002

Memphis Brooks Museum of Art
Memphis, Tennessee
February 22–May 19, 2002

North Carolina Museum of History
Raleigh, North Carolina
June 21–September 15, 2002

Virginia Historical Society
Richmond, Virginia
October 18, 2002–January 12, 2003

ISBN (hardcover edition): 0-8478-2298-2
ISBN (paperback edition): 0-8478-2327-X
Library of Congress Card Number: 00-101338

Front cover: *Abraham Lincoln* (detail) by George Peter Alexander Healy
Illustrated in full on page 64

Frontispiece: *Franklin D. Roosevelt* (detail) by Douglas Chandor
Illustrated in full on page 110

Back cover: *Hitting the Wall (John F. Kennedy)* by George Tames
Illustrated on page 119

Edited by Frances Stevenson and Dru Dowdy
Designed by Tsang Seymour Design, NY
Printed in Italy

Contents

The Presidents

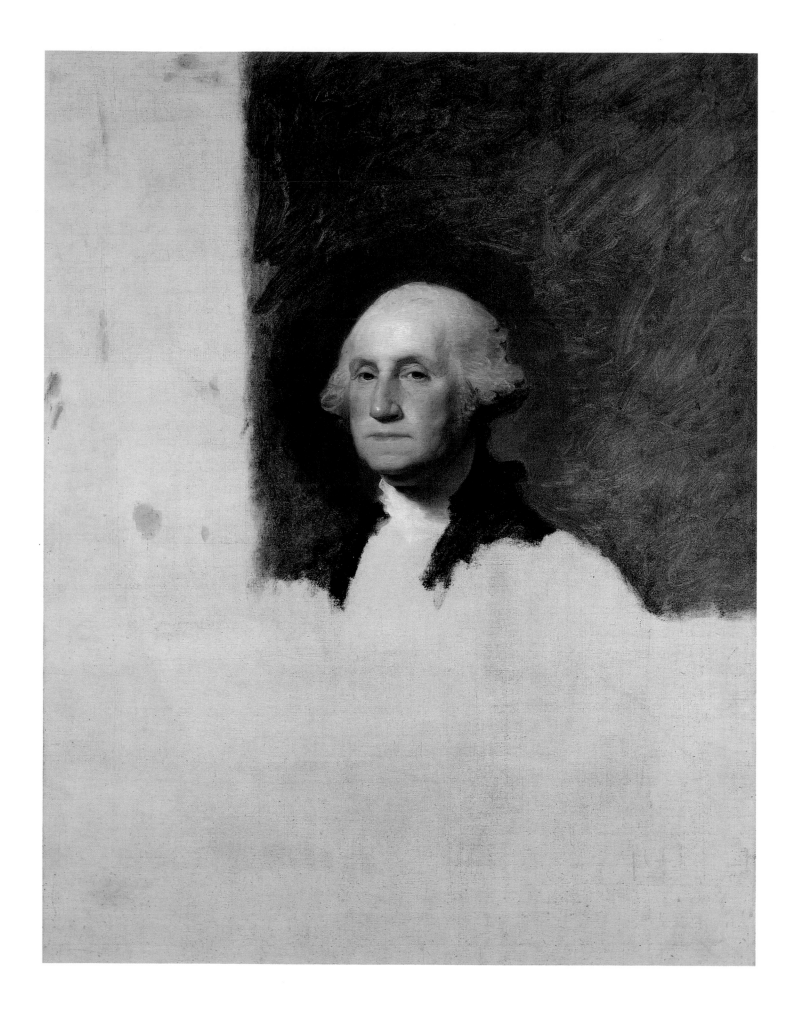

Foreword

The "Athenaeum" portrait of George Washington

If there is a definitive image of Washington, it is this unfinished likeness by Gilbert Stuart, known as the "Athenaeum" portrait. Of the many reproductions of it that Americans see in their daily lives, the most familiar is the Washington image found on the one-dollar bill. It has been said that if Washington came back to earth and did not look like Stuart's picture, he would be declared an impostor.

Washington's wife, Martha, commissioned the portrait in 1796, expecting to take it with her to Mount Vernon when her husband left the presidency the following year. Unfortunately, she had not counted on Stuart's unreliable ways. The painter never finished the picture, despite repeated efforts to persuade him to do so. Instead, it remained in his possession until his death, and he used it as a template for the scores of portraits he painted for Washington admirers. The replicas were a source of easy cash, and he came to refer to them affectionately as his hundred-dollar bills.

Gilbert Stuart, 1755–1828
Oil on canvas, 121.9 x 94 cm
(48 x 37 in.), 1796
Owned jointly with the Museum of Fine Arts, Boston

From its earliest days, the Commissioners and staff of the National Portrait Gallery determined that they would try to assemble the best portraits that could be located of each of the American Presidents—not an easy job when started in the 1960s, almost two centuries since the establishment of the office, and when many of the portraits seemed to be firmly affixed to the walls of public institutions. Yet they did succeed, to a remarkable degree, and the process of collection and refinement continues to this day, with the assistance of Presidents, ex-Presidents, and presidential descendants, as well as donors eager to support the Gallery's work in this field. So, today it is possible to see images of all the Presidents together at the Gallery, from Washington to Clinton, in juxtapositions not even possible at the White House.

There is an undeniable thrill in seeing the presidential portraits on view in the Executive Mansion. The impact of their presence in the very house in which all but Washington resided is powerful, and many of the paintings there are very fine, but the public cannot usually get very close to many of them, or study them at leisure, and a number of the earlier Presidents are installed in areas not usually open to the public. Thus, the National Portrait Gallery's Hall of Presidents serves in a uniquely instructional way to speak about the entire span of the political leadership of the United States of America to hundreds of thousands of people each year.

One might expect that presidential portraits all would be cut from the same cloth, but this is far from the case. In his text, our historian Frederick Voss takes note of the range of approaches to the portrayals of our chief executives. Some are depicted in poses and clothing that proclaim the political stature of the sitter. Others are painted in the posture and garb of the ordinary citizen. A few artists have evoked republican Rome in their representation of a President, others have placed their subject firmly in the time and place in which he worked. The portraits also suggest much about the personalities of the Presidents. Virtually all of them are dignified, and most are sober. Some of the men come across as dour, remote, or even sad. Others seem to burst with life and energy. A few remain opaque. But however they are rendered, all of these portraits seem to have an enduring attraction, for no single area of the National Portrait Gallery is more frequently and consistently visited than the Hall of Presidents.

Going through the Hall of Presidents, one is struck by the impact of the office on its occupants. Its enduring popularity

speaks to the special interest of the public in both the office of the presidency and the people who have occupied that office. In the years I have been associated with the Gallery, I have passed through this area several times each day, and it is never empty of visitors. Some gaze at the portraits themselves with rapt attention, others prefer to study the wall texts with more care than they give to the portraits, but most give equal time to text and image.

Our visitors evidently want to know something about who these chief executives were, how they put themselves forward for the job, how they came to be elected, and what they promised to accomplish in office. Each of them faced challenges that were unanticipated when they took office, sometimes in domestic affairs, sometimes in international conflicts. Many found the political opposition to be more troublesome and vicious than expected, and virtually all were attacked in the press in unexpected ways. Yet the presidency endures as a singularly successful feature of the American political system, and the people who have occupied the highest office in our nation deserve our attention and our esteem.

In January 2000, the National Portrait Gallery temporarily closed its doors to the public, to make way for a substantial renovation of the historic building it had occupied in Washington since it opened in 1968. Established by an act of Congress in 1962, the Gallery is a free public museum for the display and study of portraits of the men and women who have contributed notably to our nation, as well as a place devoted to the study of portraiture. With a mission unique among American museums, and comparable only to a handful of institutions in other nations, the Gallery has experienced considerable success in the thirty-two years since it opened. Audiences have grown to satisfying numbers, and the quality of the collections, the range of the special exhibitions, and the distinction of our publications all are a source of pride to those who have worked here.

While it is a pity to have to interrupt the continuity of our activity in Washington, we are delighted to be able to send a substantial portion of our permanent collection out on tour during the period of renovation. We hope, thereby, to introduce a new audience to our holdings, and to give old friends who have visited the Gallery in Washington a chance to become reacquainted with some of the portraits they have enjoyed. The presidential portraits recorded in this book constitute one of these special exhibitions, and represent one of the exceptional areas of the Gallery's holdings.

Many people on the staff of the Gallery have worked hard to bring this collection together and to prepare this publication. Beverly J. Cox and her colleagues in the Office of Exhibitions have been responsible for the myriad tasks of organization of the entire project, and for working with the museums and presidential libraries that are showing this exhibition. Suzanne Jenkins and the staff of the Registrar's Office, and Nello Marconi and the Office of Design and Production, have been responsible for the physical presentation of the exhibition, as well as for its safe transport around the country. Frances Stevenson and Dru Dowdy have managed the publication you are reading with their accustomed skill and care. But most of all, credit must go to Gallery historian Frederick Voss for organizing and writing this volume, and overseeing the exhibition to which it relates.

This project is the first tangible manifestation of a new resource at the Gallery. Mr. Paul Peck has presented a most generous gift to the Smithsonian, intended to support the Gallery's activities related to the presidency, and this book is made possible in large part through the Paul Peck Fund. The Gallery, and all who read this book, must be thankful to Mr. Peck for his resourceful and imaginative support.

Alan Fern
Director Emeritus, National Portrait Gallery

Introduction

The presidency is by far the most influential and prestigious political office in the United States, and because of America's ascendancy in the international arena, it is a central focus of world politics as well. As the nation's chief administrator, the holder of this office determines how and when the laws of the United States are to be implemented. Given a power of veto over congressional acts and a prestige that comes with being the only public official elected by all of the people, the President has also come to exercise a substantial and, on occasion, dominant influence on what those laws should be. As the constitutionally designated commander in chief of the country's armed forces, the President is charged with overseeing national security against both internal and external threats, and in time of war that responsibility can vest him with powers that are almost dictatorial in their scope. Finally, as chief diplomat, the President is the primary architect of the policies that determine the country's relationships with the rest of the world.

The powers of the presidency are not unlimited, however, nor is the holder of this office free to pursue courses strictly according to his own desires. On the contrary, the democratic process of which the President is a part places numerous constraints on his power to act, and many a presidential wish has gone unfulfilled in the face of a recalcitrant Congress or a hostile climate of public opinion. Moreover, on many occasions when the President has had his way, the unforeseen negative consequences of his triumph have diminished his credibility and, in turn, his capacity to lead.

The presidency is an enormous job. To carry out its multifaceted responsibilities requires at times more genius, stamina, and foresight than any individual could be expected to possess. It therefore comes as no surprise that over the past two centuries, many of the holders of that office have taken a decidedly negative view of it. Thinking back on his White House years, John Adams once said: "Had I been chosen President again, I am certain I could not have lived another year." For Adams's successor, Thomas Jefferson, the presidency meant "unceasing drudgery and daily loss of friends," and John Quincy Adams claimed that his presidential term represented "the four most miserable years" of his life. Abraham Lincoln compared his feelings about being President to those of the hapless man who had just been tarred and feathered and ridden out of town on a rail. When someone asked the man what he thought of the experience, he replied, "If it wasn't for the honor of the thing, I'd rather walk." And then there was Grover Cleveland, who, at a particularly troublesome moment late in his first term, took the hand of a young White

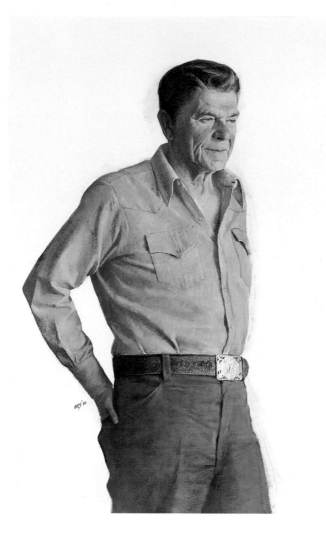

Ronald Reagan's 1980 Man of the Year portrait. By Aaron Shikler, born 1922, essence of oil on paper, 66 x 45.5 cm (26 x 17⅞ in.), 1980. *Time* cover, January 5, 1981. Gift of *Time* magazine

House visitor named Franklin Roosevelt and said: "My little man, I am making a strange wish for you. It is that you may never be President of the United States."

To some extent, these and many other similar statements made about the presidency by those who have known it most intimately are only expressions of momentary frustrations that anyone might feel in a job. Indeed, some Presidents have reveled in the burdens of their office. The most notable was the incurably ebullient Theodore Roosevelt, who once declared, "No one ever enjoyed the presidency as I did." Still,

the presidency is an office that has more than the usual potential for causing unhappiness for anyone who attains it. If it were possible to poll the forty-one men who have occupied the presidency since 1789, perhaps most of them would not summarize their White House years in the unequivocally gloomy terms that John Quincy Adams did. By the same token, however, they would undoubtedly fully understand why he felt that way.

Despite its attendant travails, the presidency has never suffered from a scarcity of applicants. Henry Clay once said, "I would rather be right than be President." But that was near the close of his long political career, and one wonders how much he really believed it, given the many years he spent promoting his White House hopes. More to the point, while many an ambitious politician might publicly applaud Clay's high-minded declaration, it would not be surprising if secretly they thought this a bit overrated.

According to the Constitution, there are only three qualifications that a would-be President has to meet before seeking the office: The individual must be a native-born American, must have been a legal resident of the United States for at least fourteen years, and must be over the age of thirty-five. Beyond that, legally speaking at least, there are no other criteria that must be met. That is not to say, however, that there are no other less explicitly stated barriers to achieving the presidency. Until 1960, for example, it was generally thought that a Catholic could never be President, and it is only recently that the American electorate has shown even vague signs that it might one day accept the notion of putting a woman, an African American, or a person of Asian or Hispanic descent into the White House.

But even within the limits set by the Constitution and custom, the origin and background of America's Presidents have varied considerably. In terms of their education, for example, White House occupants have ranged from the largely self-taught Andrew Johnson,

A caricature portrayal of Franklin D. Roosevelt's inauguration, March 4, 1933, for *Vanity Fair.* By Miguel Covarrubias, 1902–1957, color halftone, 34.2 x 48.3 cm (13 $^{7}/_{16}$ x 19 in.), 1933

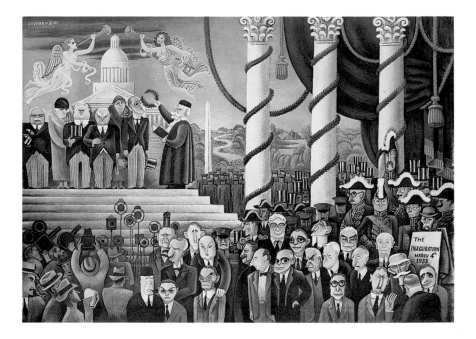

who did not master the basics of writing until early adulthood, to the scholarly Woodrow Wilson, who held a doctor of philosophy degree from Johns Hopkins. With regard to social and economic origins, the variety has been equally striking. In contrast to Theodore and Franklin Roosevelt, who hailed from America's most socially prestigious elite, and John F. Kennedy, who was the son of a multimillionaire, other Presidents, including Abraham Lincoln and Dwight Eisenhower, began life under circumstances that could only be described as hardscrabble.

Perhaps a more interesting aspect of presidential diversity is the great range of vocational backgrounds from which these residents of 1600 Pennsylvania Avenue have come. While Andrew Johnson began life as a humble tailor and Ronald Reagan was for many years a movie actor, the first rung on Herbert Hoover's ladder to the White House was his career as an internationally acclaimed mining engineer. Ulysses S. Grant, in the years immediately following his resignation from the army in 1854, was at one point reduced to pawning his gold watch to carry his family through the Christmas holidays. Another exam-

ple of pre-presidential failure was Harry S. Truman's ill-starred venture into the men's clothing business, which left him at the age of thirty-eight with a mountain of debt and very poor prospects of ever paying it off.

In contemplating the considerable variety in presidential backgrounds, the question arises: Is there any correlation between a President's past and his performance in the White House? At best, the answer is an ambiguous maybe. In the case of George Washington, for instance, his brilliance as a leader of men through the trying circumstances of the Revolution promised success as his country's first President, and his presidency did indeed live up to that expectation. Similarly, Lyndon B. Johnson's expertise in bringing his presidential will to bear on Congress can clearly be traced to his many years of experience as the Democratic majority leader of the Senate. In view of Warren Harding's lackluster career in Congress, it is no surprise that he turned out to be one of the country's weakest Presidents.

On the other hand, the United States has had many Presidents whose White House behavior and accomplishments were at odds with their past. Herbert Hoover's humanitarian instincts,

for example, led to his immensely successful efforts to feed the starving civilian masses of Europe during World War I. But in the face of the Great Depression that set in during his presidency, he could not see his way to mounting a similar drive to alleviate the resulting widespread hardships. Chester Arthur was another man whose White House behavior did not square with his pre-presidential career. He owed his political existence to the spoils system that had thoroughly corrupted the federal civil service of his day, but after taking office he used his presidential prestige to help abolish that system. An even more startling presidential surprise was Franklin Roosevelt, whose reputation as a political trimmer with little taste for reforming adventurism seemed to promise an administration unnoted for innovation. Yet within days of his inauguration, Roosevelt was rushing headlong into a series of experimental reforms that would dramatically redefine the role of the federal government in American life.

One of the most intriguing aspects of the presidency is that there is no way to predict how an aspiring candidate will behave when elected. Of Andrew Jackson's imminent accession to the presidency in 1829, Daniel Webster wrote, "When he comes, he will bring a breeze with him. . . . Which way it will blow, I cannot tell." That comment could have been made of many Presidents as they prepared to undertake their White House responsibilities.

But if anticipating presidential behavior is an uncertain game at best, it is not necessary to go far to discover why. Nothing in a newly elected incumbent's previous experience can fully prepare him for the uniqueness of the presidency and the magnitude of its demands. As a result, until an individual actually experiences the office, even he cannot chart with accuracy the course he will travel. As Lyndon Johnson was fond of saying, becoming President was like being a father: "You can't know what it's like until you are one."

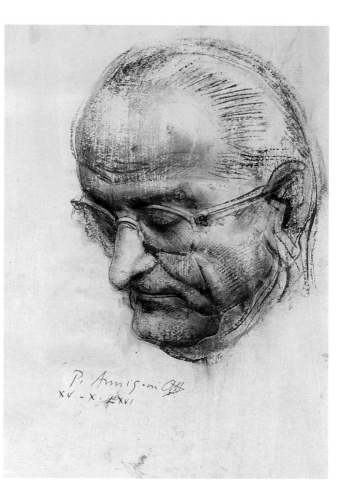

The Italian artist Pietro Annigoni sketched this portrait as Johnson spoke with the press at the White House in 1966. Commissioned for the cover of *Time* magazine, the drawing did not run with the story that it was originally supposed to accompany because it was deemed too somber for the occasion. The picture's contemplative gravity did, however, win it a place on a cover in April 1968. The subject of the story on that occasion was Johnson's surprise announcement of his decision not to seek another presidential term in the face of ever-deepening public hostility to his Vietnam War policies.

By Pietro Annigoni, 1910–1988, pastel on paper, 48.5 x 38.1 cm (19 ⅛ x 15 in.), 1966, *Time* cover, April 12, 1968. Gift of *Time* magazine

Presidential Likenesses at the National Portrait Gallery

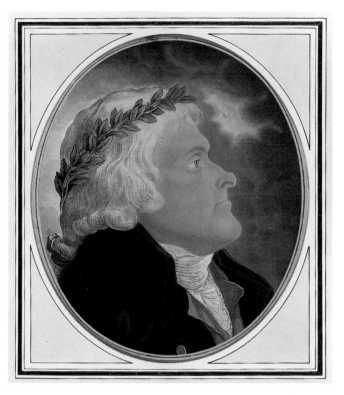

A print image of Thomas Jefferson, based on a drawing by Thaddeus Kosciusko, the Polish patriot who served in the American Revolution. By Michel Sokolnicki, 1760–1816, hand-colored aquatint, 24.7 x 20.6 cm (9 ¾ x 8 ⅛ in.), 1798–1799

Just as the presidency is the focal point of American politics, presidential likenesses occupy a place of eminence in the American portrait tradition. Replications of presidential images are to be found everywhere, from our coined and paper currencies to advertisements to public classrooms. It would not, in fact, be an overstatement to say that familiarity with at least certain presidential likenesses—most notably Washington's and Lincoln's is one of the few aspects of our heterogeneous cultural heritage that most Americans have in common almost from toddlerhood onward. Moreover, when a retired President returns to Washington for the unveiling of his portrait at the White House (as has become the custom in recent years), it may be just about the only modern-day portrait unveiling that is apt to receive coast-to-coast media coverage. Finally, presidential likenesses are sometimes even capable of inspiring public controversy. During the first half of the nineteenth century, for example, debates would periodically break out in print over which likeness of George Washington was the most authentic, and in the early 1960s, Pietro Annigoni's somber, somewhat haggard-looking portrayal of John F. Kennedy for *Time's* Man of the Year cover generated an unprecedented onslaught of indignant letters from readers. Any artist, wrote one of the more irate, who dared to paint the country's handsome President that way deserved to be "boiled in his own oils."

Against this backdrop of abiding, and sometimes vitriolic, interest in presidential images, it should come as no surprise that among the National Portrait Gallery's richest troves are its many images of the individuals who have occupied the White House. In addition to the more predictable painted and sculpted likenesses, the museum's presidential collections contain photographs, prints, drawings, original *Time* magazine covers, and caricatures. Among its most recent acquisitions is a rare group of Indian peace medals—all bearing profile likenesses of Presidents—that were used from Washington's administration into the late nineteenth century as tokens of friendship in the government's dealings with Native American tribes. Today the Gallery's presidential collections include more than 1,200 pieces and are constantly growing.

To search for a common strand or overarching theme that runs throughout the Gallery's presidential portraiture is very nearly an exercise in futility. But the operative phrase here is "very

Andrew Jackson in silhouette. By E. B. and E. C. Kellogg lithography company, active 1842–1867, after William Henry Brown, lithograph, 34.3 x 25.4 cm (13½ x 10 in.), 1844. Gift of Wilmarth Sheldon Lewis

nearly." For there is one verity that applies to all: Viewed in its totality, the assemblage of images is above all eclectic. The Gallery's more than two hundred years' worth of images are as widely varying as the backgrounds and personalities of the individuals they depict and as the diverse democracy that elects them to office.

Aesthetically speaking, some of the likenesses represent the best and most sophisticated portraiture of a given era. The most noteworthy case is perhaps Gilbert Stuart's unfinished portrait of George Washington [SEE PAGE 6]. Probably the best-known image of a President ever painted, the picture has a fleshlike vitality that, despite its incomplete state, ranks it among the finest works by one of the most skilled artists of the early Republic. Yet another instance of painterly virtuosity is the Gallery's portrait of

John Tyler, where artist George P. A. Healy's masterful rendering of skin tone invested Tyler's face and one visible hand with a palpability that is little short of extraordinary. Finally, there is the portrait of Grover Cleveland by Swedish artist Anders Zorn, where the loose brushwork coalesces with a seemingly spontaneous quality of pose and natural lighting to make it a vibrant expression of the impressionistic portraiture that became the height of fashion in the last years of the nineteenth century [SEE PAGE 84].

Some Presidents, however, have not been concerned about enlisting the most able or fashionable artists of the day to paint their portraits. To meet the brisk demand for likenesses among his legions of admirers, Andrew Jackson, for instance, remained quite satisfied to rely on the mediocre Ralph E. W. Earl, who actually moved into the White House when Jackson became President. Earl's portraits tended to be flat, and more wooden than lifelike [SEE PAGE 38]. Had it not been for his warm relationship with Jackson and all the patronage that came with it, the prosperity of his portrait painting business doubtless would have been substantially less. Nevertheless, Earl's renderings of Jackson hold a certain charm for modern-day viewers, who can see in their awkward simplicity an evocative reflection of the rural culture that prevailed in Jacksonian America.

Another President who did not worry about the talents of his portraitist was John Quincy Adams. In his old age, as a member of the House of Representatives, it almost seemed as if he was willing to sit for just about any artist who asked him, and given his fame as the House's "Old Man Eloquent," a good many did.

One artist wanting to paint him was George Caleb Bingham. Though certain that this Missouri-born artist was unlikely to make "either a strong likeness or a fine picture," Adams consented to sit [SEE PAGE 34]. Later to become much celebrated for his portrayals of life on the trans-Mississippi frontier, Bingham proved his

PRESIDENTIAL LIKENESSES

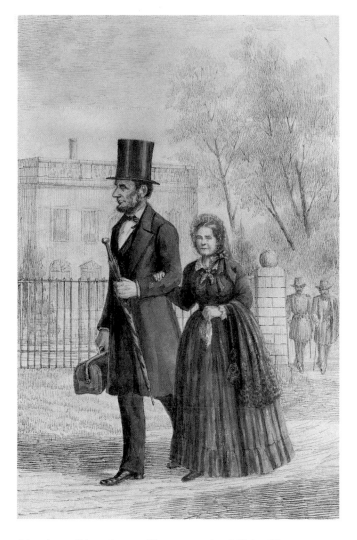

Abraham Lincoln strolling near the White House with his wife. By Mary Pierre Moran, 1820–?, ink and ink wash on paper, 20.4 x 12.8 cm (8 1/16 x 5 1/16 in.), circa 1864

subject wrong on both counts. The resulting picture is a compelling testament to the subject's stony New England tenaciousness, and posterity is grateful indeed for Adams's willingness to pose for a painter in whom he had such little faith. Remarking on Adams's longevity, Ralph Waldo Emerson observed, "When they talk about his . . . nearness to the grave, he knows better, he is like one of those old cardinals, who quick as he is chosen Pope, throws away his crutches . . . and is as straight as a boy. He is an old roué who . . . must have sulphuric acid in his tea." And that is the selfsame crusty old man that Bingham captured on his canvas.

When we think of presidential portraiture, the image that most readily comes to mind is a formally posed three-quarter or full-length composition. And with good reason—many presidential portraits fit that description. Often the staged quality of these images seems almost calculated to keep the viewer at a psychological distance, and that certainly is the case with the Portrait Gallery's likeness of Lyndon Johnson by Peter Hurd, where Johnson looks into the distance with the United States Capitol at his back [SEE PAGE 123]. Sometimes, however, these more formal likenesses can be surprisingly intimate, and in George Bush's portrait by Ron Sherr [SEE PAGE 136], the potentially off-putting grandeur of the gilt-mirrored backdrop is offset by an easy intimacy that makes the picture eminently approachable.

But perhaps the museum's most intimate portrait of a President is the one that Norman Rockwell painted of Richard Nixon shortly after the 1968 election [SEE PAGE 125]. In scale, the picture is small and looks all the more so when seen in relation to the much larger presidential likenesses that normally surround it when it is on view in the Gallery. Nevertheless, it manages to hold its own admirably in that more imposing company, with its relaxed informality and affable warmth.

Ironically, several of the Portrait Gallery's most satisfying presidential portraits originally were meant to serve only as preliminary studies for more ambitious pictures. One of them is George P. A. Healy's seated likeness of Abraham Lincoln, the prototype for which the artist conceived in 1868 [SEE PAGE 64]. That prototype was intended to serve merely as a template for the Lincoln figure in *The Peacemakers,* a much larger picture depicting Lincoln in conference with key military advisers. But Healy was quick to sense that his template was quite a good picture in its own right, and he eventually made three copies of it, including the one now at the Portrait Gallery. Another likeness initially meant only to

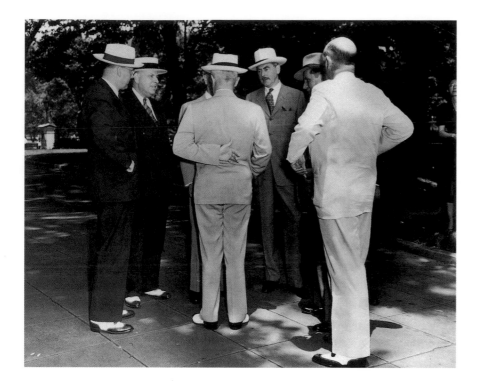

be a study is Douglas Chandor's portrait of Franklin D. Roosevelt [see page 110], which was done in preparation for a substantial, never-realized tableau depicting Roosevelt with Winston Churchill and Joseph Stalin at Yalta. As most studies do, the picture looks obviously unfinished. Still, when combined with the hand studies and the sketch in the canvas's lower portion, the central likeness has the weight of a good finished portrait, and one cannot help but think that a greater state of completion might have diminished its impact.

Caricature is a type of likeness that no self-respecting collection of presidential portraiture can afford to be without. After all, who has been more caricatured in the annals of American satire than the residents of 1600 Pennsylvania Avenue? Among the museum's most memorable examples of that brand of portraiture is a drawing by the famed nineteenth-century cartoonist Thomas Nast, depicting his favorite White House target, Andrew Johnson, as a mean-spirited "King Andy I" [SEE PAGE 70]. Another caricature worth noting is a drawing of Calvin Coolidge by Miguel Covarrubias. Perhaps the most interesting thing about this acerbic portrayal of the ascetic, taciturn "Silent Cal" is how closely it parallels a description of Coolidge by a Harvard professor. Coolidge, the professor observed, was "a small, hatchet-faced, colorless man, with a tight-shut, thin-lipped mouth; very chary of words, but with a gleam of understanding in his pretty keen eye." Covarrubias was never privy to that comment; yet to look at his interpretation of Coolidge, it is almost as if the good professor had stood over the drawing board directing the artist's pen.

Formal presidential portraiture by and large falls into conservative stylistic patterns, and good, bad, or indifferent, a portrait of a President rarely reflects the avant-garde trends in the art world. The reason for this is simple: Like presidential politics, presidential portraiture tends to cater to mainstream tastes, which by definition shy away from adventurous extremes. But there have been exceptions, and one of the most memorable occurred in 1962. Just after Christmas that year, armed with a commission made on behalf of the Harry S. Truman Presidential Library, artist Elaine de Kooning

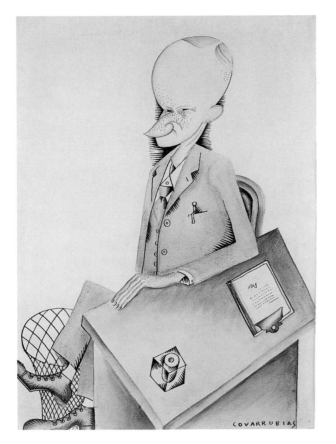

Caricaturist Miguel Covarrubias's take on the taciturn Calvin Coolidge. By Miguel Covarrubias, 1902–1957, watercolor and india ink on paper, 35 x 24.8 cm (13 ¾ x 9 ¾ in.), circa 1925

arrived at the family home of John F. Kennedy in Palm Beach, Florida. Closely identified with Abstract Expressionism, she was soon bringing to bear the influences of that modernist school of painting on Kennedy's features. As de Kooning worked, she became utterly fascinated with Kennedy's protean demeanor, so much so that she could not stop at making the one likeness for the Truman Library. Instead, she ended up using her drawings and oil sketches from the sittings to produce an extended series of portraits that number among the most innovative in presidential portraiture. No exception is the Portrait Gallery's full-length version from the series [see page 120]. Although this likeness of Kennedy remains safely within the bounds of the realist tradition, its free brushwork and restless, almost chaotic spontaneity clearly link it to Abstract

Expressionism, which, in its heavy emphasis on self-expression and eschewal of representational content, was in many respects the antithesis of the rules that guide conventional portraiture.

During the first five decades of the presidency, painted, sculpted, and drawn portraits (or prints derived from them) were often the only way in which most Americans could know their country's chief executive. When, for example, President-elect Monroe sat for the Gallery's portrait of him by John Vanderlyn in late 1816 [SEE PAGE 32], the first order of business at the picture's completion was to have it translated into an engraved print for popular distribution. The advent of photography in 1839, however, began to challenge the primacy of the hand-crafted image, and by the eve of the Civil War, the photographic print was well on its way to displacing the older forms of portraiture as the main vehicle by which Presidents were known. They were displaced even further in the twentieth century with the coming of movie newsreels and then television. Some ten years ago, a reporter writing on the presidential portrait tradition suggested that the formal likeness may have lost much of its relevance in an age inundated by instant photographic and video images that seemed to capture "the Chief Executive in virtually every mood and every activity." In many senses that may be true. Certainly the day is long since past when the public's familiarity with a President hinged on the availability of a painted or sculpted portrait. Still, there is an enduring fascination with the traditional forms of portraiture and with the chemistry between artist and subject that goes into a painted or sculpted likeness. And if the enthusiastic visitor response over the years to the National Portrait Gallery's collection of presidential likenesses is any gauge, modern-day Americans take an especially lively interest in seeing how that chemistry applies to their Presidents, whether they be George Washington and Thomas Jefferson or George Bush and William Clinton.

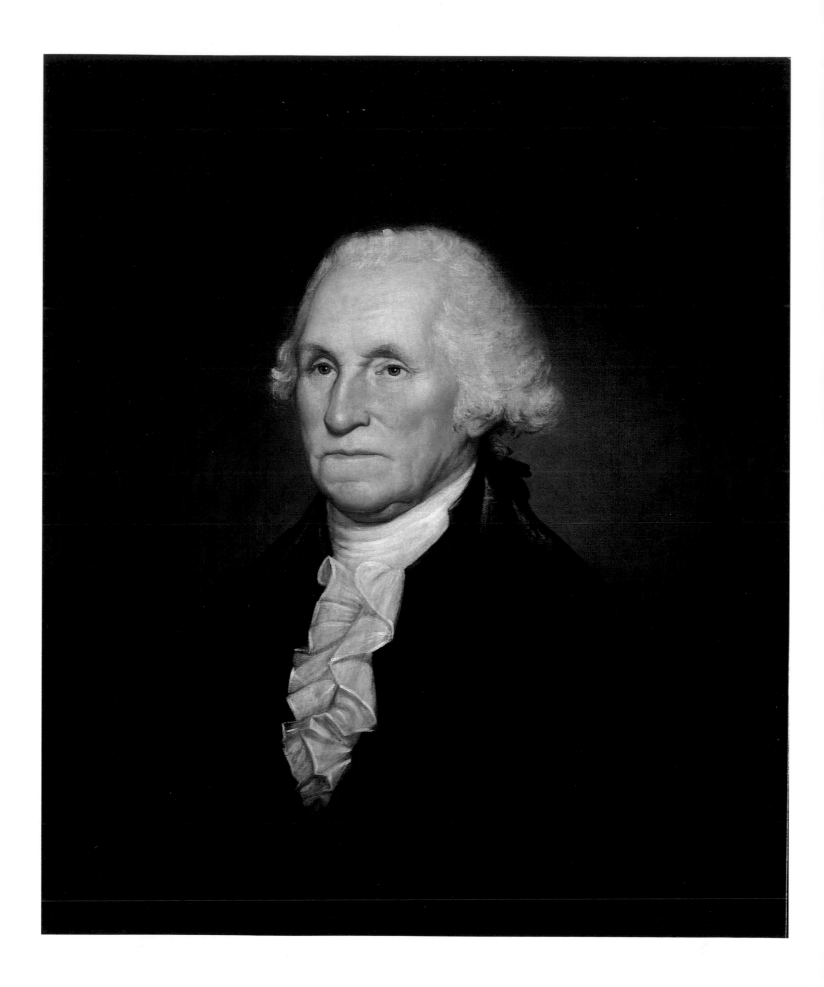

George Washington

1732–1799

Rembrandt Peale's portrait of Washington

Rembrandt Peale was only seventeen when he painted the original version of this likeness, and Washington would probably have refused to sit for him had it not been for the intercession of Rembrandt's father, artist Charles Willson Peale, whom Washington had known for many years.

On the morning of the first sitting, the younger Peale was so awed at the prospect of confronting the great Washington that he could barely prepare his pigments. Finally, to soothe his jangled nerves, it was agreed that his father should come along to the sittings and work alongside his son on a Washington portrait of his own. One of a number of replicas that Rembrandt Peale made from his original, this version went to Henry William de Saussere, director of the United States Mint.

Rembrandt Peale, 1778–1860
Oil on canvas, 75.6 x 64.1 cm
(29 3/4 x 25 1/4 in.), circa 1795
Transfer from the National Gallery of Art; gift of Andrew W. Mellon, 1942

Today in the United States, a President reaches office after a hard-fought, drawn-out campaign between two major candidates, which is marked by heated debate about issues both serious and petty. In the country's first two presidential elections, however, in 1788 and 1792, the mechanisms for determining who would lead did not work that way. On those occasions, George Washington claimed the nation's highest office in contests in which he was virtually the only candidate.

The reason for this anomaly was simple. As commander of the Continental army during the Revolution, Washington had guided the country to independence. As presiding officer of the Constitutional Convention of 1787, he had also been a major influence when the plans for the federal government were drawn up. Moreover, he had always performed his services to the country with a dignity and evenhanded forcefulness that had by the late 1780s transformed him in the eyes of his countrymen into a kind of demigod. Thus, when Americans elected their first President under the newly ratified Constitution, they considered George Washington the only logical choice.

Despite the luster attached to Washington's name, his eight years in the presidency did not pass without criticism. Thomas Jefferson, his secretary of state, remarked, for example, on his fiery temper and his social aloofness that inspired charges of elitism. The Jay Treaty of 1794 with England, which was meant to settle questions largely related to trade and overlapping territorial claims, spawned the accusation that Washington's administration had betrayed American interests. And among the newspaper attacks on policies late in his administration was one describing him as "the scourge and misfortune of our country."

Nevertheless, the election of Washington as first President of the United States was indeed a wise choice. Under his leadership, the new republic achieved a stable and responsible fiscal policy that created a sorely needed climate of assurance for trade and industry. In diplomacy, he adroitly steered the country clear of hazardous hostilities in the Anglo-French conflicts that came in

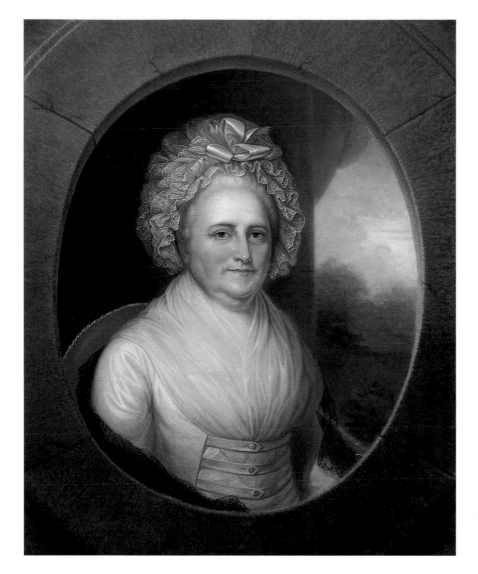

Martha Washington

During her tenure as the nation's first lady, Martha Washington (1731–1802) likened herself to a "state prisoner." Like her husband, however, she recognized the duties of her position, and for eight years she presided with great warmth and skill over the weekly receptions and state dinners of her husband's administration. Shortly after retiring with George Washington to their Mount Vernon home in 1797, she expressed her relief at being out of the public eye in a letter describing herself as "steady as a clock, busy as a bee, and happy as a cricket."

Painted as the companion to the "Patriae Pater" likeness of her husband, Rembrandt Peale's portrait of Martha Washington was based on an original image painted from life sittings by his father, Charles Willson Peale, in 1795. That picture now hangs in Independence Hall in Philadelphia

Rembrandt Peale, 1778–1860
Oil on canvas, 91.4 x 73.6 cm
(36 x 29 in.), probably 1853
Gift of an anonymous donor

the wake of the French Revolution. Finally, when western Pennsylvanians rebelled over a federal whiskey tax, Washington's decisiveness in the situation demonstrated that the young republic's unity could weather the divisiveness of local unrest. In short, even with benefit of hindsight, few historians would dispute the long-standing assertion that Washington was one of the most effective chief executives the country has ever had.

Perhaps Thomas Jefferson explained this extraordinary presidential success best. On the one hand, he noted that Washington's intellect was by no means "of the very first order." But far outweighing that was Washington's fearlessness, integrity, and sense of justice, which were unmatched among his contemporaries. "He was indeed," Jefferson claimed, "in every sense of the words, a wise, a good, and a great man."

Jefferson might also have added that personal power was never an end in itself for George Washington. Where others might have used a commanding prestige such as his to hold on to the presidency for a third term, he was quite content to retire in 1797, firm in the belief that the need for his services had passed.

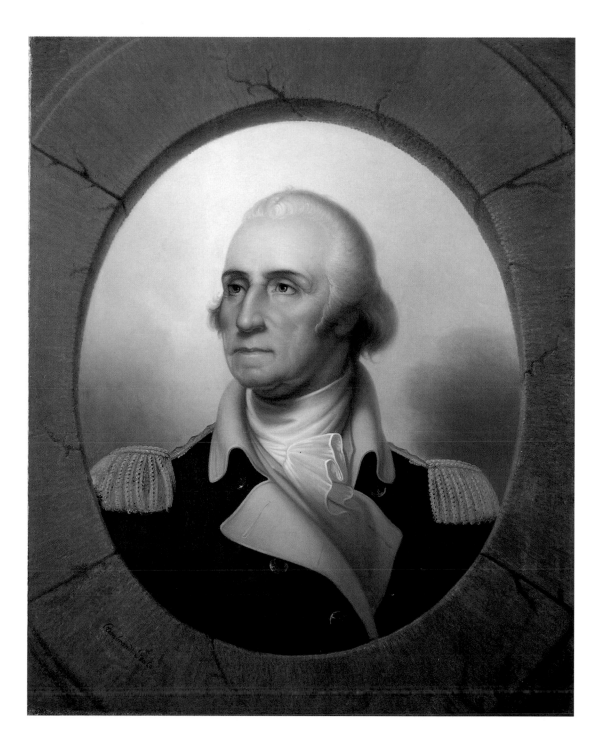

Version of Rembrandt Peale's "Patriae Pater" portrait of Washington

Not long after Washington's death in 1799, Rembrandt Peale began to think about creating a definitive portrait of Washington. Using the Washington likeness he had painted in 1795 as his starting point, he finally, in 1823, created a portrait that measured up to his expectations for it. Set in a trompe-l'oeil stone frame to underscore the monumentality of the subject, the image became known as "Patriae Pater," and it was Peale's ambition that this be the likeness by which posterity would know Washington. Though prints of the picture enjoyed brisk sales and patrons ordered oil replicas of it from Peale, in the end, Peale's *Washington* never quite became the national icon he had hoped it would be.

Rembrandt Peale, 1778–1860
Oil on canvas, 91.4 x 73.7 cm (36 x 29 in.), probably 1853
Gift of an anonymous donor

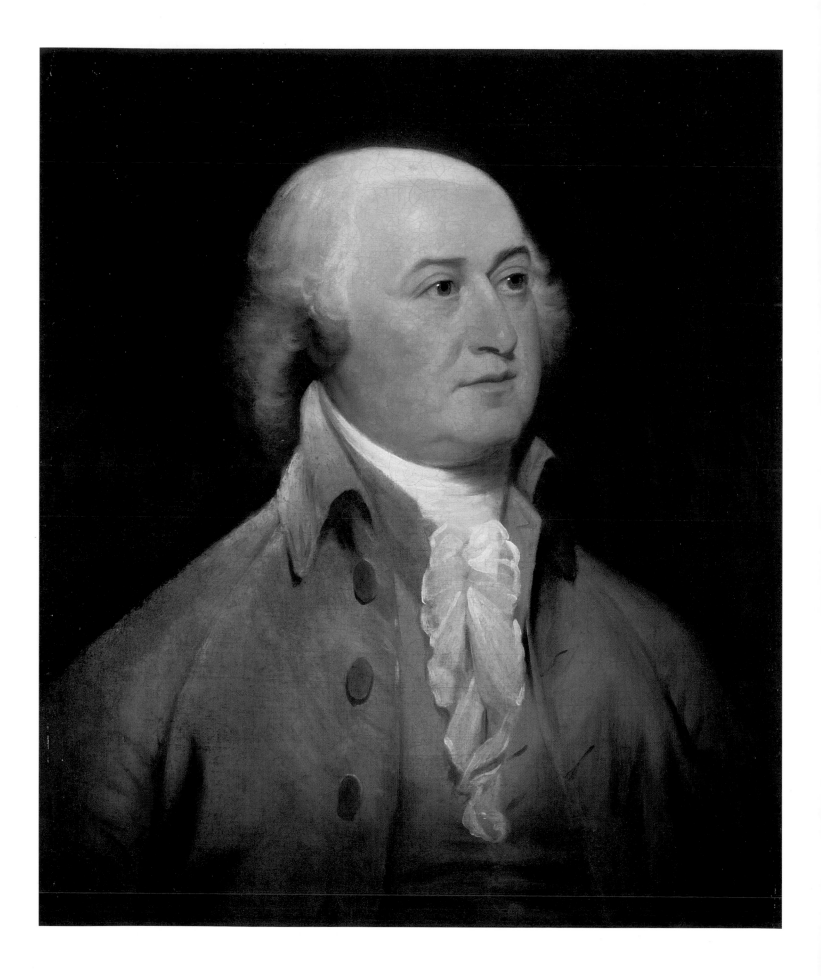

John Adams

1735–1826

John Adams late in his term as George Washington's Vice President

In 1783, shortly after helping to draw up the Treaty of Paris, which officially recognized American independence, Adams celebrated the occasion by commissioning a full-length portrait of himself, painted in the grand European manner in London by the Anglo-American artist John Singleton Copley. Adams later felt a little sheepish about indulging in that showy bit of extravagance. More in tune with his Puritan New England conscience was this spare, modest-sized likeness done during his vice presidency by John Trumbull. By the time Adams sat for it, Trumbull knew his visage well, having painted him on two previous occasions. The earliest likeness, done in 1787, served as the basis for the Adams figure seen in Trumbull's historic tableau depicting the submission of the Declaration of Independence to the Continental Congress, a version of which resides today in the Capitol Rotunda.

John Trumbull, 1756–1843
Oil on canvas, 65.1 x 54.6 cm
(25 $^5/_8$ x 21 $^1/_2$ in.), 1793

When John Adams took up his duties as George Washington's Vice President in 1789, he found that his responsibilities were few and generally unimportant. No matter how he tried, he realized that the position would never carry much weight, and he soon confessed to his wife that he now occupied "the most insignificant office that ever the invention of man contrived."

The proud Adams brooded over this situation as he performed his duties as the Senate's presiding officer. In the course of his brooding, it undoubtedly crossed his mind that this was a poor way indeed for a country to reward a man of his distinction. Such a thought was not unwarranted. One of the most effective opponents to British rule in the decade preceding the Revolution, John Adams served his country well when war came in 1775. As a member of the committee appointed to draft the Declaration of Independence, he was one of its most articulate supporters. Adams also played a part in negotiating the Anglo-American treaty of 1783, which officially ended the Revolution, and he served as the United States's first minister to the Court of St. James's.

Unjustly neglected though he might have felt, Vice President Adams nevertheless must have taken comfort in the knowledge that he was the most likely successor to Washington's presidency. He was not disappointed. Had he known, however, of the storms ahead, he might not have been at all pleased with this turn of events.

At the heart of Adams's presidential difficulties were relations with the new republican regime in France, which in its war with Britain and other European powers had been interfering with America's transatlantic shipping. In dealing with this problem, he found himself besieged on one side by a vocal segment within his own Federalist Party that was rabidly hostile to the French. On the other side, he faced the pro-French Antifederalists, who believed that because of America's republican ideology, the country's leaders were obliged to do everything in their power to advance France's cause against European royalists. Unfortunately, Adams's

attempt to keep the country out of the imbroglios of Europe, while still maintaining its shipping rights as a neutral nation, satisfied neither side. Everything came to a head in 1798. Out of the diplomatic mission Adams dispatched that year to Paris came the notorious "XYZ affair," in which the French refused to begin talks on United States shipping rights until Adams's emissaries had granted them a substantial loan. The insult engendered a protest from anti-French Federalists that was both instant and deafening. When Adams ultimately rejected their urgings of war with France in favor of continuing to press for a negotiated settlement, this anger was directed at him.

Adams also came under fire from both Federalists and Antifederalists because of the Alien and Sedition Acts. Passed to curb French interference in American domestic affairs, these laws were a significant infringement on free speech. While Antifederalists took his administration to task for implementing these measures at all, Federalists criticized its failure to apply them stringently.

Leaving the presidency in 1801, the much-battered Adams retired to his farm in Quincy, Massachusetts. Shortly thereafter, he remarked that he had not been so happy "since some sin, unknown to me, involved me in politics."

(opposite)

One of Jefferson's favorite likenesses of himself

An ardent admirer of classical art and architecture, Jefferson asked Gilbert Stuart in 1805 to paint a profile likeness of him in a manner reminiscent of carved Roman medallion portraiture. Of the two portraits Stuart did of him that year, Jefferson preferred the profile and in 1815 described it as the likeness "deemed the best which has been taken of me." Members of his family agreed in that judgment, and in 1836 artist Charles Bird King made this copy from the Stuart original for Jefferson's granddaughter, Virginia, and her husband, Nicholas Trist.

Charles Bird King, 1785–1862, after Gilbert Stuart
Oil on panel, 57.2 x 48.3 cm (22 ½ x 19 in.), 1836, after 1805 original

Thomas Jefferson

1743–1826

In 1962 President John F. Kennedy looked out over a White House gathering of Nobel Prize winners and declared, "I think this is the most extraordinary collection of talent, of human knowledge, that has ever been gathered together at the White House with the possible exception of when Thomas Jefferson dined alone."

Never before or since Thomas Jefferson's presidency has a man of such remarkable versatility occupied the office. As author of the Declaration of Independence, he gave the world what may be its most compelling defense of liberty and political self-determina-

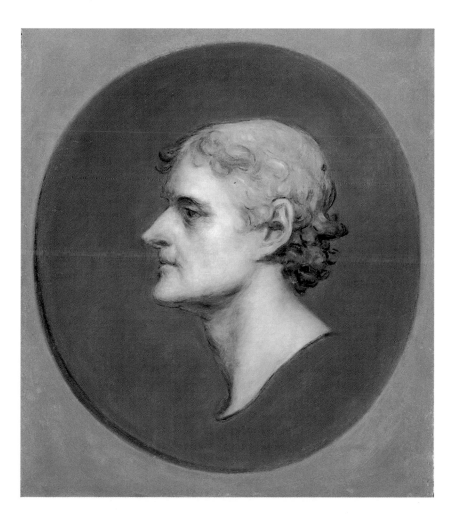

tion. As a staunch advocate of the power of education, he fathered the University of Virginia, and as a self-taught architect, he designed its wonderful colonnaded buildings. At his Monticello plantation in Virginia, he created one of the most beautiful homes ever built in the United States. As an inventor, he produced a host of ingenious contrivances, and as a naturalist, he promoted the early investigations of North America's natural environment. Yet despite his varied talents, Jefferson's presidency was at best a mixed success. While his first term yielded several noteworthy triumphs, the second left him vulnerable to bitter attacks.

On the positive side was the acquisition of the trans-Mississippi wilderness known as the Louisiana Purchase. Jefferson's narrow interpretation of the Constitution made him doubt his power to

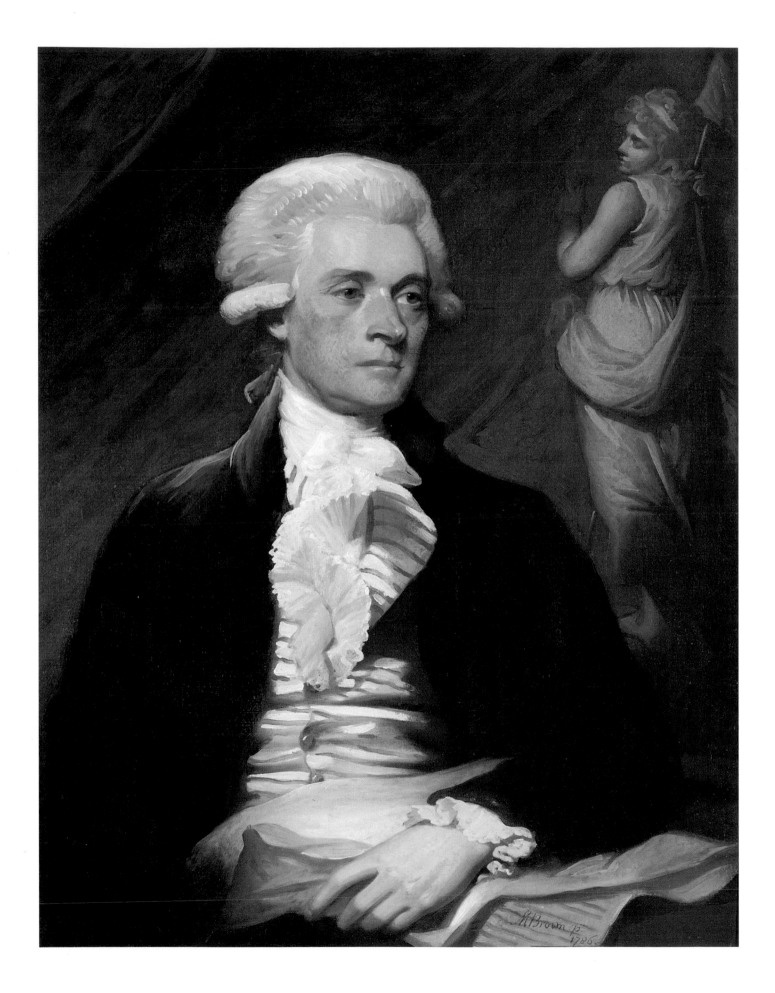

Thomas Jefferson at the beginning of his diplomatic career in Europe

The earliest known portrait of Jefferson, this likeness was the work of the American-born artist Mather Brown, who spent his career in England. It is one of two versions derived from sittings that took place during Jefferson's visit to London in 1786, one year into his tenure as the American minister to France. This version went to John Adams and was part of a portrait exchange between the two men that betokened their warm feelings of friendship and respect for each other.

Adams and Jefferson became estranged in the midst of the bitter political divisiveness of the late 1790s. But they both held on to the portraits of each other and were doubtless glad they did, following the revival of their friendship in 1812.

Mather Brown, 1761–1831
Oil on canvas, 90.8 x 71.1 cm (35 ¾ x 28 in.), 1786
Bequest of Charles Francis Adams

obtain this territory without consulting Congress. But when Napoleon offered it in 1803 at a bargain price, he had the sense to snap it up before the French emperor changed his mind. He also had the wisdom to follow up this lucky stroke by dispatching Meriwether Lewis and George Rogers Clark to discover the new territory's potential and record its natural features.

The early years of Jefferson's administration also marked the solution to an irksome problem facing American shipping—the pirates of Africa's Barbary Coast, who routinely extorted handsome fees in exchange for safe passage through the Mediterranean. Again Jefferson had to overcome his scruples—in this case his pacifism—to deal with the situation. But overcome them he did. After sending the navy to the Mediterranean on a mission of armed intimidation, the United States extracted a treaty highly favorable to its trading interests from the Barbary state of Tripoli.

Jefferson was decidedly less successful, however, in confronting Britain and France, which, in their war with each other, both claimed the right to seize American trading vessels bound for enemy ports. Jefferson's solution was the Embargo Act of 1807, which halted all foreign commerce. This draconian measure never achieved its aim of coercing Britain and France to respect the rights of the United States as a neutral nation, but it did result in enormous hardships for American citizens. As for Jefferson himself, the embargo evoked a popular wrath that quite obscured his earlier successes and undoubtedly made all the sweeter his retirement in 1809 from what he termed "the splendid misery" of the presidency.

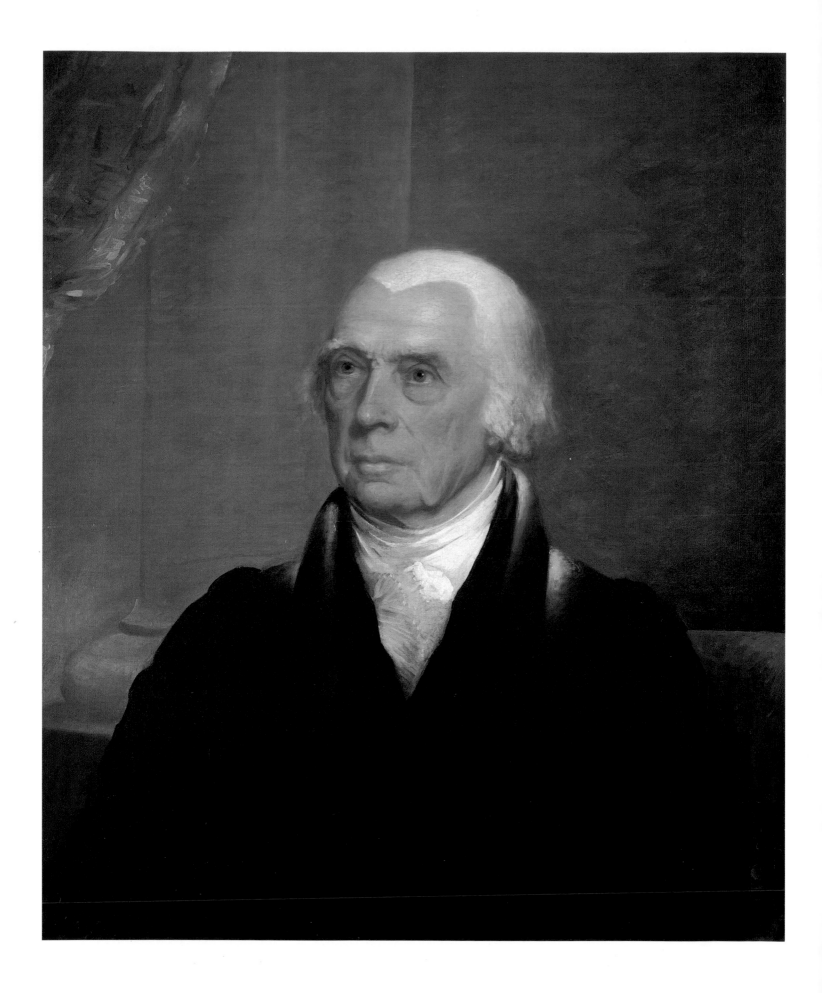

James Madison

1751–1836

James Madison toward the end of his life

In the fall of 1829, Madison attended a convention to rewrite the constitution of his native Virginia in Richmond. He was in his late seventies and suffering increasingly from the frailties of age. But reentry into the public arena seemed to rejuvenate him, and in addition to taking a part in the convention debates, he made himself the "delight of every social board" with his stock of racy anecdotes. He also found time to pose for this portrait by the Boston portraitist Chester Harding, who had come to Richmond specifically to paint members of the convention, which included yet another former President, James Monroe, and Supreme Court Chief Justice John Marshall.

Chester Harding, 1792–1866
Oil on canvas, 76.2 x 63.5 cm
(30 x 25 in.), circa 1829–1830

"Every Person seems to acknowledge his greatness. He blends together the profound politician with the Scholar. In the management of every great question he evidently took the lead in the Convention, and tho' he cannot be called an Orator, he is a most agreeable, eloquent, and convincing Speaker. . . . The affairs of the United States, he perhaps has the most knowledge of, of any Man in the Union." That is the way one of his fellow delegates described the diminutive James Madison as he appeared at the United States Constitutional Convention of 1787. But flattering though these words were, they did not do the Virginian full justice.

Known today as the Father of the Constitution, James Madison had long deplored the weaknesses of the central government that had been established under the Articles of Confederation following the Revolution. It had been his proddings, as much as anything, that had led to the Constitutional Convention and to a second attempt to create a strong political union among the states. It was Madison who also inspired the so-called Virginia Plan, which served as the invaluable springboard for the convention's debates. And in the battle for the Constitution's ratification following the convention, no one worked more effectively to win its popular acceptance.

As President under the Constitution that he sired, however, Madison was not nearly so successful. Inheriting the problem of British and French interference in American shipping from the Jefferson administration, he never managed to find a peaceful solution to that thorny issue. Instead, clever French maneuvering eventually coalesced with British encroachments on the country's western frontiers to create the perception that Britain was by far the worst of the two violators of America's shipping trade. Consequently, the growing anti-English sentiment had forced Madison to declare war on Britain.

Madison proved to be a poor wartime administrator. Among other things, he took the country into conflict at a moment when it was ill-prepared, and he was inexplicably slow to remedy the situation by appointing capable military leaders. As a result, the war

went badly for the United States and for Madison. By the time the British burned the nation's capital in 1814, his popularity was severely diminished. In many quarters, especially in New England, where the War of 1812 had been opposed from the start, the conflict was bitterly characterized as "Mr. Madison's War."

Still more potentially harmful to Madison's waning reputation was the Treaty of Ghent, which finally brought the nation peace but also left unsatisfied most of the grievances the war was intended to redress. But news of the treaty, which in effect turned the war into a costly draw, inspired no angry move to drive Madison out of the nation's charred capital. Instead, he soon found himself largely restored to the public's good graces.

This was due in part to the constructiveness of Madison's final two years in the White House. It was also the result of the nationalistic pride that came with several battlefield triumphs in the war, the most notable of which was Andrew Jackson's dramatic victory at the Battle of New Orleans. When the public celebrated the triumph of Jackson and other war heroes, they also made a place in that pantheon for Madison, the little man who had dared to take on the British Goliath.

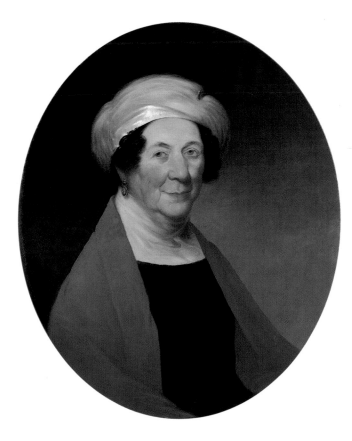

First Lady Dolley Madison in her later years

James Madison's wife, Dolley (1768–1849), proved to be one of his greatest assets during his presidency. Serving as White House hostess during the administration of the widowed Thomas Jefferson as well as that of her own husband, she invested Washington's social life with an elegance and gaiety that long would be remembered. Although she avoided enlisting her social skills for partisan ends, there is little doubt that the difficulties of Madison's administration would have been all the more severe without her vibrant presence.

This portrait was painted the year before Dolley Madison's death. Living near the White House, she was still a much loved fixture in Washington society. Purchased by news publisher William Seaton, the picture shows her in a turban, which had been her sartorial trademark ever since her days as first lady.

William S. Elwell, 1810–1881
Oil on canvas, 76.2 x 63.5 cm
(30 x 25 in.) feigned oval, 1848

James Monroe

1758–1831

In 1819 there was a financial panic in the United States, followed by much personal suffering. Although such an event might be expected to thwart whatever hopes the White House incumbent might have for reelection, it actually had no negative impact on James Monroe's bid for a second term in 1820. To the contrary, he became that year the only presidential candidate, other than George Washington, to gain office virtually unopposed.

The reasons for this turn of events did not lie in a compelling personality, for in truth Monroe was a rather dry and colorless individual. He was, however, the last of the so-called Virginia dynasty, which included Washington, Jefferson, and Madison, and which had played such a crucial role in the nation's early history. Although Monroe's own part had been minor compared to those of the three other men, it was not negligible. As an officer in the Revolution, he had nursed the wounds of the great Marquis de Lafayette and figured prominently in the defeat of the British at the Battle of Trenton. During Washington's and Jefferson's administrations, he had served as a diplomat, and under Madison he had performed admirably as secretary of both the War and State Departments.

Monroe's connection to the Virginia dynasty accounted only in part for his electoral success in 1820. His unopposed candidacy was, above all, a result of the Era of Good Feelings, which set in after the War of 1812 and which was marked by a surging nationalism and the temporary halt of two-party factionalism.

Monroe brought to the presidency a temporizing outlook that meshed well with the Era of Good Feelings. When, for example, heated congressional controversy over the admission of Missouri as a slave state ended in a compromise, admitting Missouri while banning slavery in other western territories, Monroe questioned its constitutionality. But rather than risk fueling animosity between the country's pro-slavery and abolitionist factions, he signed the bill into law. Similarly, when he vetoed a bill calling for federal improvements in transportation on the ground that it was

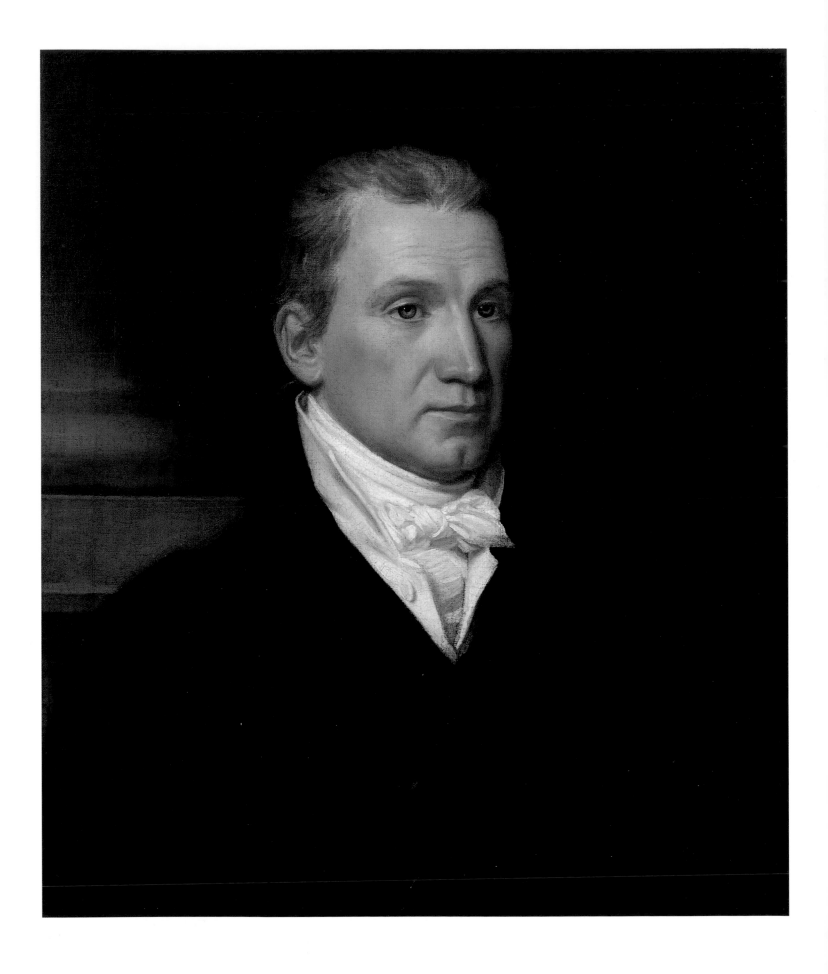

James Monroe on the eve of his presidency

Monroe sat for this portrait in Washington shortly
after his election to the presidency became final in
November 1816. The painter of the picture, John
Vanderlyn, was the first American artist to seek his
professional training primarily in France, and the tight
brushwork and subdued palette clearly show the influ-
ence of French neoclassicism. One of several versions
derived from the sittings, this likeness belonged to
Monroe and descended in his family until it came to
the National Portrait Gallery. Another version was
done for Monroe's White House predecessor, James
Madison, with whom Monroe had enjoyed a long and
warm friendship.

John Vanderlyn, 1775–1852
Oil on canvas, 67.3 x 56.8 cm (26 ½ x 22 ⅜ in.), 1816

unconstitutional, he sought to placate the bill's
supporters by suggesting legislative strategies for
satisfying his objections.

The best-remembered achievements of
Monroe's presidency, however, were in the field of
foreign policy, and he capped his first term with
the acquisition of Florida from Spain in 1819.
Four years later, with rumors that there was
scheming in Europe to help Spain regain domin-
ion over Latin American countries that had
recently won their independence from her,
Monroe gave voice to a doctrine that would for-
ever bear his name. The occasion was his seventh

annual message to Congress, in which he stated
that the United States would not tolerate
European tampering with the sovereignty of
states in any of the Americas. Actually authored
by Secretary of State John Quincy Adams, the
Monroe Doctrine did not have any immediate
impact, since the threats from Europe had no real
substance. But as the years passed, situations
arose in which Monroe's successors found it use-
ful to invoke his doctrine as justification for their
actions. Today, many Americans regard the
Monroe Doctrine as an immutable article of
their national faith.

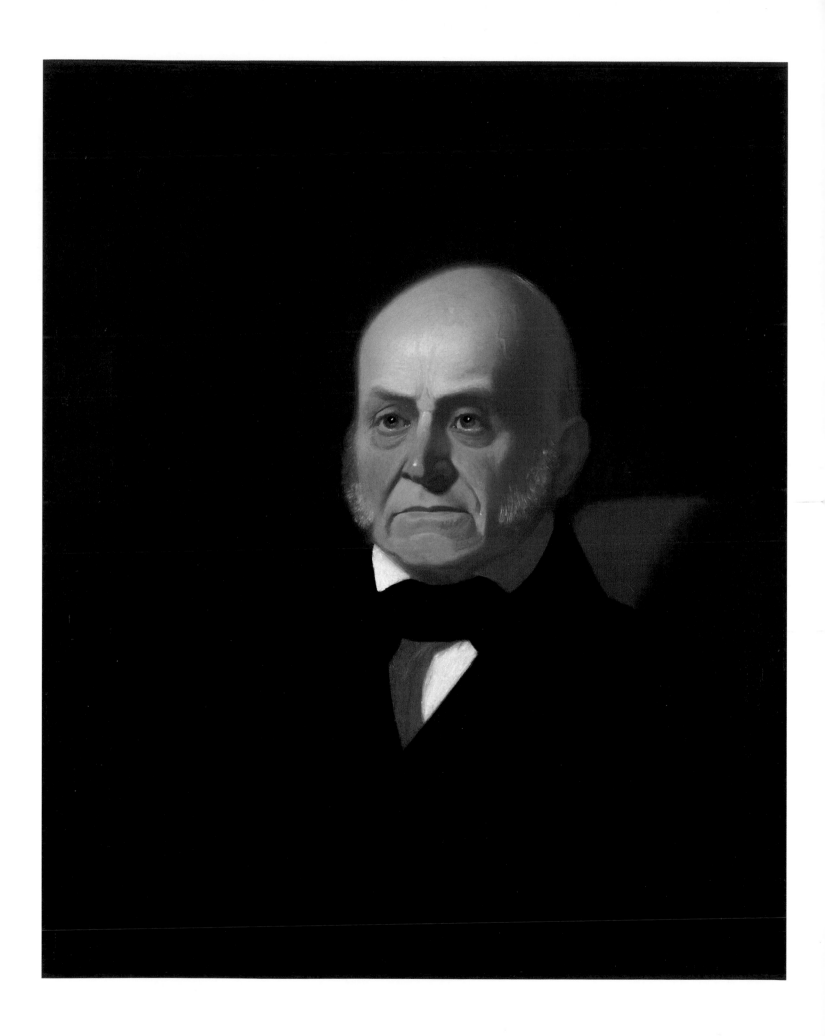

John Quincy Adams

1767–1848

John Quincy Adams in the last years of his public career

John Quincy Adams frequently expressed dislike for portraits of himself, but that did not deter him from sitting for them. In the last ten years of his life, he posed for likenesses on an average of almost three a year. The Missouri-born artist George Caleb Bingham painted the original version of this portrait in the spring of 1844 in his temporary hut-like studio situated at the bottom of Capitol Hill in Washington, D.C. Bingham would later gain much acclaim for his depictions of life on the trans-Mississippi frontier. At the moment, however, he was an unproven quantity, and Adams's willingness to sit for him stemmed largely from the fact that Bingham was sharing his studio with painter John Cranch, who was an Adams kinsman.

George Caleb Bingham, 1811–1879
Oil on canvas, 76.2 x 63.5 cm (30 x 25 in.), circa 1850, from an 1844 original

Of the four candidates—Andrew Jackson, John Quincy Adams, William Crawford, and Henry Clay—who sought the presidency in the campaign of 1824, Jackson clearly garnered the most popular votes. Unfortunately for Jackson, however, this did not give him the majority in the Electoral College that was needed to put him in office. As the Constitution requires in such situations, the task of choosing the nation's next President from among the four candidates was therefore left to the House of Representatives, which ultimately selected John Quincy Adams.

Unfortunately for Adams, however, this victory was not untainted. For he owed his election to a political horse trade; he had bought the votes of Henry Clay's supporters in the House by promising to make Clay his secretary of state. Thus, with Jackson's followers crying "Corrupt Bargain" and swearing to even the score at the next election, Adams embarked on his administration under a cloud that challenged its very legitimacy.

Another man might have been able to rise above that cloud. But not Adams. Aloof, rigid, and often tactlessly abrupt, this son of the nation's second President was poorly suited for the political game of compromise and conciliation. Consequently, when Congress balked at his proposals for such things as a comprehensive national transportation system and a means for regulating the country's resources, he proved incapable of changing its mind.

Adams's presidency, however, was not completely without accomplishments. By the time he left office, after his defeat by Jackson in the election of 1828, he had secured congressional approval of funding for the Chesapeake and Ohio Canal, as well as several commercial agreements with European powers. Nevertheless, these were small triumphs when measured against his administration's many failed hopes.

When weighing Adams's presidential failures against his successes in other phases of his career, however, their significance also shrinks. As minister to the Netherlands and Prussia in the 1790s, he had been an unusually able representative of American interests. Still more impressive was his record as James Monroe's

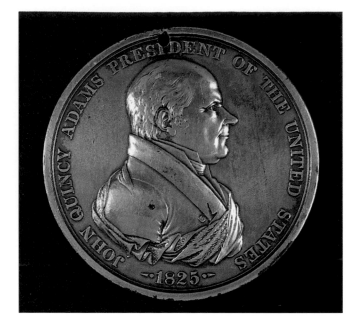

Indian peace medal bearing the likeness of John Quincy Adams

Through much of the nineteenth century, an important part of the federal government's diplomacy with the American Indians were peace medals that bore the likeness of the current President and were presented to tribal leaders as tokens of peace and amity. Many Native Americans placed great store in the medals, and those who received them often wore them as a badge of honor.

Moritz Furst, the Hungarian-born medalist who fashioned the peace medal for John Quincy Adams's administration, also made the medals for three other presidencies. Adams found Furst irritating and did not think much of his professional skill, either. Following one of his encounters with the artist, he described him as "pinchingly poor, both in purse, and as an Artist."

Moritz Furst, born 1782
Silver medal, 7.6 cm (3 in.) diameter, 1825
Gift of Andrew Oliver

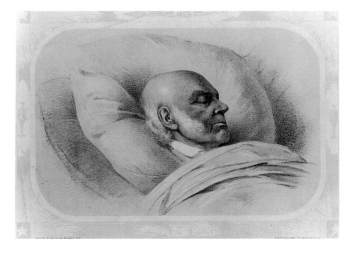

John Quincy Adams on his deathbed in 1848

As John Quincy Adams continued to hold his seat in the House of Representatives through the 1840s, it began to seem that this aging former President would go on forever. The end finally came, however, on February 21, 1848, as he sat in the House listening disapprovingly to a resolution of thanks to officers of the Mexican War—a conflict that he had adamantly opposed. Suddenly he fell across his desk and shortly thereafter was carried to the Speaker's Room, where he fell into a coma and died two days later. In his final hours, an enterprising artist named Arthur Stansbury sketched the last portrait of Adams, which was eventually turned into this print and which is the only first-hand image ever made of a dying President.

Attributed to Napoleon Sarony, 1821–1896, after Arthur J. Stansbury
Lithograph with tintstone, 19.7 x 31 cm (7 ¾ x 12 ³/₁₆ in.), 1848

secretary of state, and many historians claim that Adams might rank as the country's most effective secretary of state. But of the several public roles he played, perhaps the most interesting came after his retirement from the presidency.

On leaving the White House in 1829, Adams likened himself to "a nun taking the veil," but he was not as ready for cloistered life as he had thought. In the year following, he won election to the House of Representatives, where he sat for eighteen years. Predictably, Adams's stubborn inflexibility prevented him from becoming a major power broker in Congress. On one issue, however, this quality made him effective. Thanks to his dogged efforts over many years, in 1844 the House finally repealed its "gag rule," which had prohibited it from accepting citizen petitions condemning southern slavery. The repeal campaign made Adams the object of bitter hatred in the South, but among northern abolitionists he became affectionately known as "Old Man Eloquent."

Andrew Jackson

1767–1845

In 1828 Andrew Jackson's reputation rested mainly on his fame as the frontier general who in the War of 1812 had defeated the British at the Battle of New Orleans. That year, as the campaign to make him President gained momentum, his opponents were therefore deeply troubled that the electorate might be able to place a man in the White House merely because of his military record. But even more disturbing to the conservative, propertied interests who made up much of Jackson's opposition were the populist sentiments that his supporters invoked in their appeals to the voters. As a result, the anti-Jacksonians of 1828 had fearful visions of a new administration that would succumb to the mercurial will of the rabble.

When Jackson triumphed at the polls and his inauguration turned Washington into a town overrun by hordes of rustically mannered celebrants, it seemed that this nightmare had become reality. Indeed, it appeared to many conservatives that the well-being of the United States was about to be undone, now that its fate lay in the hands of a leader all too willing to cater to the rank and file.

Of course, Jackson's White House years did not mark the onset of the country's ruination. But that was scant comfort to his critics. Just as they had feared, the hallmark of Jackson's two terms was his use of presidential powers to challenge, in the name of the people, the nation's vested commercial and financial interests. In 1830, for example, he vetoed a congressional public roads bill on the ground that it would benefit only a few. Two years later, claiming that the Bank of the United States was the creature of a privileged elite, he invoked his veto power again to block the congressional rechartering of that institution.

In thwarting such measures, Jackson incensed his critics on two counts. First, they claimed that he was jeopardizing the nation's economic stability and potential for growth. Second, in contrast to his more circumspect predecessors, he had dared to offer rationales for his vetoes that were not related to constitutional interpretation and, in the process, had turned the presidency

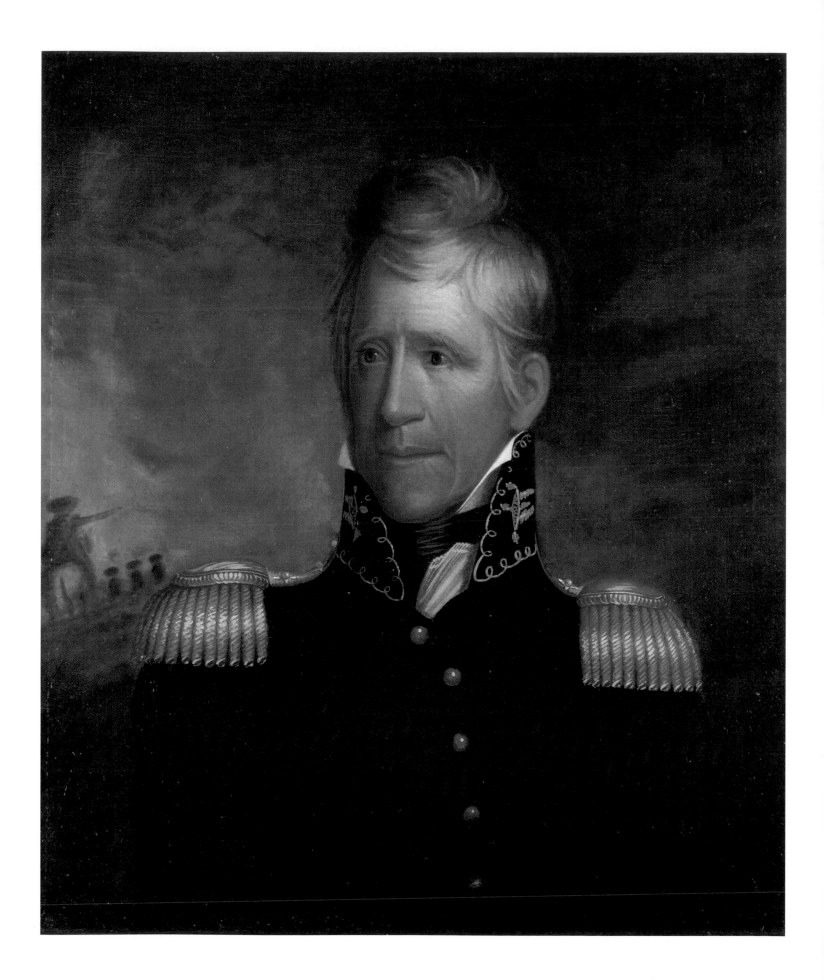

A portrait of Andrew Jackson commemorating the Battle of New Orleans

In 1817, the itinerant artist Ralph E. W. Earl arrived at Andrew Jackson's home, the Hermitage, near Nashville, Tennessee, and began painting the first version of the portrait here. Showing Jackson in military uniform against a vaguely drawn backdrop of battle, this commemoration of Jackson's triumph over the British at New Orleans was the turning point in Earl's career. Settling in Nashville, Earl soon became a major supplier of likenesses to Jackson's legions of admirers. He also became an intimate in Jackson's household. When Jackson went to the White House in 1829, Earl came along and made so many portraits of the President and his household that he was eventually known as Jackson's "court painter."

Ralph Eleaser Whiteside Earl, 1788?–1838
Oil on canvas, 76.2 x 64.8 cm (30 x 25 ½ in.),
circa 1817
Transfer from the National Gallery of Art; gift of
Andrew W. Mellon, 1942

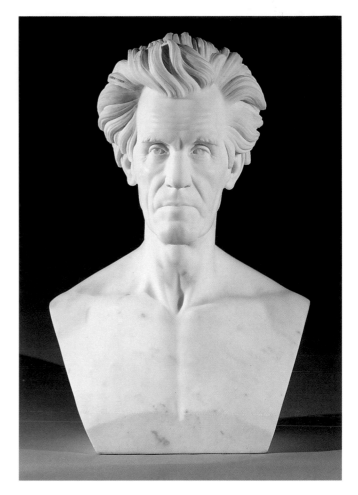

into a monarchical dictatorship. Thus, as his opponents coalesced into the new Whig Party, in preparation for their unsuccessful bid to oust him in 1832, their favorite cartoon became one portraying Jackson as the Constitution-trampling "King Andrew the First." In light of the President's refusal to implement a Supreme Court ruling concerning the fate of Cherokee Indians in Georgia, such imagery seemed all the more justified.

But while conservatives fumed about Jackson, the nation's farmers and laborers gave him their unflagging loyalty and hailed him as the contemporary equivalent of George Washington. The most important consequence of Jackson's administration, however, was not his popularity with the common man. Rather, his aggressive use of his powers had set a precedent that later Presidents would expand upon.

Bust of Andrew Jackson modeled in the last year of his presidency

The creator of this bust of Jackson, German-born sculptor Ferdinand Pettrich, came to Washington in 1836 hoping to win some federal commissions for statuary at the Capitol. Although his training with the renowned Danish sculptor Bertel Thorwaldsen gave him cachet, he never succeeded in obtaining any of those commissions. During his residence in the city, however, doubtless in an effort to advertise his talent, he made likenesses of a number of noted public figures. It is not known whether Jackson ever actually sat for his portrait by Pettrich, but judging from the strength of the final likeness, it is thought that he probably did.

Ferdinand Pettrich, 1798–1872
Marble, 63.5 cm (25 in.) height, 1836

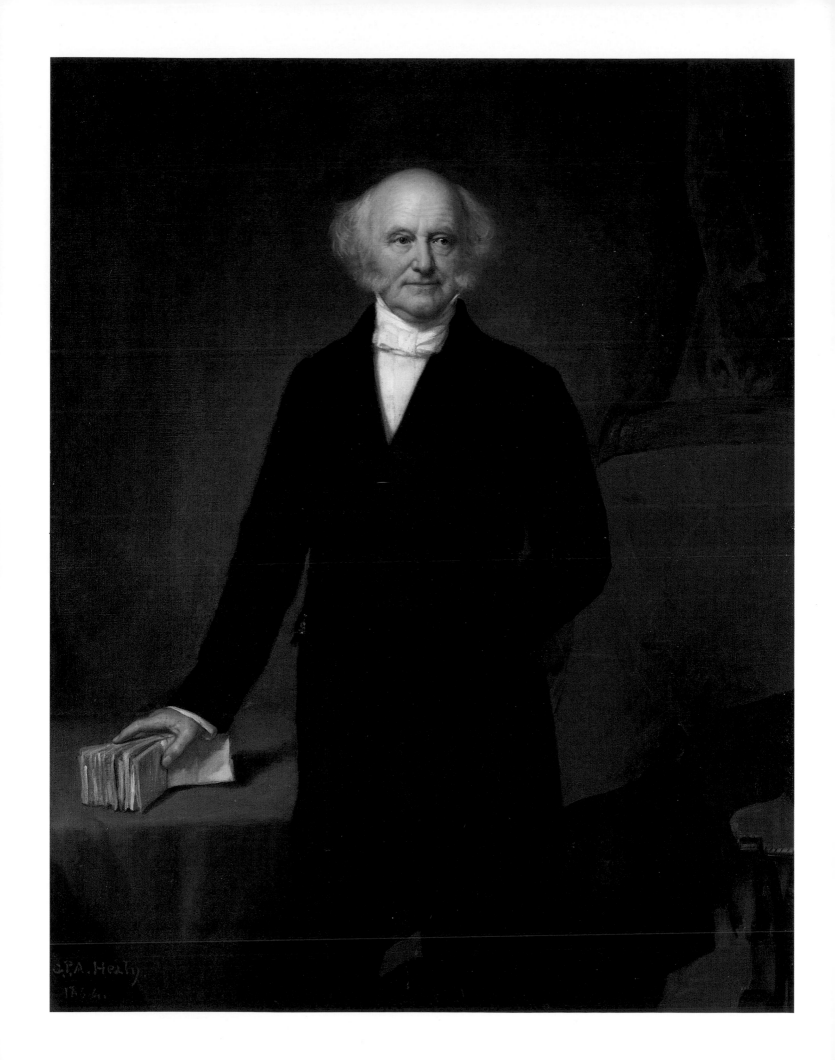

Martin Van Buren

1782–1862

Martin Van Buren in his later years

In 1857 Congress authorized the commissioning of a series of presidential portraits for the White House. The artist selected to do the work was George P. A. Healy, one of the most popular portraitists in mid-nineteenth-century America. This portrait of Van Buren was part of that commission and was based on sittings that Healy had with him in 1857 and 1858. While painting the former President, the gregarious Healy alluded to painting Van Buren's longtime political ally, Andrew Jackson, just days before his death in 1845. Van Buren was fascinated with the artist's story, and Healy later composed a narrative for him of his encounter with the dying Jackson.

George P. A. Healy, 1813–1894
Oil on canvas, 158.8 x 120.3 cm
(62 ½ x 47 ⅜ in.), 1864, from 1857 and 1858 sittings
On loan from the White House, Washington, D.C.

A former governor of New York, secretary of state under Andrew Jackson, and later his Vice President, Martin Van Buren was Jackson's handpicked successor, and he rode into the White House in 1837 on the shirttails of his enormously popular predecessor. But the goodwill engendered by his close association with Jackson did not last long. When Van Buren left the presidency four years later, he was a discredited man.

In many respects the sharp decline in Van Buren's reputation was undeserved. Today, many historians claim that he was a much more able chief executive than his contemporaries judged him to be. Among his presidential accomplishments, for example, was an eminently sound plan for an independent federal treasury system, which he eventually pushed through Congress in an effort to restore the nation's financial stability following the great economic downturn of 1837. He also had the good sense to ignore cries that he was a tool of British imperialism and to stand by his conviction that Americans must take no part in fomenting civil unrest in Canada over British rule. To Van Buren's credit, too, was his mandate for shortening the workday for laborers employed on federal work projects.

What seems in retrospect to be a quite respectable presidential performance, however, was largely unacknowledged in Van Buren's own day. In good part this was the result of the economic depression that set in with unprecedented severity soon after he took office. Like most Presidents who preside over the nation in such circumstances, he was blamed for that misfortune and was soon known as "Martin Van Ruin." Then, too, in 1840, as his Whig opposition geared itself to block his bid for a second term, some of the very campaign strategies that he had exploited so cleverly in helping to put Jackson in the White House in 1828 were used against him. In much the same way that Van Buren had painted Jackson as the man of the people pitted against the nation's rapacious elitists, the Whigs now began casting Van Buren in the part of the "lily-fingered" aristocrat. Against the

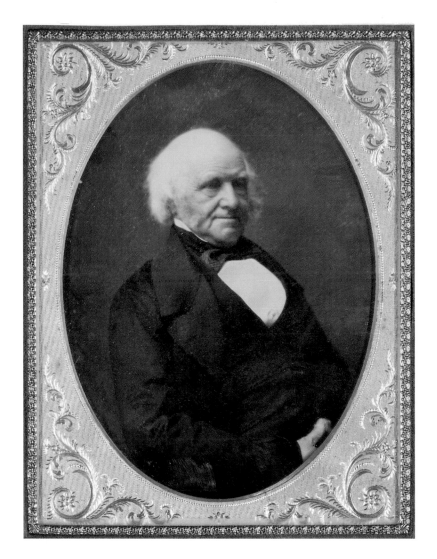

Daguerreotype of Martin Van Buren

When Martin Van Buren sat for this daguerreotype in the mid-1850s, his active involvement in politics had long since ended. But that did not keep him from taking an interest in the current issues of the day, and at the moment he was deeply disturbed by the South's push to extend slavery ever farther into America's western territories.

The maker of this image, Mathew Brady, would ultimately become best known for the remarkable pictorial record that he and his field assistants made of the Civil War. In the 1850s, however, his reputation rested on his studio portraits, and his gallery in New York was a much visited site, where people came to glimpse his many photographic images of America's notables, including former President Van Buren.

Mathew Brady, 1823–1896
Daguerreotype, 14 x 11 cm (5 ½ x 4 ⁵/₁₆ in.), circa 1856

backdrop of the continuing depression, the ploy worked well. Thus, when the Whigs used Van Buren's dapper tastes in clothing and an expenditure of several thousand dollars to refurbish the White House as the springboard for depicting him as a perfumed, wine-sipping dandy, the impact was devastating. And when they contrasted this luxury-loving Van Buren with the alleged homespun simplicity of their own presidential hopeful, William Henry Harrison, it became all the more destructive. "Let Van from his coolers of silver drink wine," one Whig ditty began, "And lounge on his cushioned settee; / Our man on his buckeye bench can recline, / Content with hard cider is he!"

Naturally, Van Buren resented this treatment by the Whigs. But when it resulted in his defeat at the polls, he remained the model of courtesy. When Harrison arrived in Washington to take office, Van Buren offered to ease the presidential transition by vacating the White House early. He was also the first defeated incumbent President to pay a call on his successor.

William Henry Harrison

1773–1841

As a United States senator and the leader of the anti-Jackson coalition that emerged as the Whig Party in the early 1830s, Henry Clay wielded great influence over the politics of his day. But he was never quite satisfied. More than anything else, he wanted to be President, and for many years, it was clear that should his Whig allies want to make him their White House candidate, he was definitely available. On three occasions—in 1824, 1832, and 1844—they were inclined to do just that. But in 1840, the year when the Whigs were almost certain to oust the beleaguered Democratic incumbent, Martin Van Buren, they did not support Clay's candidacy. When Clay heard of this, he exploded, "My friends are not worth the powder and shot it would take to kill them."

Instead the Whigs chose as their standard-bearer William Henry Harrison, the sixty-eight-year-old former governor of the Indiana Territory, who had served two undistinguished terms in Congress and had briefly been America's minister to Colombia. Although Harrison's political experience was unimpressive, especially when compared with Clay's, he had one asset that Clay did not. He was a genuine military hero. In the public mind, his victory against the Indians in 1811 at the Battle of Tippecanoe and his defeat of the British during the War of 1812 at the Battle of the Thames were among the country's great moments of martial glory. In short, the Whigs had learned a valuable lesson from their old antagonist Andrew Jackson, who had owed his presidential victory of 1828 largely to his military record. And the lesson was simple: If the choice of presidential nominee is between a well-seasoned politician and a distinguished soldier, support the man with the gold braid and epaulettes.

From Jackson the Whigs had also learned the importance of identifying their candidate with the common man. Consequently, in 1840 Harrison's campaign became a carnival of banner-waving, in which his supporters portrayed him as a man who liked to sit outside his humble log cabin chatting with a neighbor over a cup of hard cider. Harrison was not, however, the homespun rustic he was touted as. On the contrary, he came from a patrician

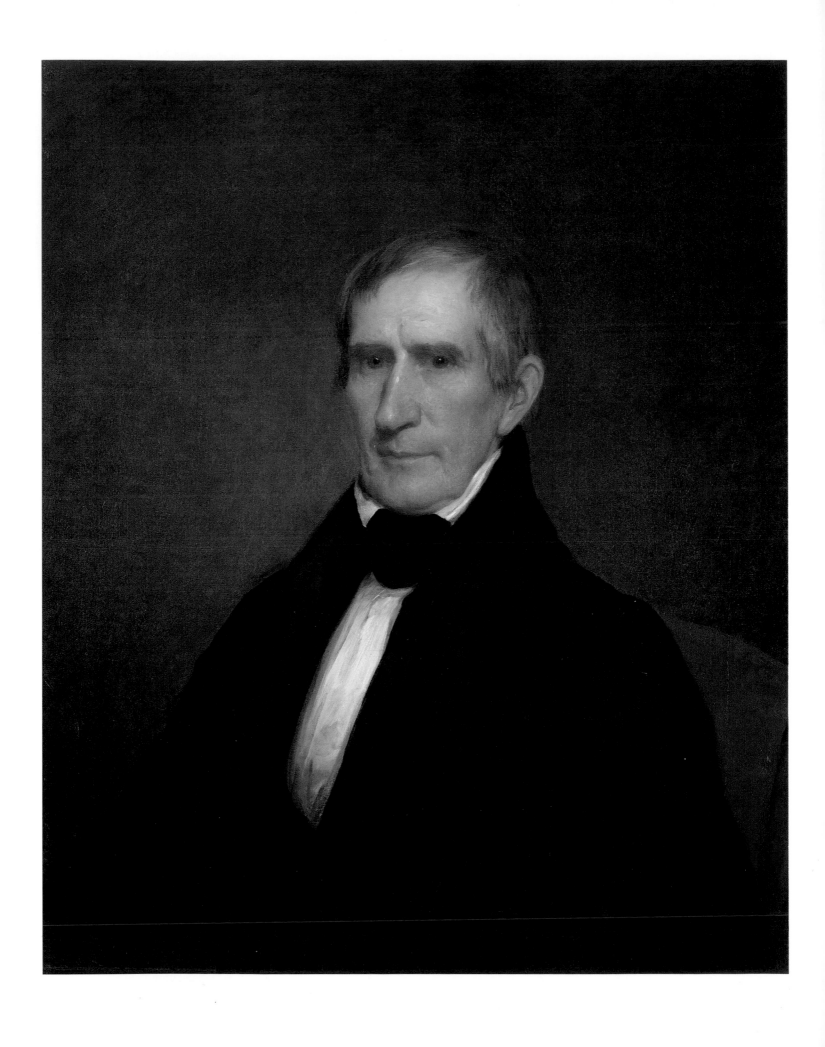

Portrait of William Henry Harrison taken in the year of his election

William Henry Harrison's presidential candidacy inspired many requests from artists for portrait sittings, but generally he turned them down. An exception was the politically well-connected New England painter Albert Gallatin Hoit. On his arrival at Harrison's home outside of Cincinnati in May 1840, Hoit was too well armed with letters of introduction from Harrison's Whig Party allies to be denied a sitting.

In a letter to his father from Cincinnati, Hoit effused over Harrison's "striking head," and of his chances for doing it justice on canvas, he confidently boasted, "I cannot fail." A critic who saw the finished picture in Boston the following year thought that he had made good that boast. Hoit's likeness, according to that observer, was "the best portrait of the many extant" done of Harrison.

Albert Gallatin Hoit, 1809–1856
Oil on canvas, 76.2 x 63.5 cm (30 x 25 in.), 1840

family, was the son of a signer of the Declaration of Independence, and had been raised in an elegant plantation mansion in Virginia. In addition, his Ohio home was a far cry from the simple one-room cabin that Whig propaganda implied. The truth, however, remained irrelevant in the campaign. While Harrison was discreetly silent about any real political issues, a majority of the electorate soon became convinced that "Old Tippecanoe" was their man.

Unfortunately, it will never be known how effective a President Harrison would have been.

Within a month of delivering the longest inaugural address ever, he contracted pneumonia and died. Nevertheless, it is possible to surmise what his presidency might have been. Judging, for example, from Harrison's several months as President-elect, when he promised the same posts to two or three office-seekers, his administration might well have been remembered best for its chaos. Either that, or a group of powerful Whigs—among them Henry Clay—might have taken him firmly in hand and made themselves the power behind the throne.

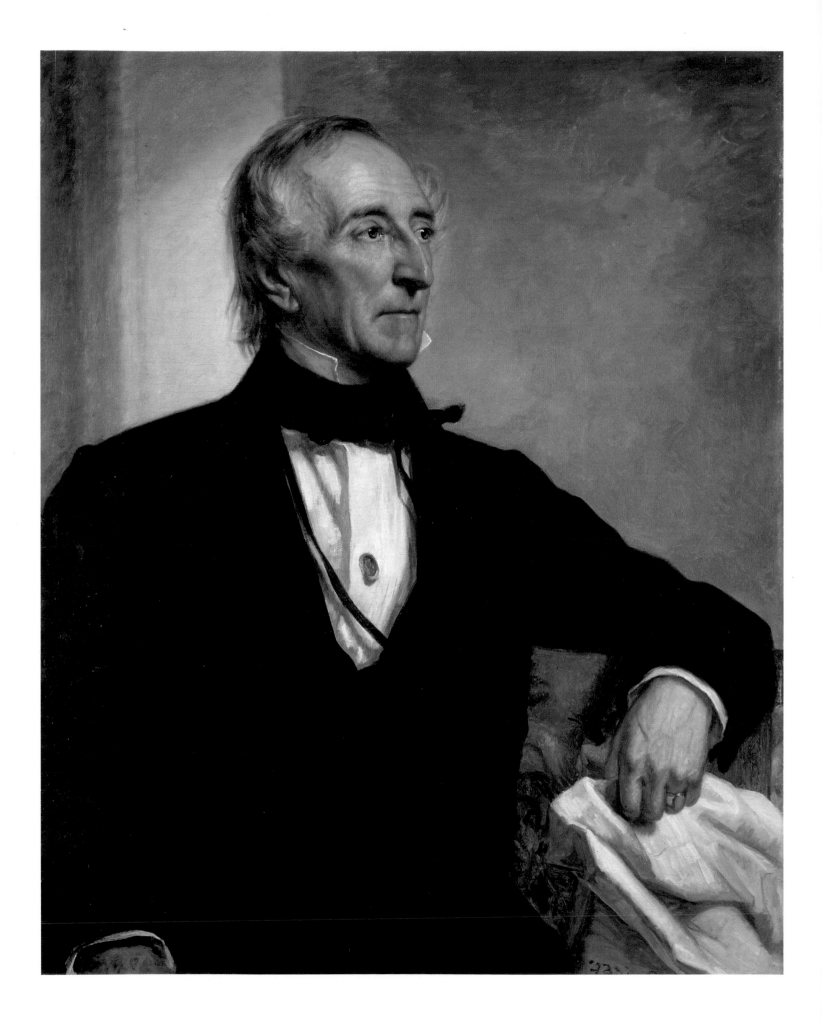

John Tyler

1790–1862

John Tyler in retirement

In 1859, the year in which he sat for this portrait, John Tyler was nearing seventy and had retired long since to private life. Even so, he was enough of a political presence to inspire thoughts among a few that, if the current debate over slavery prevented the Democrats from uniting behind one of its more likely presidential candidates for 1860, then maybe they should nominate Tyler. Although Tyler really did not want to be President again, he rather liked the idea of running for the White House, seeing it as a way to repair a reputation that had suffered so much vilification during his presidency.

The painter of Tyler's portrait, George P. A. Healy, derived two likenesses from the 1859 sittings—the one here and a larger, three-quarter-length version that was part of Healy's commissioned series of presidential portraits for the White House.

George P. A. Healy, 1813–1894
Oil on canvas, 91.8 x 74 cm
(36 ¹/₈ x 29 ¹/₈ in.), 1859
Transfer from the National Museum of American Art; gift of Friends of the National Institute, 1859

During the presidential campaign of 1840, the most often heard cry was "Tippecanoe and Tyler Too." In rallying to that Whig Party slogan, voters had their eyes fixed on the man referred to in the first word of that phrase, White House hopeful William Henry Harrison, whose army had triumphed over the Shawnee Indians in the Battle of Tippecanoe in 1811. For most, his vice-presidential running mate, John Tyler, represented no more than a catchy poetical afterthought. But the electorate that ultimately swept Harrison into the presidency would have done well to consider Tyler a bit more carefully. Just a month after Harrison's inauguration, Tyler became the first Vice President to succeed to the nation's highest office due to the death of the President.

Formerly a states' rights Democrat who had switched his political loyalties because of dissatisfaction with Andrew Jackson's assertive administration, Tyler was never fully at ease with the Whig eagerness to expand the federal government's role in American life. Consequently, shortly after assuming the presidency, he found himself at bitter odds with his fellow Whigs in Congress over the legislative attempt to reestablish a national bank. When he refused to sign a bill authorizing that institution, most of his cabinet resigned in protest, and he became an outcast in his own party. Throughout the rest of his presidency, Whig publicists vied to outdo each other in vilifying this "reptile-like" man who had accidentally made his way into the White House.

Despite stormy relations with fellow Whigs, both in and out of Congress, Tyler's administration was not without its accomplishments. By the time he retired to his Virginia plantation in 1845, he could lay claim to settling the Canada-Maine boundary dispute that had plagued Anglo-American relations for years. He could also take a large share of the credit for the annexation of Texas.

Perhaps Tyler's most important legacy, however, was the precedent he set as the country's first unelected President. In taking office at Harrison's death, he had not, as some thought he should, acted merely as a caretaker, subservient to the wishes of

his Harrison-appointed cabinet advisers and their congressional allies. Rather, he had assumed the presidential powers in his own right. In so doing, he incurred great unpopularity in many quarters, but he also provided a valuable example for future Vice Presidents who found themselves in the same situation.

For the next fifteen years, Tyler lived in relative obscurity. On the eve of the Civil War, however, hoping to prevent an armed conflict, he reentered the public arena to preside over the Washington Peace Convention. When the convention failed to achieve sectional peace, he joined his fortunes to the southern Confederacy. Shortly before his death, Tyler was elected to the Confederate House of Representatives. Thus, the first Vice President to succeed to the presidency as a result of an incumbent's death also became the only former President to turn actively against the Union he had once led.

James K. Polk

1795–1849

In selecting a standard-bearer for the presidential campaign of 1844, the Democrats had a number of choices well known to the nation's electorate, not least of whom was former President Martin Van Buren. But in the end, they bypassed this front-running contender for their party's endorsement, as well as a number of other logical possibilities. Instead, they added to the country's fund of minor political lore by entering in the White House sweepstakes James K. Polk, the first "dark horse" candidate in the nation's history. Consequently, the favorite remark among the Democrats' Whig opposition in 1844 took the form of the belittling question, "Who is James K. Polk?"

Polk was not quite as obscure as that inquiry suggests. During his tenure in the House of Representatives from 1825 to 1839, he had exercised considerable influence and had been one of the Jackson administration's most potent congressional allies. During his last four years, as House Speaker, he had also revealed remarkable gifts for bringing even the most obstreperous politicians to his parliamentarian's heel.

Nevertheless, it was not Polk's congressional record that explained his presidential nomination and ultimate victory at the polls. Rather, it was his frankly stated view that there should be an aggressive policy to promote America's westward expansion. With expansionist sentiment running at full tide in 1844, such an attitude was the very thing needed to spur Polk from his dark-horse starting position and through the White House door.

Polk embarked on his presidency with four objectives: He wanted Congress to lower the country's tariffs; he wished to acquire California from Mexico; he wanted to settle the Anglo-American dispute over the Canada-Oregon boundary; and he intended to reestablish Martin Van Buren's Independent Treasury System, which had been abolished in 1841. Because he achieved all of these goals in only four years, Polk is often counted among the country's most effective Presidents.

At least one of these accomplishments—the acquisition of California—was not realized, however, without great cost. When

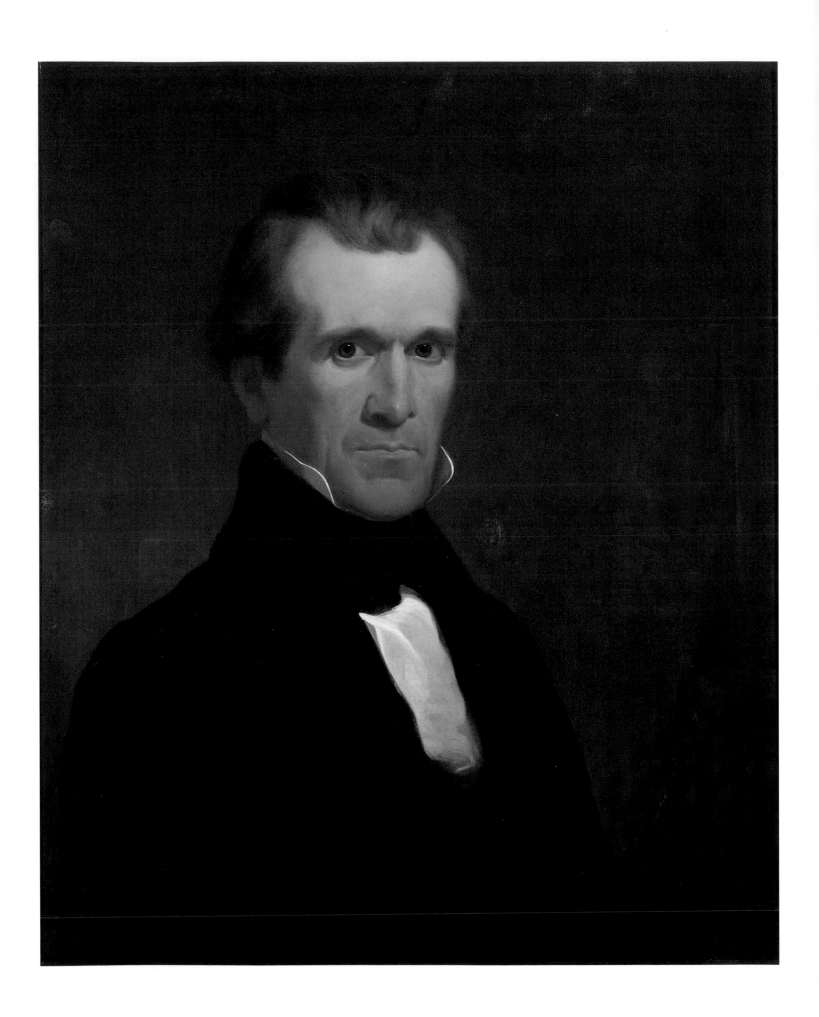

James K. Polk during his term as governor of Tennessee

James Polk was serving as governor of Tennessee when he sat for this portrait in 1840. The maker of the likeness, Miner Kellogg, was a mostly self-taught artist who had spent part of his youth in New Harmony, Indiana, a communal experiment founded by Robert Dale Owen. Kellogg later studied painting in Europe, and in 1848 he had the opportunity to paint Polk again, at the White House. By then, Kellogg had begun to mix art dealing and promotion with painting, and had come to Washington as the agent in charge of arranging for the exhibition of sculptor Hiram Powers's celebrated *Greek Slave*.

Miner Kilbourne Kellogg, 1814–1889
Oil on canvas, 67.3 x 55.9 cm (26 ½ x 22 in.), 1840
On loan from the Cincinnati Art Museum; gift of Charles H. Kellogg Jr.

Mexico turned down his administration's offer to purchase California, Polk decided that his only alternative was to provoke a war with that country. Although the subsequent conflict had popular support, many objected strenuously to this resort to arms for a territory that rightfully belonged to another country. More serious, however, was the suspicion, voiced by Polk's critics, that sowed some of the earliest seeds of the Civil War. The hostilities with Mexico, they charged, were being waged to facilitate the South's expansion of its slaveholding empire. When the Mexican War ended in 1848 with the annexation of both California and the New Mexico Territory, that suspicion grew into a certainty as the North and South opened their bitter debate about whether these new territories should be slave or free.

The success of Polk's administration also exacted great personal costs. A secretive man who insisted on controlling every phase of his presidency, Polk was incapable of delegating responsibility. For him this was a source of pride. But the long hours devoted to the affairs of state took a tremendous toll on Polk's health, which was not good to begin with. Within four months of leaving the White House, he was dead.

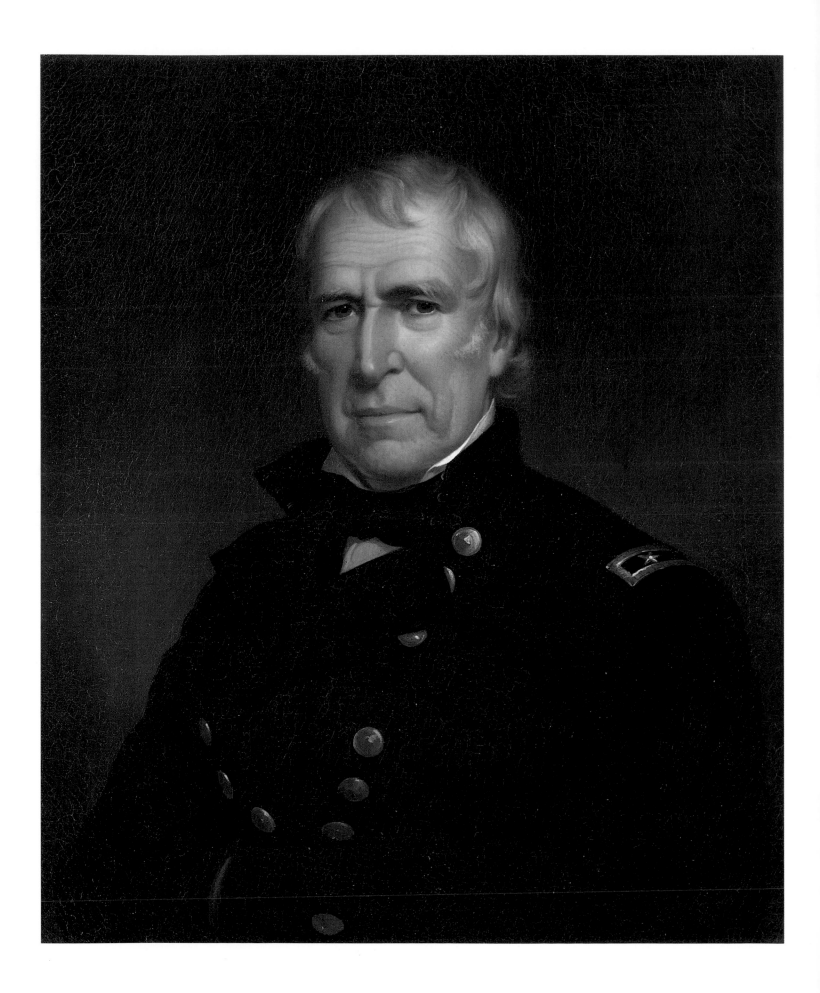

Zachary Taylor

1784–1850

Zachary Taylor on the eve of his presidency

This portrait of Zachary Taylor depicts him in a more decorous light than the reality of his appearance often warranted. In or out of uniform, he was no stickler for spit and polish, and what frequently struck people upon meeting him was his frayed, dusty, and wrinkled appearance.

The portrait is thought to be the work of James Reid Lambdin, a Pittsburgh-born painter who later became director of the Pennsylvania Academy of the Fine Arts.

Attributed to James Reid Lambdin, 1807–1889
Oil on canvas, 76.8 x 62.9 cm (30 ¼ x 24 ¾ in.), 1848
Gift of Barry Bingham Sr.

President James K. Polk's war with Mexico achieved his territorial aims. But even as those aims were being reached, Polk sensed that built into this military triumph was trouble for his own Democratic Party. For out of the war there had come a new hero whose charisma threatened to earn him the Whig nomination in the presidential election of 1848. Polk knew that if that happened, his party would have all it could do to hold on to the White House.

The name of this threat to the Democrats was Zachary Taylor, the leathery-faced "rough and ready" general who had defeated the Mexican armies at the battles of Palo Alto, Monterrey, and Buena Vista. When reports of his martial prowess began reaching the eastern seaboard in 1846, many Whigs realized that he personified a golden opportunity. Not only was Taylor a national hero; his homespun appearance and well-known indifference to rules of military protocol were assets that were certain to play well among the voters. There was only one problem: No one was certain whether the apolitical Taylor, who had never voted in a presidential election, would consent to run.

When first asked about this possibility, Taylor unequivocally declared that even if victory at the polls were assured, "I would not be a candidate." But his Whig supporters did not believe him, and in the face of further courting, "Old Rough and Ready's" once flat denial of any presidential ambition began to take on a decidedly more qualified edge. So, with the door to Taylor's candidacy ajar, the campaign to send him to the White House was on. But in one respect the hero of Buena Vista remained apolitical to the end: When the final vote count proclaimed him the winner, he could claim the singular distinction of becoming President without bothering to cast his own vote.

At his inaugural ceremonies, Taylor stated that the main object of his administration was to "harmonize conflicting interests, and . . . perpetuate the Union." But with the nation locked in angry debate about a number of issues related to slavery, including its extension to the newly acquired California and New Mexico territories, that proved a difficult goal to achieve.

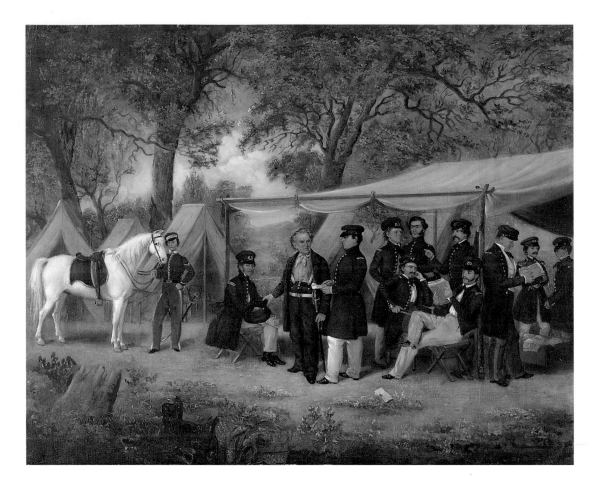

Zachary Taylor *(center)* at Walnut Springs

As Zachary Taylor's victories in the Mexican War
gave momentum to the drive among Whigs to nomi-
nate him for President, plans were set afoot to pro-
mote his already considerable popularity with rank-
and-file voters. One such plan, hatched by a Whig
newspaper editor, involved sending the English-born
artist William Garl Brown out to Taylor's military
encampment to paint a single portrait of the general,
for use in advancing the subject's presidential chances.
Finding a warm welcome in Taylor's camp, Brown
stayed longer than he intended, and instead of just
one likeness, he produced a number of pictures,
including this scene showing Taylor fraternizing with
some of his officers. Also featured in the picture was
Taylor's trusty horse, Whitey, who became almost as
famous in the course of the war as his master.

William Garl Brown Jr., 1823–1894
Oil on canvas, 76.2 x 91.4 cm
(30 x 36 in.), 1847

Though a southern slaveholder himself,
Taylor feared the North's deepening animosity
toward slavery, and he considered its spread a
dangerous threat to the nation's unity. As a result,
he was firmly determined to thwart the South's
drive to permit slavery in either California or
New Mexico and to oppose demands from the
slaveholding state of Texas that part of New
Mexico be ceded to it. This unwillingness to give
the South any quarter, however, only fueled the
fires of disunity further. By mid-1850 Taylor's
opposition to Congress's compromise plan,
granting various concessions to the South's slave
interests, seemed to be pushing the country
toward civil war. But the sudden death of Taylor
changed everything. With Vice President Millard
Fillmore now in the White House, Congress was
able to enact its compromise without fear of a
presidential veto, and the unity that Taylor had
promised at his inauguration was restored, at
least for the moment.

Millard Fillmore

1800–1874

Tall and husky, good-natured and outgoing, Millard Fillmore was a onetime member of the House of Representatives and Zachary Taylor's Vice President. He entered the White House after Taylor died in office in 1850. A man of principle and strong conviction, Fillmore could claim credit for dispatching Commodore Matthew Perry on his successful mission to convince Japan to end its centuries of isolation by opening its ports to American shipping and commerce. It was Fillmore, too, who had blocked France's Napoleon III from claiming dominion over Hawaii and who thwarted southern conspiracies to annex Spanish-held Cuba to the United States.

Fillmore's greatest distinction, however, grew out of his role in averting the very real possibility of civil war in 1850. Unlike Taylor, who had balked at Congress's compromise measures for placating both North and South in the debate over the expansion of slavery, Fillmore believed in compromise. Consequently, it was his succession to the presidency that finally permitted the five bills of the Great Compromise to pass through Congress without the threat of a White House veto.

Some historians fault Fillmore for this, claiming that his signing of the compromise bills only delayed the inevitable armed confrontation between North and South, which, had it taken place in 1850, would have been far less costly. Although that charge might seem a bit harsh, it is nevertheless true that, like many well-meaning politicians of his day, Fillmore failed to understand that his country had passed the point where compromise on the slavery issue was possible.

Thus, Fillmore's signatures on the bills that made up the Compromise of 1850 were barely dry before it was apparent that the resulting tranquility in the nation was temporary at best. The most dramatic indication of that fact was northern anger over one of the Compromise's major concessions to the South—a new law promising strong federal support in the capture of runaway slaves. When Fillmore made clear that despite his own aversion to slavery, he meant to enforce the Fugitive Slave Act to the letter, this

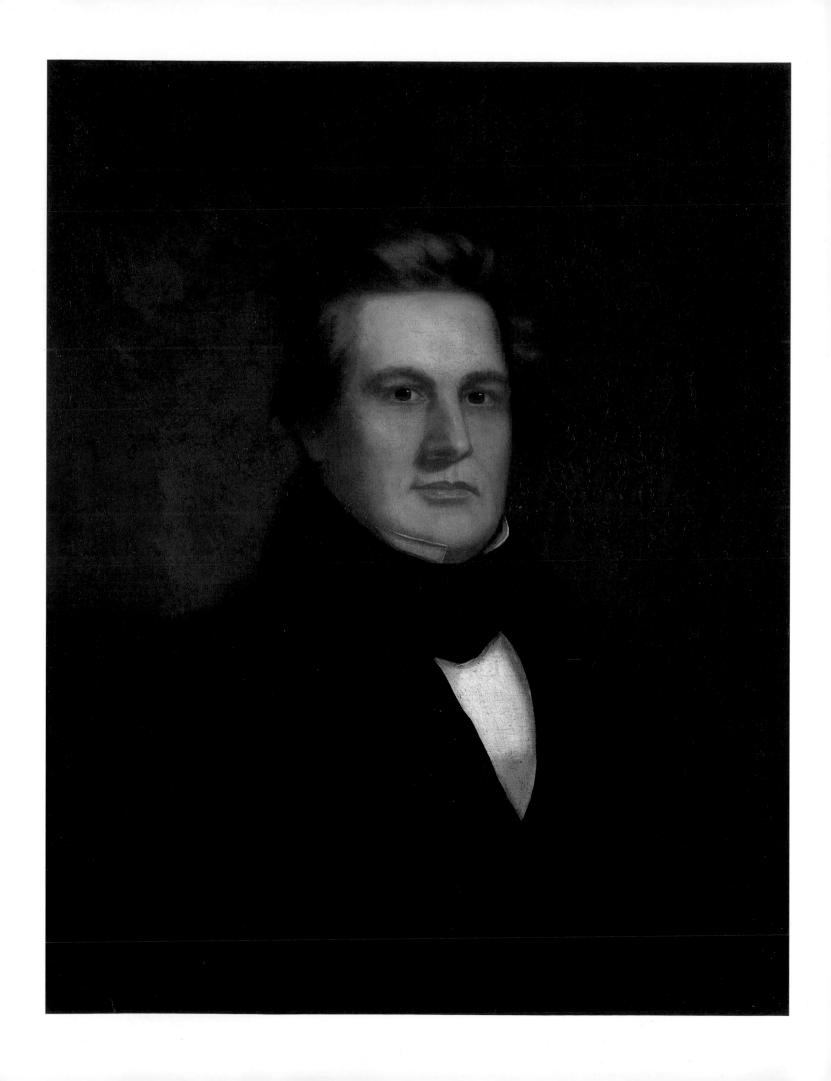

Millard Fillmore at about age forty

Millard Fillmore's portrait by an unidentified artist is thought to date from about the time he retired from the House of Representatives, early in 1843. His skillful leadership as chairman of the Ways and Means Committee had just resulted in a major victory for him and his fellow Whigs—the passage of the protectionist Tariff Act of 1842. But rather than savor the increased prestige in the House that this triumph doubtless would give him, he preferred to return to his native New York to help mend the growing rifts there in his party.

Unidentified artist
Oil on canvas, 76.2 x 63.5 cm (30 x 25 in.), circa 1843

anger soon translated into action. While armed Bostonians sought to prevent the apprehension of alleged runaways in their city, Harriet Beecher Stowe expressed her indignation by writing that most persuasive antislavery tract, *Uncle Tom's Cabin*. Meanwhile, across the North the ranks of committed abolitionists began to swell as they never had before. And, as the South watched those events transpire, its hostility for the North deepened yet further.

Simply put, Fillmore's facilitation of the Compromise of 1850 produced mixed results. On the one hand, it momentarily eased sectional tensions. On the other, it added new sources of friction between North and South and, in so doing, moved the country one step closer to the very war that Fillmore had hoped to prevent.

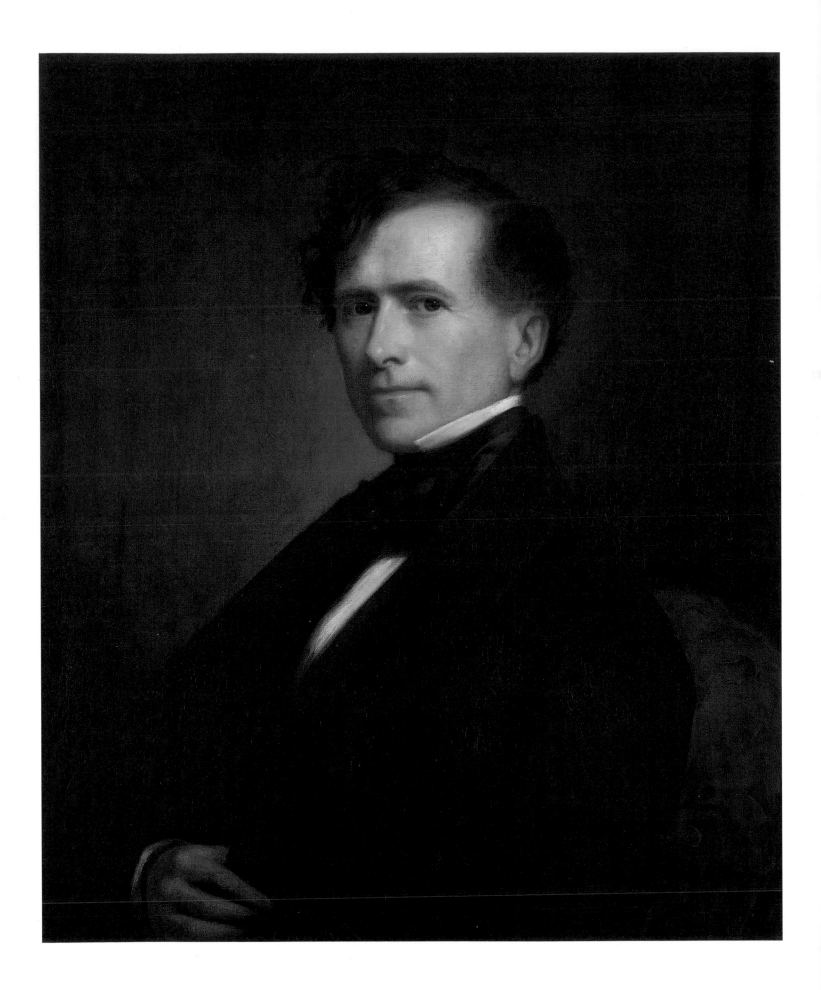

Franklin Pierce

1804–1869

Franklin Pierce on the eve of his presidency

Portraitist George P. A. Healy derived the original version of this portrait from sittings that took place in Boston in November 1852, shortly after Pierce heard confirmation of his presidential election. At the same time, Healy was painting for the President-elect a likeness of his campaign biographer and longtime friend, Nathaniel Hawthorne. Healy eventually produced several variants of his Pierce likeness, the most formidable of which was a full-length work painted for the White House in the late 1850s.

George P. A. Healy, 1813–1894
Oil on canvas, 76.2 x 64.1 cm
(30 x 25 ¼ in.), 1853, after 1852 original
Transfer from the National Gallery of Art; gift of Andrew W. Mellon, 1942

When Nathaniel Hawthorne agreed to help promote the presidential candidacy of his old college friend Franklin Pierce by writing Pierce's biography, he found himself somewhat hard-pressed for material. Indeed, Pierce's rise from a seat in the New Hampshire legislature to membership in the House of Representatives, and finally the Senate, was decidedly lacking in both distinction and drama. To make matters worse, the story behind his presidential nomination by the Democrats did not promise a campaign that would present Pierce in a flattering light. He owed his Democratic nomination not to his proven ability, but rather to his reputation as a northerner with southern sympathy, who, in that election year torn by the continuing debate over slavery, seemed eminently "safe." Good material or not, Hawthorne was determined not to let his friend down and did produce a biography that was moderately engaging. But as Hawthorne himself admitted, "it took a romancer to do it."

Like his predecessor, Millard Fillmore, Pierce entered the White House intent on maintaining a peaceful equilibrium between the increasingly abolitionist North and the slaveholding South. There were two factors that made this especially difficult. First, just before his inauguration, Pierce had witnessed the death of his eleven-year-old son in a train accident. Consequently, he took up his presidential duties in an emotionally distraught state. Second, he was never a particularly strong personality, and his desire to please everyone made him all too susceptible to injudicious advice.

Thus, Pierce allowed some of his southern-oriented advisers to drag his administration into an aborted conspiracy to wrest from Spain the island of Cuba, which the South had long considered a likely place for expansion of its slave interests. He also listened sympathetically to railroad promoters anxious to build a transcontinental line across the Great Plains to the Pacific. This was admirable, except for one of the enterprise's requirements. Before it could be launched, it was necessary to establish territorial governments for the regions of Kansas and Nebraska. To gain

southern congressional support for that action, the Kansas-Nebraska Act, signed into law by Pierce in 1854, contained a proviso opening up these lands, previously closed to slavery, to settlement by southern slaveholders.

The consequences of this catering to southern interests were disastrous for the nation and for Pierce. Soon after the Kansas-Nebraska Act took effect, Kansas became a bloody battleground with pro-slavery and abolitionist settlers pledging themselves to fight for control of the region literally to the death. As for Pierce, a good many of his fellow northerners could not find words harsh enough to describe this man who seemed to be selling out to the South's rapacious demands.

While Ralph Waldo Emerson said that the only excuse for Pierce's politics was "imbecility," others characterized him as the spineless tool of the slave power. But worst of all, Pierce had helped to raise northern antislavery sentiment to near fever pitch and in the process made future accommodations between North and South almost impossible to achieve.

James Buchanan

1791–1868

In opening up the Kansas Territory to slavery, the Kansas-Nebraska Act of 1854 caused angry feelings of betrayal in the North, the intensity of which had never before been felt in the nation's seething debate over slavery. In the wake of that anger, a new political party had arisen, dedicated to halting the spread of slavery. By 1856 this fledgling coalition, known as the Republicans, was fielding western explorer John C. Frémont as its first presidential candidate. Most of the electorate of both North and South, however, still hoped that the growing rift between them could be settled peaceably. As a result, the voters of 1856, fearing that Republican militance would force a final rupturing of the Union, rejected Frémont in favor of the Democratic candidate, James Buchanan.

Judging from Buchanan's record, the decision was wise, and his frank confession that he deplored slavery while recognizing a constitutional necessity to protect it made him seem like the embodiment of evenhandedness needed to cool the nation's temper. Even more reassuring, in his forty years of public life, he proved that he had the ability to make his way unscathed through the labyrinths of political divisiveness.

Unfortunately, the task of curbing the growing volatility of the slavery issue was beyond the capacities of even this astute politician. Indeed, Buchanan's attempts to promote harmony only drove the North and South farther apart. When, for example, the strife-torn Kansas Territory came under the control of its proslavery factions and applied to Congress for admission to the Union as a slave state, Buchanan felt compelled to support this action. In the process, of course, the abolitionist temper in the North waxed more militant than ever. Also feeding this militance was the 1857 Supreme Court decision in *Dred Scott* v. *Sanford*, which focused on the question of whether extended residence in a territory where Congress had prohibited slavery made the slave Dred Scott free. With pressure from Buchanan to settle definitively the long-festering debate over slaveholders' rights in congressionally controlled areas, the Court declared that Congress had no power

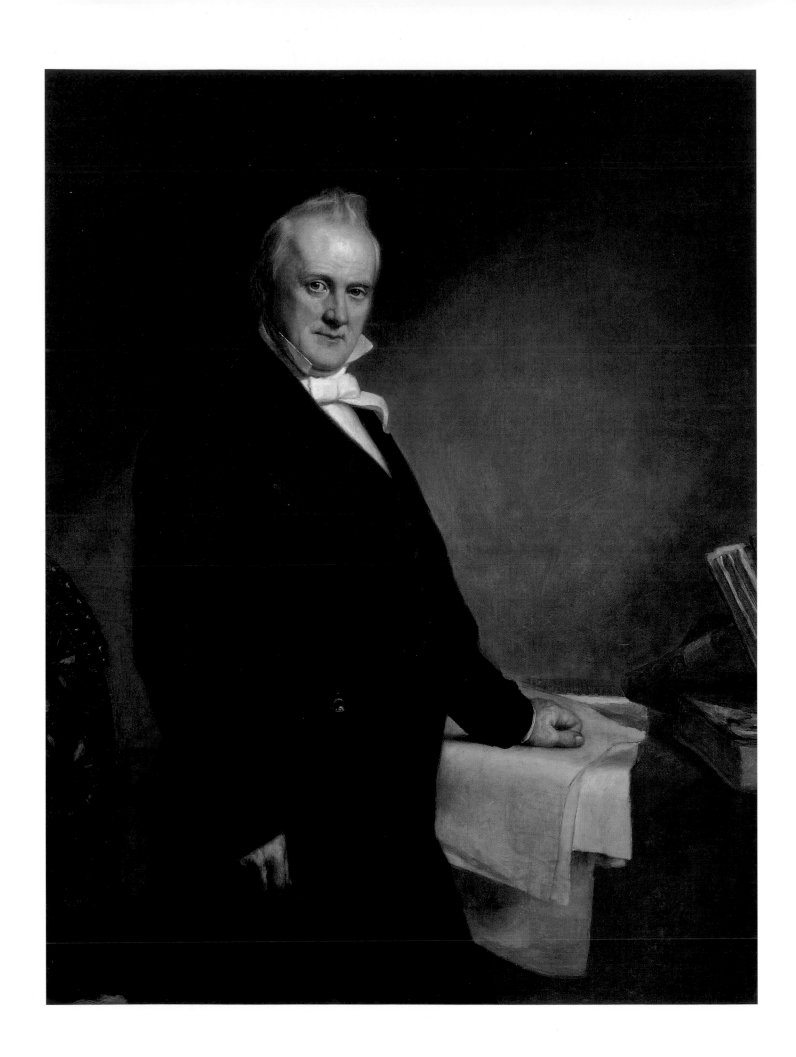

James Buchanan in the third year of his presidency

This portrait by George P. A. Healy is one of several likenesses that resulted from sittings with Buchanan in spring 1859. A version somewhat larger than the one here was meant to be part of Healy's presidential portrait series, which Congress had authorized in 1857. But in mid-1861, Congress informed the artist that it would not pay for it. It is not clear just why Congress balked at buying the Buchanan likeness while purchasing the other portraits in Healy's presidential series. One factor, however, was probably the swift decline in Buchanan's reputation that came with the outbreak of the Civil War early in 1861. Looking for someone to blame for the conflict, the Republicans—now in control of both the White House and Congress—focused on Buchanan's Democratic administration and branded Buchanan himself the Union's Judas Iscariot. As a result, Congress was in no mood to purchase his portrait.

The angling of the head in Healy's likeness was typical of all pictures of Buchanan and represented an effort to minimize his lazy eye.

George P. A. Healy, 1813–1894
Oil on canvas, 157.5 x 119.4 cm (62 x 47 in.), 1859
Transfer from the National Gallery of Art; gift of Andrew W. Mellon, 1942

to ban slavery. With that, many in the abolitionist movement became convinced that nothing short of war could keep the blot of slavery from spreading. And a war, of a kind at least, was exactly what "Bleeding Kansas" and the *Dred Scott* case precipitated. In 1859 a band of armed men led by John Brown launched their abortive slave-freeing conspiracy in Virginia.

Now it was the South's turn to be wildly indignant. As Buchanan moved into his final year in the White House, his hopes of pacifying North and South were shattered. Much worse, however, lay ahead. When Abraham Lincoln, the antislavery Republican candidate, claimed victory in the presidential election of 1860, southerners believed that they had no alternative but to leave the Union. One southern state after another acted on that conviction, and during his last months in office, Buchanan found himself presiding over the worst crisis since the Revolution. But as a lame-duck President, he was powerless to deal with it.

It was hardly surprising that in March 1861 Buchanan turned over the White House to Lincoln with a sigh of relief. "If you are as happy on entering . . . this house as I am in leaving it," he told his successor, "you are the happiest man in the country."

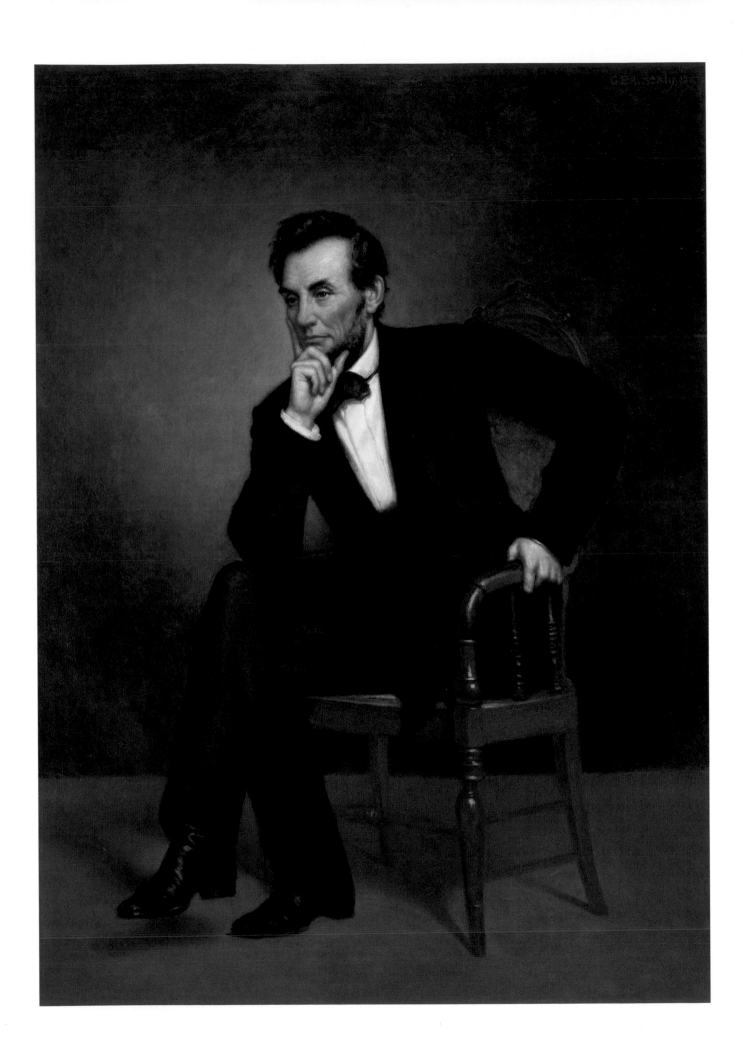

Abraham Lincoln

1809–1865

Lincoln the peacemaker

In the late 1860s, George P. A. Healy began conceiving a huge painting, to be entitled *The Peacemakers*. The picture was to depict Lincoln's consultation in March 1865 with Union generals Ulysses S. Grant and William T. Sherman and Admiral David Dixon Porter, in which the terms of the expected surrender of the Confederate armies were discussed. For the likenesses of the three military figures in the composition, Healy had the advantage of life sittings. But in the case of the dead Lincoln, he had to rely on other sources. To achieve an accurate sense of Lincoln's lanky frame, he took for his model a Chicago lawyer similar in build to Lincoln, and for the face, he probably worked from a combination of plaster busts and photographs. In addition to making this portrait of Lincoln the basis for the seated central figure in *The Peacemakers*, Healy also used it as a template for three other likenesses, including the one here, which he painted for Lincoln's friend Elihu Washburne in the 1880s. Another version belonged for years to Lincoln's son Robert and hangs today in the White House.

George P. A. Healy, 1813–1894
Oil on canvas, 188 x 137.2 cm
(74 x 54 in.), 1887
Transfer from the National
Gallery of Art; gift of Andrew
W. Mellon, 1942

In any opinion poll asking Americans whom they consider to be their greatest Presidents, it is certain that George Washington and Abraham Lincoln would top the list. It is, therefore, one of the more intriguing ironies of presidential campaign history that while Washington won the nation's highest office by virtually unanimous popular consent, Lincoln claimed it by garnering less than 40 percent of the votes. Thus, it can hardly be said that Lincoln's elevation to the presidency in 1860 resulted from a widely held perception that he was the proverbial "right man for the moment." Rather, he owed his success in the election to the nation's slavery crisis, which had thrown his opposition into disarray, and instead of facing one candidate in the campaign, he faced three. As a result, although the final ballot count indicated that a solid majority of the electorate disliked Lincoln and his abolitionist Republican Party, they had sufficiently divided their votes among his three opponents to make him the victor.

Unlike Washington, then, whose presidential merits seemed obvious even before he took office, Lincoln faced a steep climb before he would reach his Olympian heights. In fact, as his election became the final spur in driving the South from the Union and the nation into a bloody civil war, it seemed that this homely, lanky Illinois lawyer was destined for an unexalted place in history.

Mocked and disdained for his earthy humor and rustic appearance, Lincoln was beset from the start by criticism from all sides. On the one hand, his attempt to curb the activities of southern sympathizers in the North through arbitrary arrest and temporary suspension of basic civil rights drew accusations of despotism from his enemies. On the other hand, his initial insistence that his main goal in the Civil War was restoration of the Union, and not the wholesale elimination of slavery, led to charges of moral cowardice among his more radical abolitionist allies. And when the war went badly for Union forces, particularly at the outset, he was made to take much of the blame.

Although the barrage of criticism never entirely ceased, northern victories on the battlefield at least somewhat blunted it. Still,

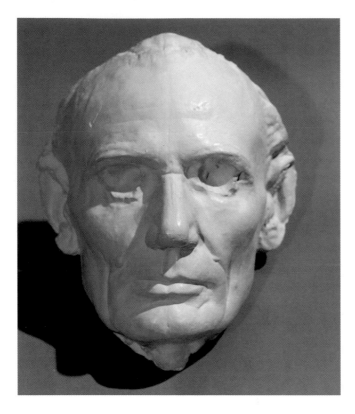

Casting of a life mask of Lincoln

During Lincoln's visit to Chicago in the early spring of 1860 to argue a court case, sculptor Leonard Volk asked him to sit for a bust. When Lincoln consented, the artist decided that to keep the sittings to a minimum he would start by making a life mask. Lincoln found the process of letting wet plaster dry on his face, followed by a skin-stretching removal procedure, "anything but agreeable." But he endured the discomfort with good humor, and when he saw the final bust, he was quite pleasantly surprised, declaring it "the animal himself." Volk would use the life mask and bust of 1860 as the basis for other renderings of Lincoln, including a full-length statue for the Illinois State Capitol in Springfield.

Leonard Wells Volk, 1828–1895
Plaster life mask, 25.4 cm (10 in.) height, circa 1917 cast after 1860 original
Transfer from the National Museum of American History

it was not combat success alone that muffled Lincoln's critics; it was also Lincoln himself. As he brought his unique blend of pragmatic realism, patient forbearance, and compassion to bear on his administration, he gradually assumed a grandeur that was larger than life. Moreover, after it became clear that his Emancipation Proclamation of 1863, calling for the freeing of slaves in territories controlled by the southern armies, was not merely an unenforceable sop to abolitionists but the very real death knell for slavery everywhere, that grandeur began to have an almost saintly aura.

Lincoln's final investiture, however, as one of the country's two unassailably great Presidents did not occur until after his death at the hands of a southern assassin in April 1865. In the wake of this martyrdom to his country's cause, the many alleged blemishes of his wartime administration soon disappeared and were replaced by an almost mystical adoration of the "Great Emancipator."

(left)

A portrait of Lincoln made to advance his presidential candidacy in 1860

By no stretch of the imagination could the coarse-featured Lincoln be considered handsome, and during the presidential campaign of 1860, some of his backers were fearful that his homeliness might even cost him votes. That prospect so worried one supporter in Pennsylvania that when he hired artist John Henry Brown to paint the prototype for a campaign portrait of Lincoln, he instructed Brown to make it "good looking whether the original should justify it or not." The mandate to prettify resulted in this miniature, painted in part from life sittings in Springfield, Illinois, in August 1860. The likeness pleased all concerned, from Lincoln to his anxious Pennsylvania backer, and engravings of it were soon being marketed to the public.

John Henry Brown, 1819–1891
Watercolor on ivory, 14 x 11.4 cm (5 ½ x 4 ½ in.), 1860

Abraham Lincoln a month before his second inauguration

The faint, tired smile of this likeness makes it one of the most compelling photographic images ever made of Lincoln. For many years, it was commonly thought that this photograph dated from early April 1865 and that it was the last one ever made of Lincoln. In fact, it was part of a series of photographs taken at Alexander Gardner's studio two months earlier, on February 5. In shooting the image, Gardner used a large glass negative, which broke before it could be processed. Nevertheless, he managed to make one print. Some have interpreted the crack running through the image as a portent of Lincoln's impending assassination.

Alexander Gardner, 1821–1882
Albumen silver print, 45 x 38.6 cm (17 ¹¹⁄₁₆ x 15 ³⁄₁₆ in.), 1865

Andrew Johnson

1808–1875

Andrew Johnson at about the time of his presidency

The maker of this portrait, Washington Cooper, spent his career almost entirely in his native Tennessee, where he made a comfortable living painting the state's notables. Johnson sat for Cooper on several occasions. Comparison of this likeness with other, dated, images of Johnson suggests that it may date from the years of his presidency.

Washington Bogart Cooper, 1802–1889
Oil on canvas, 92.1 x 74.3 cm (36 ¼ x 29 ¼ in.), circa 1866

When Andrew Johnson entered the United States Senate in 1856, he had reached the summit of his political ambition. But although the Senate seat was enough to satisfy the aspirations of this self-educated tailor from Tennessee, he had yet higher peaks to climb. When the Civil War began in 1861, Johnson's dislike of slavery made him the only member of Congress from a seceding southern state to oppose withdrawal from the Union. Within his own state this made him a traitor. In the North, however, he became a hero. In 1862 Lincoln appointed him military governor of Tennessee, charged with restoring the state's civil authority. Johnson performed this job well, and his political fortunes took an upward leap.

A major concern among Republicans as they looked toward Lincoln's reelection in 1864 was that voters perceived him as too hostile to the South, and therefore incapable of effecting the national reconciliation that was necessary as the Civil War drew to its close. In the hope that Johnson, who had just restored Tennessee to the Union, would allay voters' doubts about their presidential nominee, the Republicans named Johnson as Lincoln's running mate.

Had events run a normal course, this perhaps would have been the last that was heard of Johnson. After Lincoln's reelection, his new Vice President, having served his purpose in the campaign, would in all probability have sunk into quiet anonymity. But with the assassination of Lincoln in 1865, Johnson suddenly found himself in the White House.

Johnson's main task when he took office was the reconstruction of the defeated South. In shouldering this responsibility, he favored the same conciliatory policy that Lincoln had, which in essence meant readmitting the South to the Union quickly, while imposing on it only minimal retribution for making war on the Union. Congress's Radical Republican leadership, however, was not so charitable. While Johnson sought the South's reinstatement on easy terms, the Radicals called for the disenfranchising of many white southerners, aggressively protecting the rights of the

69

Andrew Johnson portrayed as "King Andy I"

Among Johnson's fiercest critics during his administration was *Harper's Weekly* cartoonist Thomas Nast. Unreservedly committed to the Radical Republicans and their stringent approach to reconstruction in the post–Civil War South, he was unsparing in his attacks on Johnson's opposition to the Radicals. Thus, Johnson found himself in Nast's cartoons transformed, by turns, into a conniving Iago, a blood-lusting Roman emperor, and a tyrannical "King Andy I."

It is thought that Nast made this version of Johnson as "King Andy I" during a lecture tour in the fall of 1873, where he entertained his audiences with demonstrations of his cartooning skills. Johnson's White House successor, Republican Ulysses Grant, was less than a year into his second term, but already there was talk of running him for a third. Democrats responded to the third-term boom with cries of "Caesarism," and in the drawing, the pro-Grant Nast placed "King Andy" opposite a laureled ass's head, which was intended to reduce the Caesarism charge to an absurdity.

Thomas Nast, 1840–1902
Pastel on paper, 130.8 x 102.9 cm (51 1/2 x 40 1/2 in.), probably 1873

region's newly freed blacks, and establishing military governments throughout the South.

Unfortunately, Johnson was unable to reconcile his disagreements with Congress. As one historian put it, "his mind had one compartment for right and one for wrong, but no middle chamber where the two could commingle." When the Radicals began replacing his Reconstruction policies with harsher measures of their own, Johnson could therefore think of no alternative but to veto them. But in the end, Congress not only overrode Johnson's vetoes, it also acquired a hearty dislike for him. In 1868 the House of Representatives voted to impeach him. At the subsequent Senate trial, however, the impeachment charges proved flimsy at best, and the Senate exonerated Johnson by a margin of one vote.

The victory was a hollow one. During the remainder of his term, Johnson's power to influence national policy was almost nonexistent. Nevertheless, he remained a self-righteous fighter to the end, and in his final message to Congress he roundly rebuked its members for their tyrannical treatment of the South.

Ulysses S. Grant

1822–1885

Much of Ulysses Grant's life reads like a classic story of the square peg being forced to fit into a round hole. Accepted at West Point in 1839, he entered the academy only because his father had pressured him. At his graduation four years later, his reputation for slovenly dress and reluctance to accept leadership responsibilities when they were offered to him seemed to mark him as a soldier destined for mediocre distinction at best. As a junior army officer, Grant only reinforced that prognosis. After serving creditably in the Mexican War, he gradually became bored with military life, and by the early 1850s the combination of prolonged absences from his wife and the tediousness of his duties at outposts in the Far West had led to a drinking problem. Just how substantial this problem was and whether it was, as some claim, the factor that finally drove him from the army are debatable questions. But one thing is certain: By the time Grant resigned his captain's commission in 1854, he was more than ready to give up his career as a soldier.

Grant, however, fared less well out of uniform than he had in. A failure at farming, he later turned to selling real estate and collecting bills. When those ventures also ended poorly, he was reduced to helping his two younger brothers as a clerk in their leather shop in Galena, Illinois.

With the onset of the Civil War in 1861, Grant's sagging fortunes took a sharp turn for the better. Answering the Union's call to arms immediately, he achieved a general's rank within only a few months and was soon providing the North with some of its most crucial victories. The reluctant West Point cadet had blossomed into a military genius. By early 1864, Lincoln entrusted him with command of all the Union armies, and by war's end Grant's reputation as a chief architect of the North's triumph over the South made him one of the most revered men in America.

But just as it seemed that Grant had found his proper niche in life, the square-peg syndrome returned. Like Zachary Taylor after the Mexican War, Grant was now eminently ripe for a presiden-

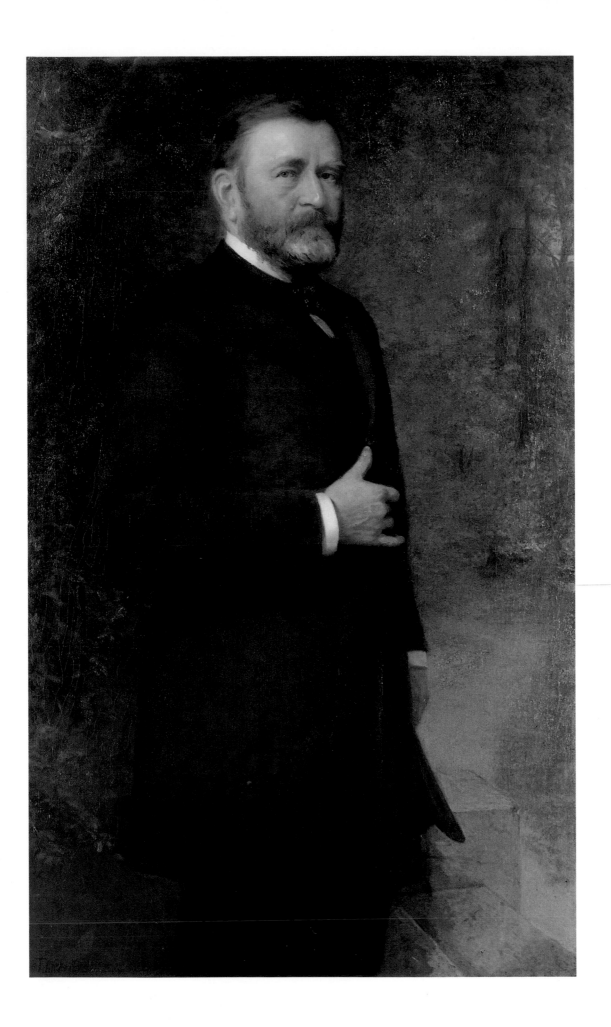

Ulysses Grant following his retirement from the presidency

After leaving the White House in 1877, Grant and his wife set out on a global tour, and everywhere he stopped there were dinners, receptions, and parades in his honor. Shortly after his return to the United States in 1879, he posed for this portrait by Thomas LeClear, a largely self-taught painter based in New York City. At least two likenesses were derived from the sittings. The one here belonged to Grant himself, and a second, larger version was acquired by the White House in about 1883.

Thomas LeClear, 1818–1882
Oil on canvas, 136.5 x 80.6 cm
(53 3/4 x 31 3/4 in.), circa 1880
Transfer from the National Museum of American Art; gift of Mrs. Ulysses S. Grant Jr., 1921

Grant and His Generals

As the Civil War moved into its final stages in the fall of 1864, the Norwegian artist Ole Peter Hansen Balling and a prosperous New Yorker conceived a plan for a large equestrian painting by Balling, depicting the commander of the triumphant Union armies, Ulysses Grant, flanked by an array of generals who served under him. Once completed, the painting was to be used to raise money for the United States Sanitary Commission, a privately funded organization for aiding sick and wounded soldiers. To obtain likenesses of the twenty-seven figures in the composition, Balling procured passes to go into Union army encampments to make life studies of each of his subjects. Among the most cooperative sitters was Grant, who gave Balling repeated opportunities to draw studies of him as he rode with staff officers to survey the situation in the forward lines.

The final rendering of *Grant and His Generals* is almost life-sized. Balling also produced this smaller version, most likely to serve as the template for a colored print of the picture. Today both of these works are in the National Portrait Gallery's collections.

Ole Peter Hansen Balling, 1823–1906
Oil on canvas, 58.9 x 92.7 cm (23 3/16 x 36 1/2 in.), circa 1866
Transfer from the Library of Congress

tial nomination. In 1868, knowing that they had a sure winner on their hands, the Republicans named him their White House candidate by acclamation and, as expected, Grant emerged from the final election a hands-down winner.

Unfortunately, when Grant assumed the presidency, the dogged aggressiveness that had characterized him in Civil War combat deserted him and was replaced by a trusting tractability. He was all too willing to place the fate of his administration in the hands of others, who all too often were rapaciously self-serving cronies and businessmen. Thus, Grant's presidency quickly became a hotbed of corruption, and as his appointees—ranging from a secretary of war to local postal officials—enriched themselves with bribes and rake-offs, "Grantism" became synonymous with violation of the public trust.

Yet Grant's personal reputation suffered barely a scratch from the disclosures of this malfeasance. A scrupulously honest man himself, he had no trouble winning reelection in 1872.

Moreover, in 1880, support for a third nomination was strong enough to make him the front-runner, and had he run, it is not altogether impossible that the electorate would have given him a third term.

Rutherford B. Hayes

1822–1893

Rutherford B. Hayes at about the time of his retirement from the presidency

At about the time that his presidency drew to its close, Hayes sat for his second portrait by Eliphalet Andrews. Trained in Germany, Andrews had first painted Hayes during the election of 1876. The following year the Ohio-born artist moved to Washington, where he became the director of a new school affiliated with the Corcoran Gallery of Art. Soon after its completion, Andrews's second Hayes likeness was added to the Corcoran's collection of presidential portraits.

Eliphalet Andrews, 1835–1915
Oil on canvas, 77.5 x 64.8 cm
(30 ½ x 25 ½ in.), 1881
On loan from the Corcoran Gallery of Art, Washington, D.C.; Museum purchase

On election night of 1876, when the Democrats' presidential candidate, New York governor Samuel J. Tilden, went to bed, he thought that he had just won the nation's highest office. Soon after the polls were closed and the ballots were counted, however, Republicans charged that Tilden's majority votes in several states were the result of fraud at the polls and that their candidate, Ohio governor Rutherford B. Hayes, had really won the contest. Charge followed countercharge, and eventually arbitration of the dispute was submitted to a special congressional commission, which, after much behind-the-scenes wheeling and dealing, declared Hayes the winner. Resigned to accepting the commission's decision, Democrats were understandably unhappy with the outcome, and in many quarters, Hayes became known as "His Fraudulency." But although the legitimacy of his presidency remained a question throughout Hayes's administration, this congenial but decidedly uncharismatic man proved to be an extremely able chief executive. Considering that he faced Democratic majorities in both House and Senate through much of his term in office, the list of his accomplishments is all the more impressive.

It was Hayes who, for example, ended the Reconstruction policies that Congress had imposed on the South after the Civil War. The federal troops stationed in that region were withdrawn, thus terminating "carpetbag" state governments often ruled by unscrupulous northern politicians and setting in motion the final reconciliation of North and South. Hayes also took the first significant step to curb the "spoils system," which had largely reduced the civil service to a body of political hacks whose only virtue was their loyalty to the party in power. To Hayes's credit as well was his choice of unusually talented men as his advisers. Among his wisest selections was Secretary of the Treasury John Sherman, with whom Hayes adroitly managed to stave off the potential fiscal damage of a congressional act calling for an inflationary currency policy. Finally, through the use of his veto power, he succeeded in thwarting efforts of congressional Democrats to minimize the influence of the Republican-leaning black vote in

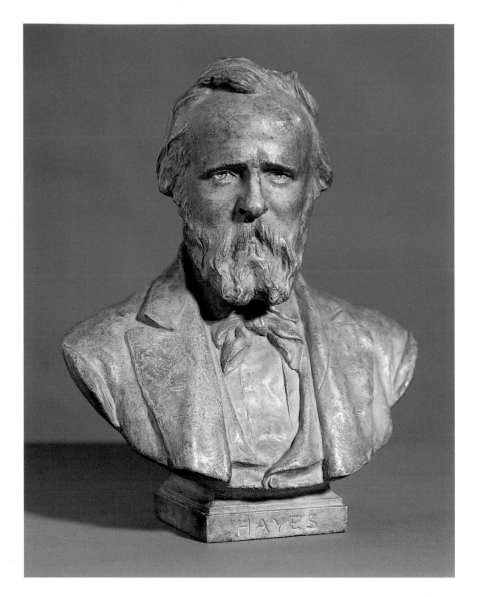

Likeness of Rutherford B. Hayes modeled during his presidential campaign

In the summer of 1876, the sculptor Olin Warner, with no income-producing commissions in the offing, approached the two major political parties about doing busts of their current presidential candidates that could be replicated for campaign purposes and, at the same time, yield Warner some revenue. His proposition struck a responsive chord in the Republican camp, and in August the artist was on his way to Columbus, Ohio, for sittings with the GOP's White House hopeful Rutherford B. Hayes. One Hayes supporter was especially pleased with the resulting bust, and he placed great hope in its ability to persuade a so-far doubting public that Hayes was "a man of power." The venture for replicating the bust, however, never got very far, and only a few copies of it were ever made.

Olin Levi Warner, 1844–1896
Plaster, 28 cm (11 in.) height, 1876
Transfer from the National Museum of American Art; gift of Mrs. Carlyle Jones, 1974

the South by curtailing federal oversight of national elections in the region.

For all its constructiveness, however, Hayes's brand of leadership did not make him especially well regarded by the politicians within his own party. While some fellow Republicans berated him for restoring the South to self-rule, others bitterly resented his drive to transform the civil service into a meritocracy. And when it became clear that Hayes would not seek a second term,

the response from many Republicans was "good riddance!"

Had the anti-Hayes Republicans looked beyond their short-term interests and biases, however, they might have seen that in one important respect Hayes had served his party well. It was his impeccably honest administration that gave a new polish to the Republican image so badly tarnished by the scandals of the previous presidency.

James A. Garfield

1831–1881

In the late 1850s, the young James Garfield was a respected lay preacher and teacher-principal at northern Ohio's Western Reserve Eclectic Institute. It seemed, therefore, that if he was to make a significant mark in life, it would be in education or religion. But beneath the outward signs that he had found his proper vocational niche, Garfield was restless. In 1859, armed with an unusual flair for the grandiloquent turn of phrase, he decided to enter politics. Four years later, after serving in the Ohio legislature and as a colonel in the Union army, he won a seat in the House of Representatives.

Garfield rose rapidly in the House hierarchy and eventually became an influential member of the Radical Republican circles that opposed Andrew Johnson's lenient treatment of the war-torn South after the Civil War. By the late 1870s, he was serving as his party's minority leader in the House.

Unlike so many others who attain influence in American politics, Garfield harbored no presidential ambitions. Instead, the only office to which he aspired was a seat in the Senate. Just as he was about to gain that position, however, there was an unexpected turn of events. In 1880, with the Republicans split into two factions—the "Stalwarts" led by Roscoe Conkling and the "Half-Breeds" led by James G. Blaine—the party became hopelessly deadlocked at its national convention over the nomination of a presidential candidate. Unable to choose between the Half-Breeds' Blaine and Stalwart favorite Ulysses Grant, the delegates finally decided, after thirty-five ballots, that a compromise was in order. Two ballots later, Garfield emerged as the Republican standard-bearer, and as a sop to the Stalwarts, the party shortly thereafter chose Conkling's protégé, Chester A. Arthur, to be his vice-presidential running mate.

Garfield's nomination did not end his party's squabblings, which had little to do with ideology and a great deal to do with power and, above all, with political patronage. Thus, when Garfield won the election, the foremost question in the minds of Stalwarts and Half-Breeds was who would win the greatest favor

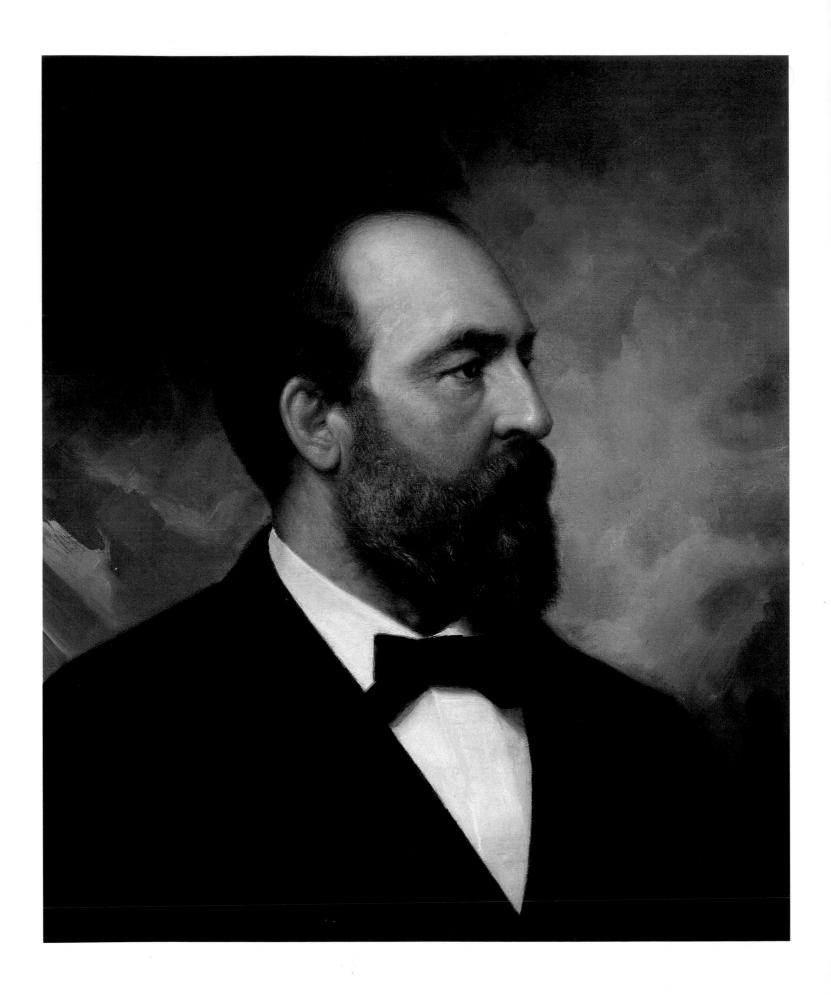

A portrait of James A. Garfield dating from the year of his death

This blandly conventional portrait of James Garfield offers no hint of one of his greatest political assets. At rest, he may have seemed ordinary, but when engaged in public speaking, he was capable of a power that ranked him among the most compelling political orators of his generation. Trying to reconstruct the impact of one of his speeches, a contemporary noted that Garfield's "voice took on a sort of explosive quality" as he moved toward his climax, "his language gained the height of simple and massive eloquence," and his arguments came forth "like solid shot from a cannon."

Ole Peter Hansen Balling, 1823–1906
Oil on canvas, 61 x 50.8 cm (24 x 20 in.), 1881
Transfer from the National Museum of American Art; Gift of the International Business Machines Corporation to the Smithsonian Institution, 1962

from the new patronage-dispensing President.

The answer to that question proved especially disappointing to Conkling. Not only did Garfield name his rival James G. Blaine as secretary of state; he also dared to appoint non-Stalwarts to the New York City Customs House where, as senator from New York, Conkling felt he had every right to dictate the choices. The Garfield-Conkling clash over this matter might be merely an amusing anecdote if it had simply ended when Conkling resigned his Senate seat and then failed in his plan to rebuke Garfield by being promptly reelected. Unfortunately, it did not. On July 2, 1881, as the President was about to board a train in Washington, Charles Guiteau,

a mentally unstable Conkling follower, drew a pistol and, shouting, "I am a Stalwart and now Chester Arthur is President!" shot Garfield in the back. Eleven weeks later, Garfield died from his wounds.

Something positive did, however, result from this tragedy. In its wake came the realization that if quarrels over federal patronage could lead to a presidential assassination, then something had to be done to stop them. Two years after Garfield's death, Congress passed the Civil Service Reform Act, which represented the first significant step in eliminating the spoils system from the country's civil service.

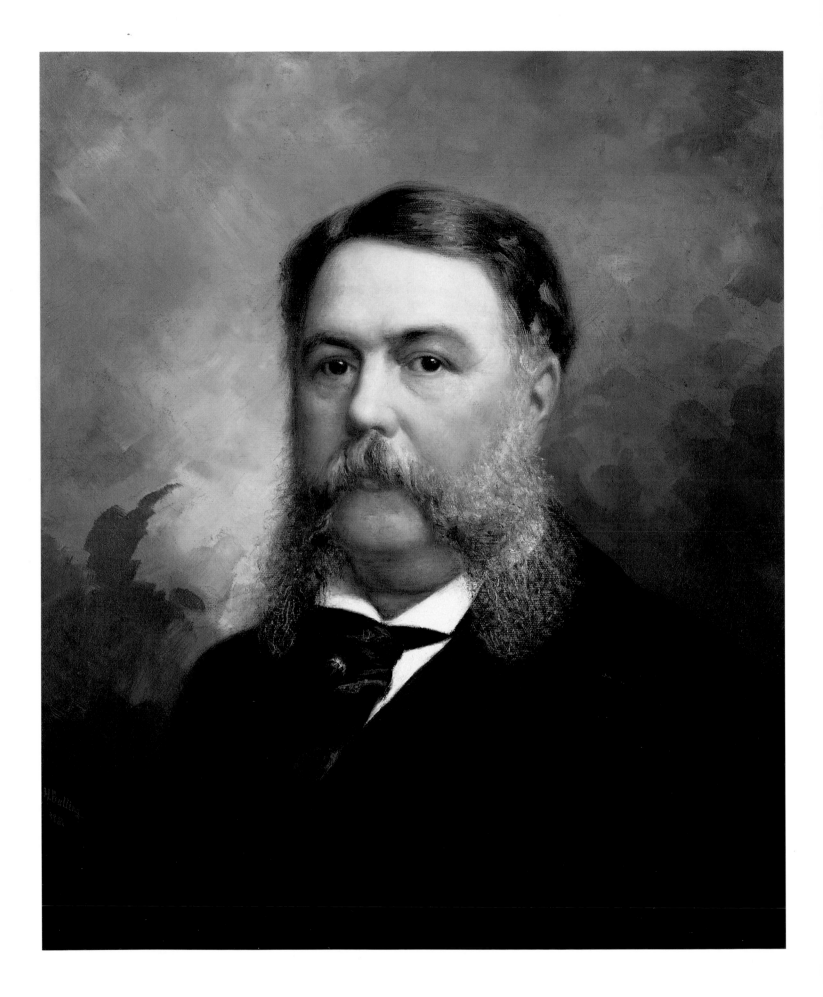

Chester A. Arthur

1830–1886

Portrait of Chester A. Arthur from the early days of his presidency

In matters of appearance, Chester Arthur numbers among the most fastidious individuals to occupy the presidency. Always dressed in the height of fashion, he insisted that his clothes be made of only the finest fabrics. On one occasion he tried on twenty pairs of trousers, all cut precisely to his measurements, before settling on a pair that he liked. All in all, with his muttonchop whiskers "trimmed to the perfection point," he was the epitome of the well-bred Victorian gentleman.

Ole Peter Hansen Balling,
1823–1906
Oil on canvas, 61.2 x 51.1 cm
(24 1/8 x 20 1/8 in.), 1881
Gift of Mrs. Harry Newton Blue

"I have but one annoyance with the administration of President Arthur," New York's Republican boss Roscoe Conkling declared in 1883, "and that is that, in contrast with it, the Administration of Hayes becomes respectable, if not heroic." Coming from Conkling, who was always rabidly anti-Hayes, this was indeed harsh condemnation of Chester Arthur's presidential performance. Yet it did not truly reflect the deep bitterness that Conkling felt toward Arthur then. For in supporting the Pendleton Act of 1883, which called for the elimination of the spoils system from much of the civil service, Arthur had taken a landmark step toward undercutting the power that Conkling enjoyed because of his control over so many choice government appointments.

The most outrageous aspect of this, from Conkling's point of view, was that Chester Arthur was himself a product of the very patronage machine he was helping to destroy. Even more galling, it was to Conkling that Arthur owed his rise through that system. When, for example, the chief customs position for New York City had fallen vacant in 1871, Conkling maneuvered Arthur into that job, which brought with it a handsome income and control over more than one thousand other customs appointments. Then, in 1877, when the Hayes administration had sought Arthur's removal from this post, Conkling again came to Arthur's aid and led the fight—albeit unsuccessfully—to block his friend's dismissal. Finally, although Conkling had urged Arthur to refuse the Republican nomination of 1880 as James Garfield's vice-presidential running mate, there could be no denying that the delegates accorded this honor to Arthur because of his close identification with Conkling. When Arthur succeeded to the White House, following Garfield's death in 1881, it was fair to say that in large degree he owed this unexpected elevation to Roscoe Conkling.

Although Chester Arthur was largely a creature of Conkling's making, he did not lack a will of his own. Nor did he share Conkling's broad tolerance for the political jobbery and chicanery that characterized the spoils system of the late nineteenth centu-

ry. Thus, in addition to putting the weight of his presidency behind the Pendleton Act, Arthur pressed vigorously for a complete investigation of rampant fraud in the nation's western postal system. He also proved to be an enemy of congressional "pork barreling," and when a bill for river and harbor improvements reached his desk, he vetoed it, claiming that it was merely a vehicle for securing special-interest votes for incumbent congressmen in their home states.

As a result of these efforts to put government on a more honest footing, Arthur's presidency proved to be a great surprise to all factions. For the Republican Party's spoils-minded bosses, the astonishment took the form of embittered shock that one of their own should dare to betray their interests. The surprise was decidedly more pleasant, however, for those concerned with cleaning up the corruption that had plagued the federal government since the scandal-ridden Grant administration. Although Chester Arthur did not entirely eradicate that corruption, he curbed it substantially and certainly far more than his spoilsman's origin had suggested he would.

Grover Cleveland

1837–1908

When New York governor Grover Cleveland first heard of the mounting enthusiasm among Democrats for his presidential nomination in 1884, he was chagrined. But in a climate of freewheeling enterprise, when elected officials routinely sold themselves to the nearest influence-seeking industrial plutocrat, Cleveland had an asset that made him an eminently desirable White House candidate: He was a man of unflinching honesty. The Democrats saw in that rectitude their first real chance in the twenty-three years since the Civil War to capture the presidency.

After Cleveland was nominated, however, the Democrats found that their candidate's closet was not skeleton-free. When the story emerged that he had fathered a child out of wedlock in his youth, the Republican opposition made the most of it. But Republican presidential hopeful James G. Blaine also had a skeleton in his closet. There were allegations that during his years in Congress he had accepted a number of bribes from the railroads. As a result, in 1884 the voters found that they had to choose between a man accused of private indiscretion and a man charged with violating the public trust. By the slimmest of margins, they cast their lot with Grover Cleveland.

As his presidency unfolded, it soon became clear that Cleveland would fully measure up to his reputation as the honest protector of the public interest. Under pressure from him, federal lands, which the railroads had wrongfully claimed as subsidies for the building of their lines, were opened to homesteading. At the same time, his administration undertook to hasten the civil service reforms that had begun during the Hayes and Arthur presidencies. Moreover, Cleveland proved painfully conscientious in finding sound men to sit on the new Interstate Commerce Commission to monitor railroad rates in the public interest. Unfortunately, the positive feelings that these actions engendered suddenly weakened when, toward the end of his first term, Cleveland pressed Congress for reductions in the nation's high protective tariffs. In the wake of cries that Cleveland's tariff proposal would destroy the country's industrial prosperity, he failed

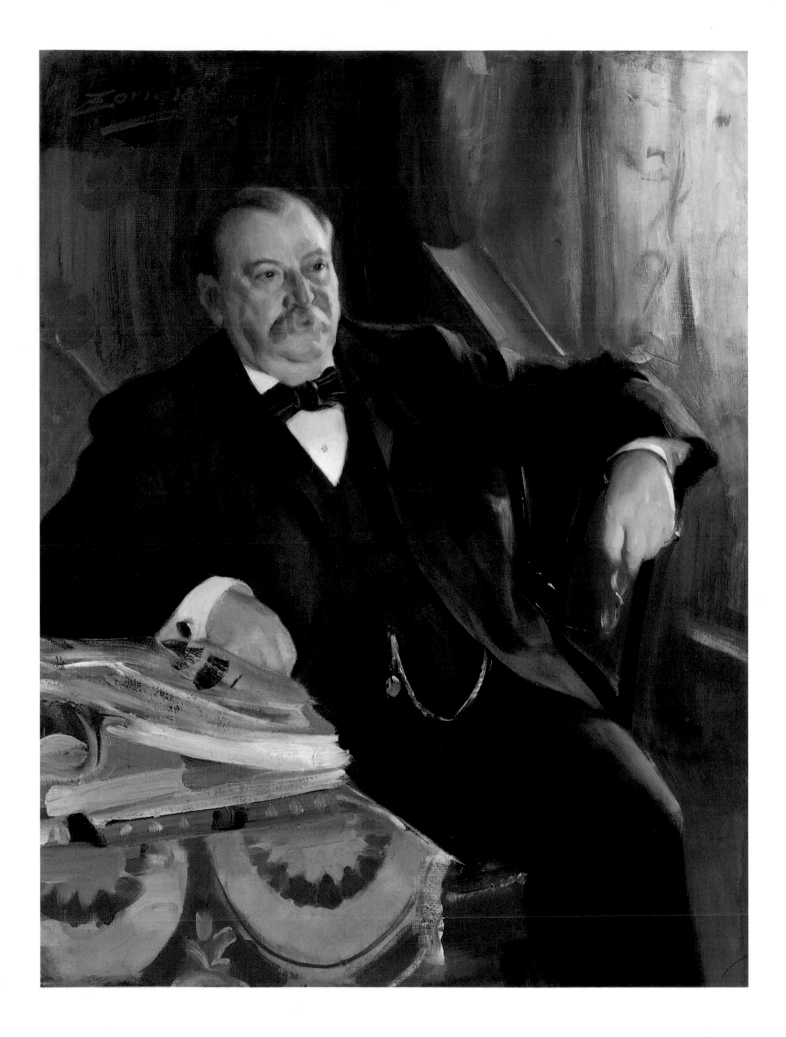

Grover Cleveland two years after leaving the White House

There is a sense of friendly intimacy in this likeness which may have resulted partly from the fact that during some of the posing sessions, Grover Cleveland was chatting with his longtime political ally Daniel Lamont. The painter of the portrait, the Swedish artist Anders Zorn, drew a good deal of his technique from French impressionism, and by the time he encountered Cleveland, the demand for his broadly painted portraits was substantial among the fashionable elite in both Europe and the United States. Cleveland was quite pleased with Zorn's handiwork, declaring to a correspondent, "As for my ugly mug, I think the artist has 'struck it off' in great shape."

Anders Zorn, 1860–1920
Oil on canvas, 121.9 x 91.4 cm (48 x 36 in.), 1899
Gift of the Reverend Thomas G. Cleveland

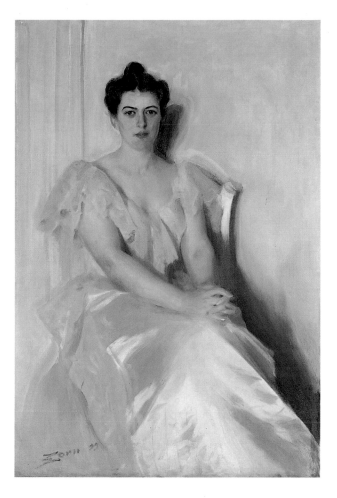

to win his reelection bid in 1888.

Cleveland's presidential career was, however, by no means over. Four years later, the electorate returned him to the White House. But Cleveland might have been better off remaining in retirement. By early 1893 the country was entering a deep economic depression, and whatever he did to meet various phases of that crisis seemed only to alienate his supporters. Thus, by ordering troops to Chicago to maintain order during the Pullman strike of 1894 and by allowing his attorney general to bring legal action against the strike's leaders, he lost whatever support he had among organized labor. Even more damaging to Cleveland were his monetary policies, and after opposing inflationary measures for raising the incomes of sorely pressed farmers and workers, he found himself denounced as a pawn of the moneyed elite. By far, the loudest protest against Cleveland's anti-inflationary stand came from populist elements in his own party. Consequently, as these inflationists gained dominance among Democrats during the final year of his presidency, Cleveland suffered the ultimate humiliation of being an outcast within the party he had once led.

Grover Cleveland's wife, Frances

Among Cleveland's greatest assets during his presidency was his young wife, Frances (1864–1947), whom he married in the White House in 1886. Twenty-one at the time of the marriage, she was beautiful and charming, and her presence in Cleveland's life seemed to breathe new energy into his administration. She also greatly enhanced the middle-aged Cleveland's popularity with the general public and, in the process, went a long way in repairing whatever damage had been done in the 1884 campaign by the revelation that Cleveland had once fathered a child out of wedlock.

Anders Zorn was thoroughly enchanted with Frances Cleveland when he painted her in 1899. Nevertheless, he seems to have had some difficulty with her portrait, at least as far as the subject's adoring husband was concerned. Zorn's likeness of his wife, Cleveland told a friend, required "a great deal of supplemental work" before it was done to everyone's satisfaction.

Anders Zorn, 1860–1920
Oil on canvas, 137.2 x 92.1 cm (54 x 36 1/4 in.), 1899
Gift of Mrs. Frances Payne

Benjamin Harrison

1833–1901

A portrait of Benjamin Harrison from his post-presidential years

In 1896 John Wanamaker, who had been postmaster general during Harrison's administration, commissioned a portrait of Harrison for himself. The artist was Theodore Steele, an Indiana painter who by then was best known for his impressionistic landscapes and rural genre paintings. The portrait was well liked among Harrison admirers, and eventually Steele made three other versions of it, including the one here, which belonged for many years to Harrison's own family and was eventually given to Purdue University, where Harrison had been a trustee.

Theodore C. Steele, 1847–1926
Oil on canvas, 102.1 x 127.3 cm
(40 ³/₁₆ x 50 ¹/₈ in.), circa 1900
On loan from Harrison Residence Hall, Purdue University, West Lafayette, Indiana

When the Whig Party nominated William Henry Harrison for President in 1840, there was little in his background to qualify him except for his record as an Indian fighter and general in the War of 1812. In 1888, when the Republicans settled on his grandson Benjamin, it seemed that history was repeating itself.

Although not quite the political nonentity that his grandfather had been, Benjamin Harrison was hardly a man of longtime prominence in national politics. Aside from serving one unremarkable term in the Senate and once running unsuccessfully for the Indiana governorship, his only distinction was that he was a safe, clean, and loyal Republican. But apparently that, combined with being the grandson of "Old Tippecanoe" and the citizen of a swing state, provided Harrison with enough cachet to make the Republicans think they could sell him to the electorate. And indeed they were right: On March 4, 1889, having convinced the public that the key to American prosperity was his party's promise to maintain a high protective tariff, Harrison took the presidential oath of office.

About two weeks later, a Washington journalist wrote of him, "he is narrow, unresponsive, and oh, so cold. . . . As one Senator says: 'It's like talking to a hitching post.'" This may have been overly harsh, but it was soon clear that a hallmark of Harrison's presidential style was an aloof and sometimes icy detachment from the political fray. This did not mean that he was a presidential idler. To the contrary, he proved to be an unusually hardworking chief executive, known for his attentiveness to detail. What it did mean, however, was that Harrison played an essentially passive role in many of the events of his administration. While, for example, he supported such measures as the McKinley Tariff and the first federal attempt to curb industrial monopoly—the Sherman Antitrust Act—he had very little to do with their actual making. Moreover, despite his abhorrence of efforts in the South to bar blacks from voting in federal elections, he refused to take an aggressive stand to prevent this disenfranchisement. Finally, like many other mainstream politicians of the day, Harrison proved

all too willing to ignore the protests of workers and farmers, who claimed that they were being denied a share in the nation's prosperity.

Although Harrison did not distinguish himself as a molder of domestic policy, he did play an active role in moving the country toward greater involvement with the rest of the world. It could be said that Harrison's support for a modernized navy and the strong posturing of his administration in various international disputes were harbingers of the emergence of the United States as a world power after 1900.

Harrison, who never particularly relished being President, consented to run for a second term in 1892 only out of a sense of obligation to his party. But growing voter restiveness over the Republicans' tendency to cater to the interests of big business prevented his reelection. As a staunchly loyal member of his party, Harrison was somewhat disturbed at this outcome, but from a purely personal point of view, the defeat, as he told a friend, carried "no sting."

TWENTY-FIFTH PRESIDENT, 1897–1901

William McKinley

1843–1901

As the severe depression spawned by the Panic of 1893 continued into 1896, it seemed to many people that the presidential election that year represented an Armageddon involving two distinctly different ways of dealing with the nation's economic woes. For William Jennings Bryan, the Democrats' White House hopeful, the key to increasing the deplorably depressed incomes of workers and farmers was an inflationary scheme to replace the country's gold monetary standard with the coinage of silver at a ratio of sixteen to one with gold. For William McKinley, the Republican presidential nominee, however, such a measure threatened disaster. So, while Bryan rallied voters with his warning that "you shall not crucify mankind upon a cross of gold," McKinleyites predicted that the day "sixteen to one" became law was the day grass would sprout in the streets of every American city.

The 1896 fight over silver and gold was one of the most impassioned battles in the history of presidential elections. But in the end, McKinley's solid reputation as an influential Ohio congressman engendered considerably more confidence than Bryan's evangelical defense of silver. Although McKinley did not claim the White House in a landslide, he certainly won it by a safe margin.

Despite the campaign's all-consuming debate about the way to restore American prosperity, McKinley's administration never had to grapple very hard with that issue. Gradually, the hard times of the mid-1890s began to recede more or less of their own accord. Instead, the main challenge facing McKinley lay in that jingoistic and vocal segment of the public that was urging active American support for the Cuban revolt against Spanish colonial rule.

Initially, McKinley adamantly opposed such interference. But when the United States battleship *Maine* blew up early in 1898 in Cuba's Havana harbor and when the press blamed the tragedy on the Spanish, popular sympathy for the Cuban rebels rapidly turned into a call for war with Spain, which McKinley found impossible to deny. Within a few months, American forces had

Portrait of William McKinley done shortly after his death

It is thought that the Swiss-born artist Adolfo Muller-Ury began painting this portrait shortly after McKinley's death in 1901. The painter settled on a pose that echoed the hand-in-pocket posture that McKinley typically adopted when addressing an audience. The evidence suggests that part of the inspiration for the pose may well have been one of the last photographs ever taken of McKinley, showing him delivering the final speech of his career at Buffalo's Pan American Exposition the day before he was shot. Muller-Ury wanted Congress to purchase his McKinley likeness for the White House, but Congress ultimately rejected it in favor of another.

Adolfo Muller-Ury, 1864–1947
Oil on canvas, 198.9 x 111.6 cm (78 ⁵/₁₆ x 43 ¹⁵/₁₆ in.), circa 1901

defeated the Spanish in both Cuba and the Philippine Islands.

This was not the end of it, however. As victor in the Spanish-American War, the United States was suddenly heir to some of the last vestiges of Spain's colonial empire, the Philippines and Puerto Rico. Despite the advice of members of his administration, who considered the Philippines a great asset in promoting American trading interests in the Pacific, McKinley was reluctant to accept these territorial spoils. But at the same time, he was an unusually attentive reader of public opinion. Consequently, upon finding popular sentiment running heavily in favor of an overseas empire, he finally acquiesced to American annexation of the two territories. In so doing, he ushered the United States into an era that marked its emergence as a world power.

Unfortunately, McKinley was not to play any role in the new era. In September 1901, just a day after he had delivered a speech declaring that America's traditionally isolationist foreign policies were no longer possible, he was shot by an anarchist while attending a reception in Buffalo. Eight days later he was dead.

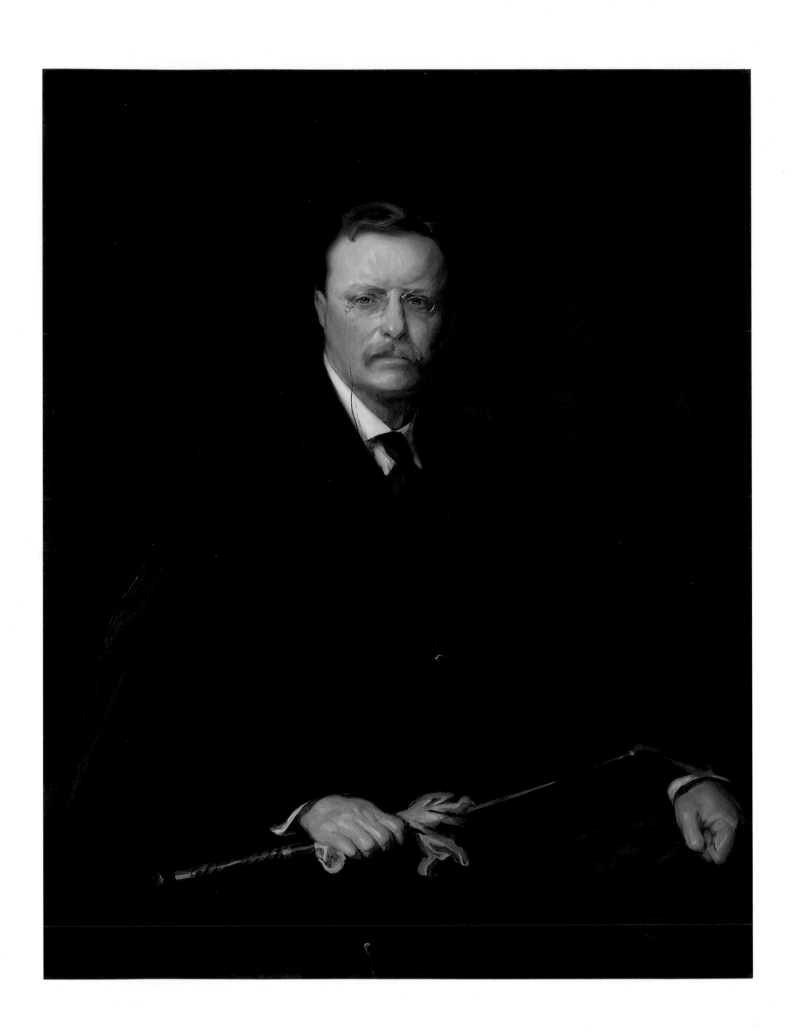

Theodore Roosevelt

1858–1919

Theodore Roosevelt in the last year of his presidency

This likeness is a copy of an original portrait by the Hungarian-born English artist Philip de László. The commission for the original came from Lord Arthur Lee, a longtime English friend of Roosevelt. When de László allowed him to pick his own garb for the likeness, Roosevelt opted for his riding clothes over the more usual frock coat—a decision that, in turn, inspired de László to pose his subject in a way that was a little out of the ordinary. The artist also encouraged Roosevelt to have visitors chat with him during the sittings. When the picture was done, Roosevelt declared it the only likeness that "I really enjoyed having painted."

Adrian Lamb, 1901–1988, after the 1908 oil by Philip A. de László
Oil on canvas, 127 x 101.6 cm (50 x 40 in.), 1967
Gift of the Theodore Roosevelt Association

Theodore Roosevelt was an amalgam of multiple interests, explosive energy, and undauntable determination. In his youth he suffered severely from asthma, but unwilling to accept this handicap, he embarked on a fitness program that would make him the most athletic President the United States has ever seen. By the time he graduated from Harvard, he was on his way to becoming a much-respected amateur naturalist and to producing a book on naval operations in the War of 1812 that is still a basic source for historians. When advised that public office-seeking was an unfit pursuit for well-born gentlemen such as himself, he ran for office anyway, and as a member of the New York state legislature in the early 1880s, he was soon making himself known as an outspoken foe of corruption in government.

A few years later, Roosevelt was roping steers on his ranch in the Dakota Badlands. By the early 1890s, he was a member of the United States Civil Service Commission, where his passionate opposition to patronage made him the bane of political spoilsmen. When the Spanish-American War broke out, he was serving as assistant secretary of the navy. But not content with sitting out this conflict at a desk, he was soon raising his own regiment of Rough Riders and, on July 1, 1898, was leading a victorious charge up Cuba's San Juan Hill. Next seen, he was residing in New York's governor's mansion, where, thanks to his aggressive enthusiasm for various labor and business reforms, he found himself locked in constant combat with Thomas Platt, the conservative boss of his own Republican Party.

In 1900, however, when Platt succeeded in ridding himself of the troublesome Roosevelt by engineering his nomination as William McKinley's vice-presidential running mate, it appeared that Teddy Roosevelt's political career had run out of steam, for with McKinley's election, Roosevelt seemed relegated to four years of anonymity. But when McKinley was assassinated in 1901, that prospect changed drastically and Roosevelt occupied an office in which his inexhaustible drive to achieve and dominate could enjoy free rein.

Theodore Roosevelt with his family at the White House

Roosevelt's children all seemed to inherit their father's ebullient energy, and their antics and menagerie of pets brought a liveliness to the White House that it had never seen before. Ever the indulgent parent, Roosevelt made few attempts to curtail them. When a friend advised him to rein in his oldest daughter, Alice, he answered, "I can be President—or—I can attend to Alice." It was, however, impossible to do both.

Harris and Ewing, active 1905–1977
Brown-toned gelatin silver print,
25.2 x 32.5 cm (9 $^{15}/_{16}$ x 12 $^{13}/_{16}$ in.),
1908
Gift of Joanna Sturm

And achieve and dominate he did. In response to a mounting call for more protection of workers and the general public against the excesses of big business, Roosevelt applied his presidential influence with unprecedented vigor and a "big stick." Under his aegis, the largely dormant Sherman Antitrust Act became an effective means for curbing industrial monopolies, and Congress enacted laws putting new bite into the regulatory powers of the Interstate Commerce Commission. At the same time, Roosevelt's intervention in the massive coal strike of 1902 represented the first instance in which a chief executive took an active role in labor arbitration.

In foreign policy, Roosevelt proved equally forceful. When, for example, Colombia refused to endorse a treaty permitting the United States to build a canal through its Isthmus of Panama, he simply sought his canal-building agreement elsewhere. Soon his administration was helping Panama win its independence, and with that achieved, a grateful Panama gave him his treaty.

But the most striking aspect of Roosevelt's administration was not what he did, but rather how he did it. For Roosevelt possessed an exuberance that inspired a turn-of-the-century optimism that the United States, with all its growing wealth and know-how, could achieve anything it wanted to.

William Howard Taft

1857–1930

Despite his early involvement in Republican politics in his native Ohio, William Howard Taft never aspired to great political power or high elective office. Above all, he never wanted to be President. He much preferred the life of the law, and his most cherished ambition was one day to sit on the United States Supreme Court.

For many years that was exactly the goal toward which Taft steadily seemed to be moving. Appointed to fill a vacancy in the Ohio superior court in 1887, he performed so creditably that within a few years he was being mentioned as a Supreme Court possibility. His sound reputation as a state judge led to his appointment as solicitor general in Benjamin Harrison's administration. When that in turn led to a federal circuit judgeship, the fulfillment of Taft's ultimate professional ambition seemed not far off.

In 1900, however, Taft's career took a detour: William McKinley chose him to head a commission charged with quelling an insurrection in the Philippines. A year later, Taft became governor of the newly acquired territory. Then, in 1904, Theodore Roosevelt brought him home to be his secretary of war. Although Taft still yearned for the Supreme Court bench, Roosevelt's great regard and enthusiasm for him again thwarted that ambition. As the national election of 1908 neared, Roosevelt cajoled a reluctant Taft into seeking the presidential nomination, and in 1909 Taft entered the White House as Roosevelt's hand-picked successor.

In many respects, Taft's presidency was a continuation of the so-called progressive reform policies that Roosevelt had implemented to correct the inequities in the nation's commercial and industrial life. Under Taft the government stepped up its campaign to curb business monopolies, for example, and strengthened the regulatory powers of the Interstate Commerce Commission. But Taft had no flair for staving off critics by advertising these and other solid accomplishments of his administration. As a result, when his administration was unjustifiably accused of backsliding on the land conservation policies begun by his predecessor, Taft proved ill-equipped to defend himself. Worse yet, he was unable to allay the perception within the progressive wing of his

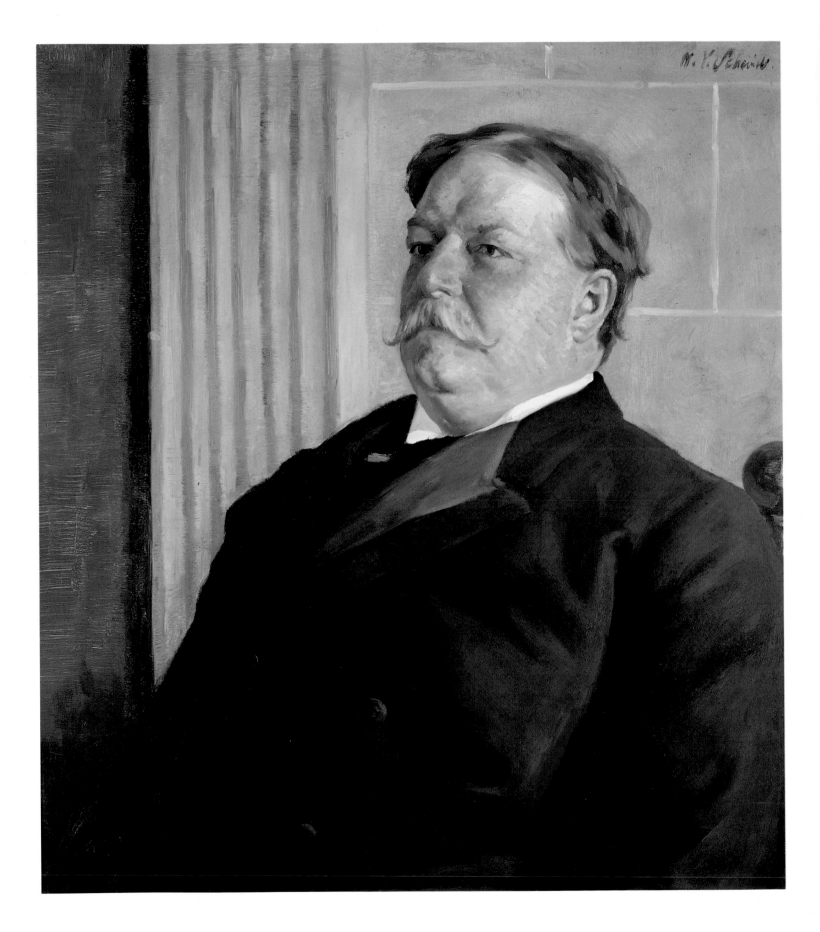

A portrait of William Howard Taft by William Schevill

A native (like Taft) of Cincinnati, William Schevill knew the Taft family fairly well and, between 1905 and 1910, painted a number of portraits of Taft. Personal acquaintance with Taft, however, did not protect the artist from criticism. In 1909, for example, his portrait commemorating Taft's tenure as secretary of war had to be reworked to meet criticisms of it that the subject had invited from his cabinet. The one thing that Taft never asked of Schevill was to slim him down. When Alice Roosevelt Longworth told Taft that the likeness of 1909 made him look pudgy, he answered, "But I am pudgy, Alice."

This Schevill likeness remained with the artist until his death. Because it is so unlike his other finished Taft portraits, it could have been a preliminary effort that for some unknown reason he had found wanting.

William Valentine Schevill, 1864–1951
Oil on artist board, 85.1 x 74.9 cm (33 ¹/₂ x 29 ¹/₂ in.),
circa 1910
Gift of William E. Schevill

Republican Party that he had betrayed all the good work that Roosevelt had done.

Among the loudest of the progressive critics was Roosevelt himself. Consequently, soon after Taft won the Republican presidential nomination in 1912, Roosevelt launched his own campaign as the presidential candidate of the anti-Taft Republicans, who now called themselves the Progressive Party. In the end, the Taft-Roosevelt split served neither man very well. Instead, it only made it easier for the Democratic candidate, Woodrow Wilson, to win in the final election.

For Taft, however, this outcome was a blessing. Having sought the presidency only because Roosevelt wanted him to, he had never really enjoyed his White House tenure. When it was over, he was greatly relieved. But Taft's public career was far from over. In 1921, he finally gained the prize he had always wanted. On October 3 of that year, he was sworn in as Chief Justice of the Supreme Court.

Woodrow Wilson

1856–1924

Portrait of Wilson done in the last months of his presidency

In late 1918 a committee was formed to commission the portraits of American and European figures who had led the effort to defeat Germany and its allies in World War I and to organize a traveling exhibition of these images. This portrait of Woodrow Wilson was part of that venture. The committee originally required that all likenesses be painted from life, and Edmund Tarbell, the artist slated to portray Wilson, generally accepted commissions only on that condition. Unfortunately, Wilson's debilitating stroke in the fall of 1919 made it impossible for him to pose, and Tarbell had to base the likeness entirely on photographic images. Judging from the final portrait, the photographs may have dated as far back as Wilson's pre-presidential days.

Edmund Charles Tarbell, 1862–1938
Oil on canvas, 116.8 x 92.1 cm (46 x 36 ¼ in.), 1921
Transfer from the National Museum of American Art; gift of the City of New York through the National Art Committee, 1923

When New Jersey's Democratic bosses first began hearing suggestions early in 1910 that they might do well to run Woodrow Wilson for the state governorship, a good many of them simply sneered. After all, they asked, what could this onetime college professor, who had spent his last eight years as president of Princeton University, know about the real world of rough-and-tumble politics? But in light of voter malaise about the rampant corruption of New Jersey's political machines, the bosses began to look more favorably on Wilson's gubernatorial candidacy. As they mulled the matter over, Wilson increasingly seemed to be tailor-made for their purposes. On the one hand, because he was good with the high-sounding phrase and free of any machine taint, he was eminently electable. On the other, because he was a political neophyte, the bosses would have no trouble controlling him once he was in office.

As governor, however, Wilson was not the mere window dressing his backers expected him to be. Over the strenuous objections of his party's leaders, he was soon launching an ambitious program of reform that, among other things, called for cleaning up the state's graft-ridden utility industry and passing a new corrupt practices law. Within a year, the New Jersey legislature had enacted virtually all of his proposals. In the wake of this reforming whirlwind, New Jersey quickly became a model of sound state government, and it was soon clear that Wilson was destined for higher things. By early 1912, a move was well under way to send him to the White House.

Once elected to the presidency, Wilson proved to be every bit as dynamic as he had been as governor. The early years of his administration brought a host of landmark reforms designed to meet the growing need for a stronger federal role in the nation's economic life. Among those measures were the establishment of a Federal Reserve System for regulating currency and banking; a strengthening of the country's antitrust laws; and legislation limiting railroad workers to an eight-hour day.

Measured on the basis of its domestic reforms, Wilson's administration was singularly successful. But when World War I forced him into a role of international leadership, Wilson met with tragic failure. Reluctantly declaring war on Germany in 1917, he brought an international idealism to his wartime leadership that called for an un-vindictive peace agreement after Germany was defeated.

Unfortunately, the country's British, French, and Italian allies balked at Wilson's vision of "peace without victory." As a result, from the moment the Treaty of Versailles ending the war was signed in 1919, it was clear that in its harsh treatment of Germany the treaty had sown the seeds of another war. Wilson's only consolation was that at least the agreement contained a provision for realizing one of his most cherished hopes—the establishment of an international peacekeeping organization known as the League of Nations. But even that victory became hollow when the isolationist-minded Senate refused to endorse the entry of the United States into the League. After suffering a severe stroke in the course of his public relations battle to force Senate acceptance of the League, Wilson left the White House thoroughly broken, both physically and emotionally.

Warren G. Harding

1865–1923

During the first two decades of the twentieth century, the reforming administrations of Theodore Roosevelt, Woodrow Wilson, and to some extent William Howard Taft accustomed Americans to an aggressive presidential style that the country had rarely seen since the days of Lincoln. But by 1920, the electorate was no longer looking for a strong chief executive. In that year, voters cast their presidential lot with Republican hopeful Warren Harding, a convivial onetime newspaper editor from Ohio whose one term in the Senate had clearly demonstrated that he had little talent for leadership and whose speeches often seemed to be words in search of ideas.

The explanation for this dramatic shift in the public's taste in White House occupants was essentially twofold. First, many Americans had simply lost their taste for progressive reform, and they felt in need of respite from presidentially inspired changes. Second, there was Harding himself, whose good-natured ways and campaign cry for a return to "normalcy" seemed to answer nicely the widespread desire for a water-treading presidency.

In many respects that was the type of administration that Harding actually gave the country. A man of slight intellect who much preferred the camaraderie of the golf course and the poker table to the world of serious critical thought, Harding allowed the nation to enjoy itself.

His presidency was not without substantial accomplishments. To a large extent, however, its achievements were due to members of his cabinet rather than to Harding himself. On the recommendation of Andrew Mellon, his secretary of the treasury, for example, Congress established a Budget Bureau, which promised to bring new efficiency to the task of allocating federal spending. Similarly, it was Harding's secretary of commerce, Herbert Hoover, who took the initiative in transforming the Commerce Department from a political backwater into a major clearing-house for the nation's economic data.

Although some of Harding's advisers served him and the country well, others within his presidential circle did not. For

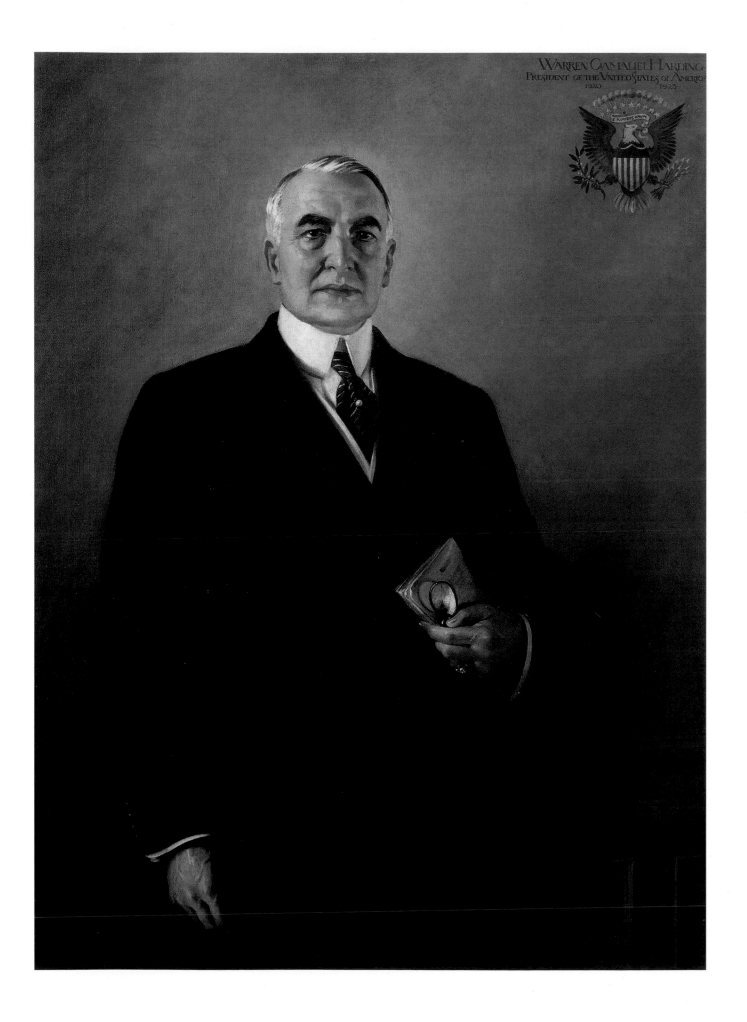

Warren Harding at the end of his second year in the presidency

In late December 1922, the English portraitist Margaret Lindsay Williams arrived in the United States to paint a portrait of Warren Harding for the headquarters of the English Speaking Union in London. Despite a bout of influenza and anxiety over mounting evidences of wrongdoing in his administration, Harding managed to give the artist sixteen sittings in the next several weeks. When the picture was done, he declared that of all his portraits he liked Williams's the best. Eventually Williams painted two versions of her Harding likeness—one that went to the English Speaking Union and another, seen here, that she retained.

Harding's dignified bearing in this portrait gives credence to the view that one of his political assets was that he looked presidential. Behind the statesmanlike exterior, however, was a man who remained forever insecure about his ability to lead.

Margaret Lindsay Williams, 1887–1960
Oil on canvas, 135.9 x 99.7 cm (53 ½ x 39 ¼ in.), 1923

Harding had included in his administration a number of men who obtained their positions not because they were capable, but because they were his friends. Unfortunately, honesty was not among the stronger attributes of some of these men. The result was public corruption on a grand scale. While Harding's Veterans' Bureau director, Charles Forbes, disposed of army surplus supplies in exchange for bribes, his secretary of the interior, Albert Fall, was trading leases on government oil lands for handsome deposits in his own bank account. Meanwhile, Jesse Smith, the longtime crony of Attorney General Harry Daugherty, was engaged in selling immunity from prosecution to violators of the country's new Prohibition law.

Harding, however, never had to face the full consequences of these and other scandals in his administration. In June 1923, seeking to escape the anxieties caused by mounting evidence of his friends' wrongdoing, he set out on a tour of the West. Several weeks later, he was dead from causes that were not entirely clear, but that were undoubtedly related to a general deterioration of his circulatory system.

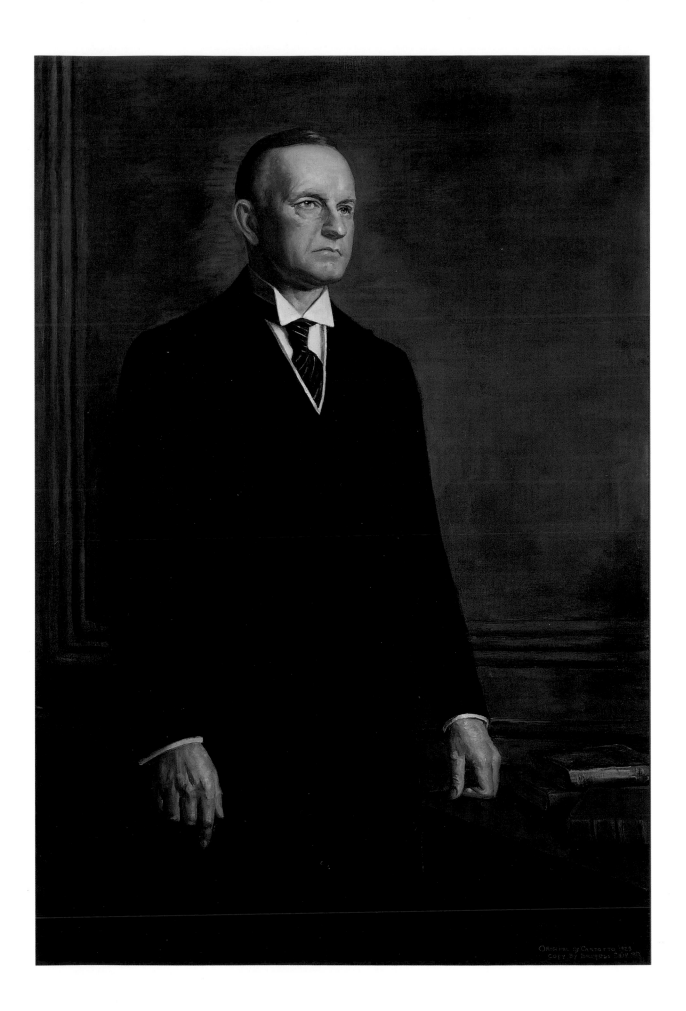

Calvin Coolidge

1872–1933

Calvin Coolidge in the final year of his presidency

The original version of this portrait was the work of Ercole Cartotto, who had been commissioned to make a likeness of Coolidge for the national headquarters of Coolidge's old college fraternity at Amherst, Phi Gamma Delta. The artist wanted to show his subject as a "man absorbed by duty and responsibility." More specifically, he was trying to capture the air of sober resolution that Coolidge wore as he arrived for a sitting, following a meeting where he had urged the Senate's endorsement of the Kellogg-Briand Pact denouncing war as an instrument of national policy.

Joseph E. Burgess, 1890–1961, after the 1929 oil by Ercole Cartotto
Oil on canvas, 143.5 x 97.2 cm (56 ½ x 38 ¼ in.), 1956
Gift of the Fraternity of Phi Gamma Delta

"In politics, one must meet people and that's not easy for me. . . . When I was a little fellow . . . the hardest thing in the world was to go through the kitchen door and give [strangers] a welcome. . . . I'm all right with old friends, but every time I meet a stranger I've got to go through the old kitchen door . . . and it's not easy." So Calvin Coolidge once described his feelings when it came to performing the most fundamental task of politics. Not only did he find this task difficult, but he also never managed, and perhaps did not even try, to conceal that fact very well.

Thus, when he came to Washington in 1921 as Warren Harding's Vice President, observers were frankly taken aback by this "well of silence" that now occupied the nation's second-highest office. Soon stories regarding his unwillingness to converse were legion. Among the most widely circulated was one told about a Washington socialite who bet a friend that she would get "Silent Cal" to say more than three words to her. After several failed attempts, she finally informed Coolidge of the wager, to which he responded, "You lose."

But despite his aloofness, somehow Coolidge had managed to make his way in the political world, rising from unpaid councilman in Northampton, Massachusetts, to the Massachusetts governorship, and finally to the vice presidency. Then, in 1923, with the unexpected death of Harding, he succeeded to the White House.

Coolidge proved to be a widely popular chief executive, and in the election of 1924, he claimed the presidency in his own right by a substantial popular majority. To a large degree, Coolidge's popularity derived from his conservative unwillingness to use the powers of his office to monitor the workings of the economy. "The chief business of the American people," he once declared, "is business," indicating that the wisest strategy for his administration was to give free rein to the country's commercial and industrial genius. In an era marked by unparalleled prosperity, this passive outlook seemed to suit the nation's needs perfectly. As the economic boom reached undreamed-of heights during his presi-

dency, "Coolidge prosperity" became a catch phrase suggesting that the days of a rising and falling business cycle were past.

Part of Coolidge's appeal lay in his reticent personality. When combined with his reputation for honesty and his stoic New England habits, this diffidence represented for many a reassuring antidote to the corruption of the Harding administration and to the uninhibited self-indulgence that accompanied the boom of the twenties.

Unfortunately, the days of "Coolidge prosperity" were numbered. Although Coolidge himself refused to see it, beneath the appearance of good times were serious weaknesses in the economic structure of the United States. In late 1929, the collapse of the stock market marked the onset of the most serious depression that the country had ever experienced. By then, however, Coolidge was out of office, and blame for this disaster went to his successor.

Herbert Hoover

1874–1964

If ever there was a man who seemed able to make a success of the presidency, it was Herbert Hoover. By the time he entered the White House in March 1929, his past achievements were a study in laudatory superlatives. As a mining engineer, he had enjoyed an international reputation as the doctor of sick mines, and by the age of forty his ability to transform marginal ore-extracting operations into thriving enterprises had made this once-impoverished orphan a multimillionaire. During World War I, he turned his energies to feeding the civilian populations of war-ravaged Europe and, after the United States entered the war, to serving as the country's chief food administrator. Once again his ability to deal effectively with the tasks at hand was superb. By the end of the war, his work in supplying food to Europe's starving populations had earned him the sobriquet "The Great Humanitarian." The list of Hoover's accomplishments, however, did not stop there. As secretary of commerce under Presidents Harding and Coolidge, he applied to his department much the same magic he had once applied to ailing mines. He changed the Department of Commerce from a comfortable sinecure for political hacks to a dynamic information clearinghouse for all phases of business and industry.

If Hoover's personal credentials boded well for his presidency, so, too, did the times. With the stock market moving ever upward and much of the nation enjoying a record prosperity, it seemed to many that Hoover's campaign assertion that he and his Republican Party were about to banish the poorhouse from America forever was not merely an idle promise.

Seven months after Hoover took office, however, the rosy prospects for his presidency acquired a decidedly gloomy tinge. With the great stock market crash in the autumn of 1929, the curtain suddenly came down on the prosperity of the late 1920s, and the nation began its plunge into the deepest and most painful depression in its history.

In responding to this disaster, Hoover operated on a conservative faith that the country's strength lay in its "rugged individu-

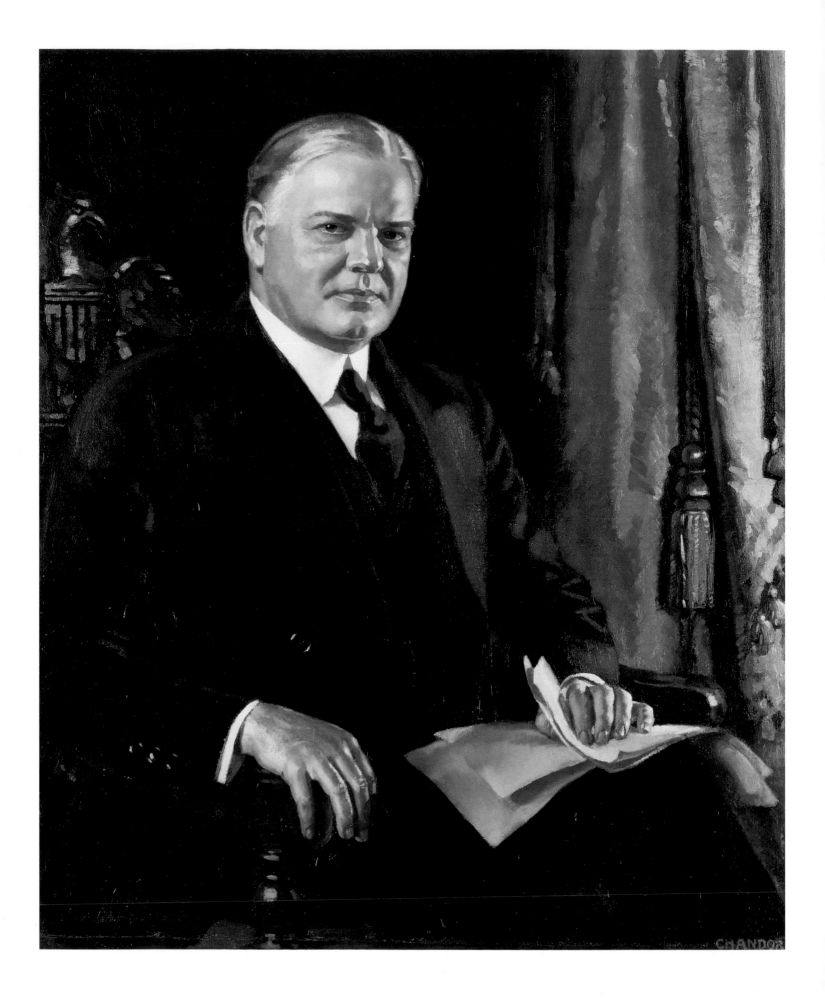

A portrait of Herbert Hoover inspired by *Time* magazine

In 1929 *Time* magazine began planning a series of covers featuring formal oil portraits of Herbert Hoover and the members of his cabinet. After the images were published separately, the magazine then intended to feature yet another picture, which combined all of them into a single group portrait—something, the magazine said, that had not been done since the days of Lincoln. Hired to carry out this enterprise was the English portraitist Douglas Chandor, who came to Washington to paint all of his subjects from life. The only problem was that several of his prospective subjects were unwilling to sit, not least of whom was Hoover. As a result, the project was only partially realized.

Hoover himself, however, finally did agree to pose in early 1931, and Chandor found him a delightful sitter once his shy reserve had been penetrated. Unfortunately, by then *Time* had lost interest in running the completed likeness, and Hoover is the only President, since the magazine's founding in 1923, who was never featured on its cover during his term of office.

Douglas Chandor, 1897–1953
Oil on canvas, 114.3 x 96.5 cm (45 x 38 in.), 1931

alism" and that the real solution for relieving the sufferings of the swelling ranks of unemployed must come from the private sector. He therefore flatly rejected proposals for massive federal works projects as a means of alleviating unemployment and was even more opposed to any kind of federally funded welfare relief. Hoover believed that his administration could do little to halt the Great Depression. When worsening conditions belatedly prompted him to depart from these views by implementing programs for channeling loans to the country's failing businesses and farmers, their impact was woefully limited.

Not surprisingly, Hoover's reluctance to act effectively had a dimming effect on his once lustrous reputation. But inactivity was not the only tarnishing agent at work; equally damaging was Hoover's coldly businesslike presidential style, which made it seem that the Great Humanitarian, who had rushed to the aid of starving Europe during World War I, simply did not care about the misfortunes of his fellow Americans. By the time Hoover left office in 1933, he had become one of the most maligned Presidents in the history of the United States.

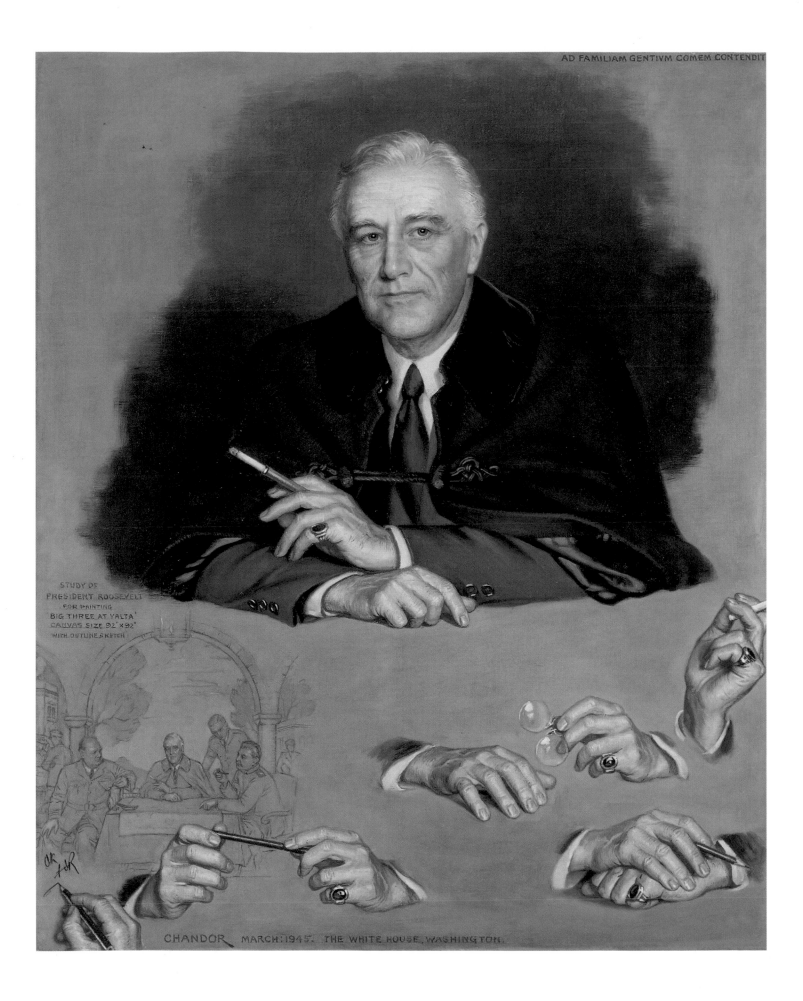

AD FAMILIAM GENTIVM COMEM CONTENDIT

STUDY OF
PRESIDENT ROOSEVELT
FOR PAINTING
'BIG THREE AT YALTA'
CANVAS SIZE 92"x92"
WITH OUTLINE SKETCH

CHANDOR MARCH: 1945. THE WHITE HOUSE, WASHINGTON.

Franklin D. Roosevelt

1882–1945

Portrait of Franklin Roosevelt done just before his death in 1945

This portrait of Franklin Roosevelt by Douglas Chandor was a study for a much larger composition, which is sketched in miniature in the picture's lower left corner. The drawing depicts Roosevelt seated with Allied leaders Winston Churchill and Joseph Stalin at the Yalta Conference of February 1945, where the three men discussed issues related to the final phases of World War II and the coming peace. Chandor intended to do three versions of the picture— one for each country involved in the conference. He insisted, however, that all three men sit for their likenesses, and when Stalin refused to pose, the artist gave up his plans for his group portrait.

Roosevelt returned from Yalta looking disturbingly haggard, and many intimates sensed that he perhaps did not have long to live. Yet when Chandor confronted him several weeks later at the White House, he chose to underplay the signs of physical deterioration. The presence of the hand studies beneath Roosevelt's likeness bespoke the artist's fascination with what he considered his subject's most intriguing feature. Roosevelt could not understand that fascination and told the artist that he thought his hands were really quite ordinary, or, as he put it, "the hands of a farmer."

Douglas Chandor, 1897–1953
Oil on canvas, 136.5 x 116.2 cm
(53 ³/₄ x 45 ³/₄ in.), 1945

Raised in a sheltered world of wealth and social privilege, Franklin Roosevelt did not exhibit much drive in his youth, and he seemed marked for a life of genteel ease in which his main preoccupations would be sitting on corporate boards and looking after his family's investments. By about 1907, however, when his distant cousin Theodore Roosevelt was in the White House, the young patrician began to entertain ambitions of quite a different kind. While chatting idly one day with his fellow clerks at a prestigious New York law firm, he outlined a plan for making his way in politics that strongly resembled the path that Theodore Roosevelt had traveled and that with any luck, he claimed, would also take him to the presidency.

What had seemed a youthful boast became a spectacular reality. By 1929, despite a crippling bout with polio, Franklin Roosevelt had indeed—like Cousin Theodore before him—gone from a seat in the New York legislature to a tenure as assistant secretary of the navy and was ensconced in the New York governorship. Four years later, as the United States sank ever deeper into the Great Depression, he took the presidential oath of office.

So began one of the most remarkable presidencies in American history. Coming to office against a backdrop of hopelessness and suffering, Roosevelt brought with him a reassuring warmth and compassion that seemed to engender optimism from the first day of his administration. More important, he brought a zest for innovation that was to redefine the federal government's role in American life. Before long, his New Deal administration was implementing myriad depression-healing measures that left no phase of the country's economy untouched. For the unemployed, there were public works projects. For farmers, there were programs to bolster commodity prices. For the nation's collapsing banking system, there was a plan to protect bank deposits, and for the securities market, there were new regulations to curb the irresponsible speculation that had been one of the causes of the depression.

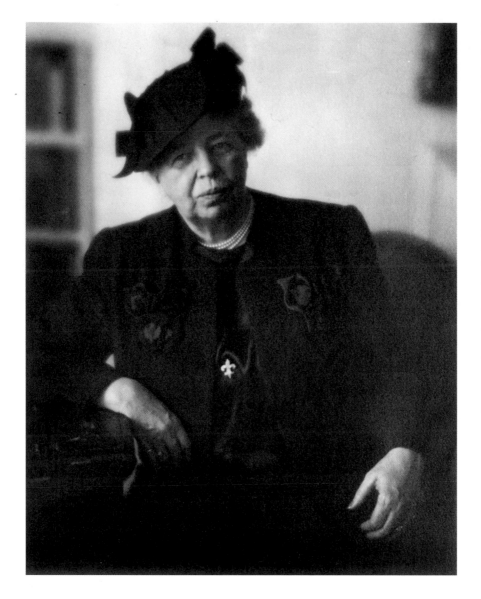

Eleanor Roosevelt

When Franklin Roosevelt became President in March 1933, his wife, Eleanor (1884–1962), declared that she was "just going to be plain, ordinary Mrs. Roosevelt. And that's all." That promise was not long kept. Driven by her own concern for social problems, she soon became almost as engrossed in the new administration as her husband's official advisers. Touring the nation's economically distressed areas, she returned to Washington eager to encourage federally sponsored planned communities. She also became the first President's wife to give regular press conferences. Perhaps most important, she acted as her husband's conscience, pushing him toward reforms that he might otherwise have avoided in the name of political expedience. As she herself once put it, "I sometimes acted as a spur even though the spurring was not always welcome."

After her husband's death, Eleanor Roosevelt continued to take an active role in public life, and in 1948 *Time* declared her the best-known woman in the world.

Clara E. Sipprell, 1885–1975
Gelatin silver print, 25.1 x 20.2 cm
(9 7/8 x 7 15/16 in.), 1949
© Special Collections, Syracuse University Library

In implementing these and the host of other measures that made up his New Deal, Roosevelt was not entirely successful in reviving the economy, and he drew bitter criticism from conservatives, who saw his policies as first steps on the road to communism. But for the vast majority of Americans, he was a savior, and when Roosevelt took the unprecedented step in 1940 of seeking a third presidential term, he could not be denied.

By then, however, Roosevelt's concerns had shifted focus. With Nazi Germany overrunning Europe, and Japan seeking hegemony in the Far East, it was becoming clear that sooner or later the United States would be embroiled in war. Finally, the inevitable happened, and following the Japanese attack on Pearl Harbor, Hawaii, on December 7, 1941, Roosevelt faced the task of leading the country through World War II.

In shouldering that responsibility, Roosevelt paid a heavy personal price. Over the next several years, his health greatly deteriorated. He died shortly after his election to a fourth term, just as the United States and its allies were about to triumph over Germany and Japan.

Harry S. Truman

1884–1972

Harry Truman could be very self-effacing sometimes about his presidential achievements. But he always hoped that his efforts in the office would at least make him worthy of an epitaph that he had seen once in the Boothill Cemetery in Tombstone, Arizona. "Here lies Jack Williams," it read. "He done his damnedest."

The peppery, plainspoken Truman had never wanted to be President. A onetime haberdasher who by 1936 had risen through the state Democratic machine to a seat in the Senate, he was quite satisfied with being a senator, and he had agreed only reluctantly in 1944 to serve as Franklin Roosevelt's running mate. His reluctance soon turned to fear as he realized that the gravely ill Roosevelt probably would not survive four more years in the White House and that at some point he would himself almost certainly be President. That point came sooner than expected. On April 12, 1945, less than three months after his inauguration, Roosevelt died. A dazed Truman girded himself for the tasks of leading the country through the final phases of World War II and overseeing its postwar adjustments to peace. Among his first and most difficult decisions was to order the dropping of the newly developed atomic bomb on Hiroshima and Nagasaki, thus ushering in the nuclear era.

Eventually, Truman came to relish the presidency, but enjoyment of the office did not always bring success. Throughout his eight years in the White House, his relations with Congress were rocky at best, and his visionary Fair Deal, which called for such things as national medical insurance and strong civil rights legislation, generally received a cold shoulder in Congress even from many of his Democratic allies. Also on the negative side was Truman's sometimes stubborn loyalty to a network of political cronies who had few scruples about using influence within the administration for private gain.

Despite whiffs of scandal and difficulties with Congress, Truman could nevertheless claim some significant achievements. In the face of the Soviet Union's postwar drive to expand Communist influence westward in Europe, for example, it was the

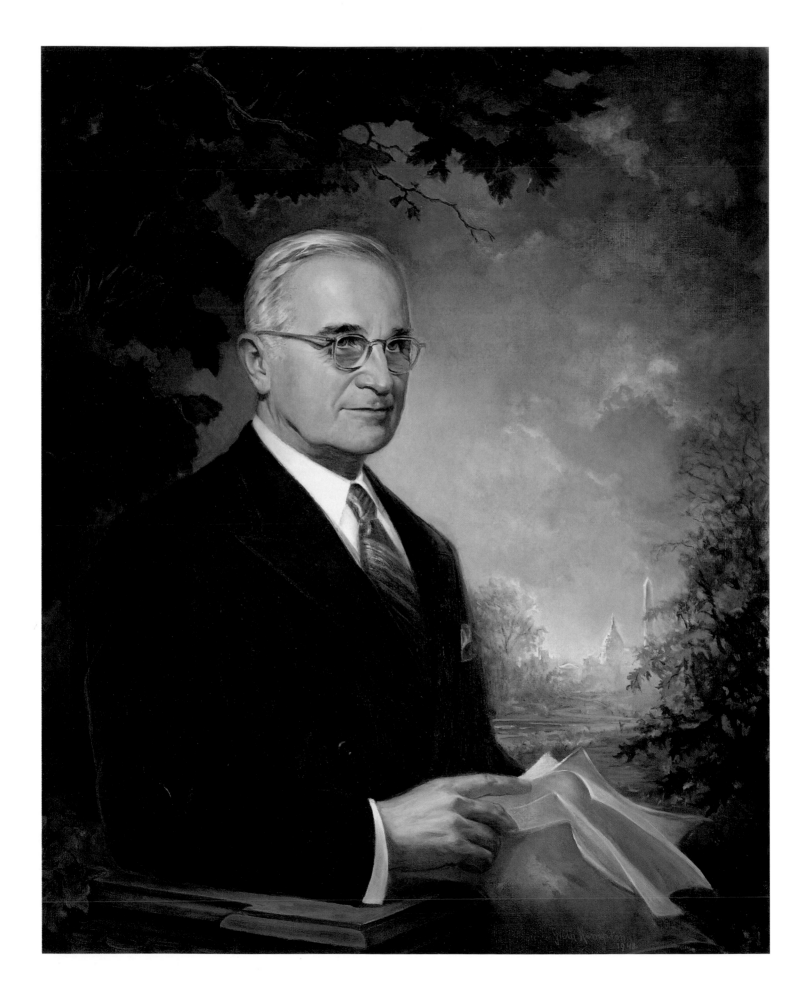

Harry Truman in mid-presidency

The painter of this portrait, Greta Kempton, did her first portrait of Harry Truman in 1947, and he liked it enough to designate it ultimately as his official White House likeness. He also liked it enough to sit for the Viennese-born Kempton again and to ask her to paint a group portrait of his immediate family. Eventually Kempton did so many portraits of Truman, his wife, and his daughter that she was dubbed his "court painter." This likeness is one that Kempton began in 1948. It remained unfinished until 1970 when, at the behest of Truman friends and former members of his administration, she completed it for presentation to the National Portrait Gallery.

When Truman first posed for Kempton, he thought that he could use the time to catch up on reviewing a backlog of memos and papers. The artist quickly told him that was not possible. Though taken aback at this ultimatum, he obeyed, and according to Kempton he proved a very compliant subject.

Greta Kempton, 1903–1991
Oil on canvas, 99 x 76.2 cm (39 x 30 in.), 1948 and 1970
Gift of Dean Acheson, Thomas C. Clark, John W. Snyder, Robert A. Lovett, Clinton P. Anderson, Charles F. Brannan, Charles Sawyer, W. Averell Harriman, David K. E. Bruce, Edward H. Foley, Stuart Symington, William McChesney Martin, Clark Clifford, Charles S. Murphy, Ward M. Canaday, and Joseph Stack

Campaign poster from the presidential election of 1948

Early in 1945, the then–Vice President Harry Truman attended a party at the National Press Club, where he was photographed playing a piano with actress Lauren Bacall seductively perched on its top. Thoroughly unamused when the picture ran in the newspapers, Mrs. Truman easily could have done without this mixture of cheesecake and politics. For artist Ben Shahn, however, the image proved a godsend, and in 1948 the photograph became the inspiration for his Progressive Party poster lampooning the White House candidates of both major parties—Truman and his Republican opponent, Thomas Dewey—as the "Tweedledee" and "Tweedledum" of American politics.

Ben Shahn, 1898–1969
Color lithograph, 109.3 x 71 cm (43 x 27 15/16 in.), 1948
©Estate of Ben Shahn/VAGA

aggressive implementation of his so-called "Truman Doctrine" of containment that largely put an end to this disturbing development and led to the formation of NATO and the beginning of the Cold War. Also much to Truman's credit was the Marshall Plan for rejuvenating Western Europe's ravaged economies after World War II through massive infusions of United States aid. Named for Secretary of State George Marshall, the plan eventually became one of the most singular diplomatic triumphs in United States history.

By the end of his presidency, Truman's inability to end a war against Communist aggression in Korea, combined with his continued bickering with Congress and allegations that his administration harbored Communist infiltrators, made him seem an incompetent fumbler. Gradually, however, that perception changed. By the time Truman died in 1972, it was widely conceded that he had indeed "done his damnedest" and that his damnedest had actually been pretty good.

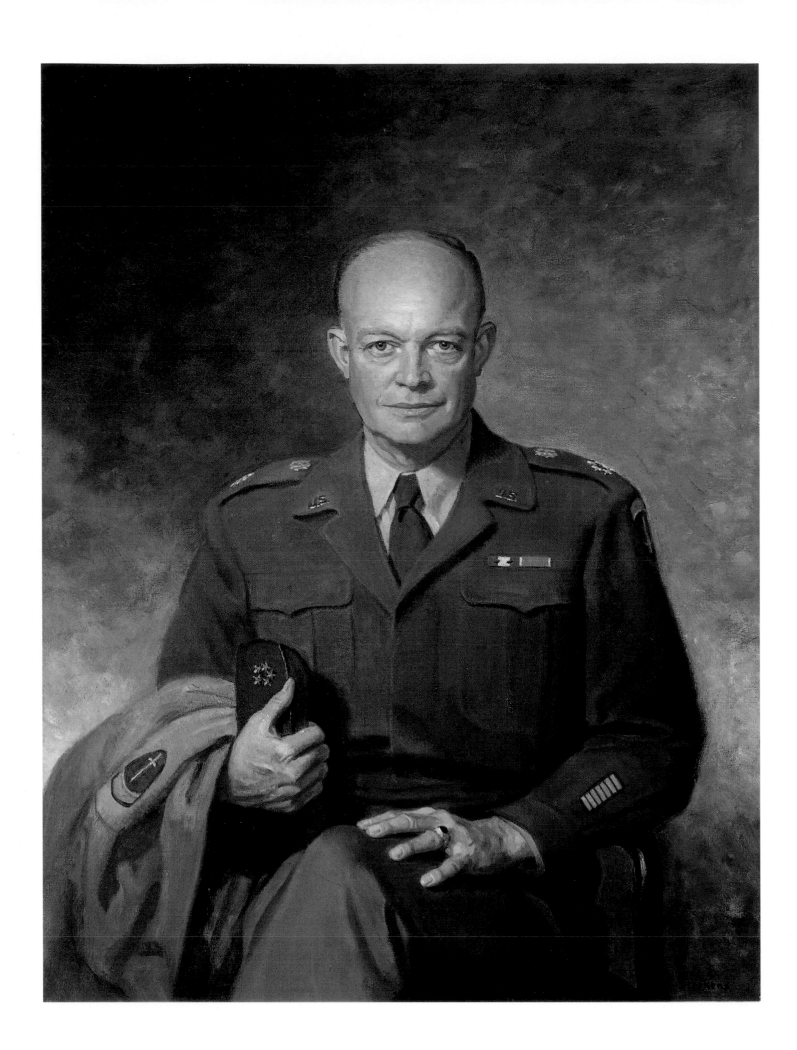

Dwight D. Eisenhower

1890–1969

Eisenhower during his tenure as army chief of staff

The Welsh-born Thomas Stephens was easily Eisenhower's favorite portraitist. Painting his first likeness of Ike in 1945, he eventually made twenty-three more. While sitting for the one here early in 1947, Eisenhower became thoroughly fascinated with the notion of painting a picture. Unable to contain himself, the artist later recalled, Ike finally exclaimed, "By golly, I'd like to try that!" Ready for a break anyway, Stephens handed him a palette and brushes and told him to give it a try. His first subject was his wife Mamie. Within another month or so, Eisenhower had taken up painting as a hobby.

Eisenhower never hesitated to recommend Stephens to others. When his brother Milton asked about a suitable portraitist to do his own likeness, he declared Stephens "the best artist that you could get."

Thomas Edgar Stephens, 1886–1966
Oil on canvas, 116.8 x 88.9 cm (46 x 35 in.), 1947
Transfer from the National Gallery of Art; gift of Ailsa Mellon Bruce, 1947

The enormous attraction of American voters to military heroes in presidential elections had been well demonstrated by the time the United States entered World War II. As the country geared up for war with Germany and Japan, it therefore required no great political wisdom to realize that, assuming victory, this conflict would almost certainly yield an irresistibly alluring gold-braided presidential candidate. For a while it appeared that the battlefield luminary destined for a White House candidacy was Southwest Pacific commander General Douglas MacArthur. But by war's end, MacArthur had been eclipsed by Dwight D. Eisenhower, the general who had orchestrated the Allied invasion of Europe.

Known affectionately as "Ike," Eisenhower had many vote-getting assets, not least of which were his broad grin and warm, fatherly manner. But before those assets could be made to work their magic in a presidential election, one stumbling block had to be surmounted: Eisenhower did not want to be President, and in 1948, in the face of efforts to make him a presidential candidate, he flatly declared that a professional soldier had no business going into politics. Over the next several years, however, his views changed, and in 1953, following a landslide victory at the polls, Eisenhower was assuming the office he had once so emphatically rejected.

After Eisenhower left the White House in 1961, a good many people believed that he had not been a particularly successful President. To substantiate that judgment, they often cited his unwillingness to denounce Senator Joseph McCarthy's divisive and groundless campaign to uncover Communist traitors in the government and his reluctance to use his presidential prestige to gain compliance with the Supreme Court's 1954 mandate for desegregating the nation's public schools. Some also claimed that in responding to the Cold War and Sino-Soviet efforts to expand Communist influence in the world, Eisenhower added unnecessarily to international tensions by too often resorting to military confrontation to block those efforts.

But there was a side to Eisenhower's administration that, as the years passed, increasingly cast his presidency in a more positive light, even among some former critics. As a fiscal conservative, for example, Eisenhower assiduously insisted on maintaining a balanced federal budget as much as possible and, in doing so, provided a favorable climate for the nation's steady economic growth during his two terms in the White House. Moreover, although he often favored armed intervention to halt Communism's spread in various parts of the globe, he understood the limits of that strategy. Knowing that such saber-rattling diplomacy could one day spark an all-out nuclear war, he explored less warlike means for achieving peaceful coexistence between the American-led free world and the Soviet-led Communist world. In the short term, those explorations yielded little of substance. Nevertheless, through his meetings with Soviet leader Nikita Khrushchev and his proposals for international disarmament, Eisenhower could be credited with paving the way for thaws in the Cold War.

John F. Kennedy

1917–1963

John F. Kennedy on the campaign trail for congressional candidates

The vigorously handsome John Kennedy was American politics' answer to the matinee idol, and crowd response to him verged at times on frenzy. Heightening this phenomenon was Kennedy's own zestful reaction to it.

Titled *Hitting the Wall*, this picture by *New York Times* photographer George Tames offers vivid documentation of how the chemistry between the idol-President and his idolizers worked. The photograph was taken at the airport in Pierre, South Dakota, in August 1962. Kennedy had just arrived there to dedicate a new power facility and, more important, to promote the election of Senate candidate George McGovern. On disembarking from his plane, Kennedy first had to acknowledge the welcome from local officials. That done, he was soon striding off toward an airport fence to conduct more important business—a round of handshaking with some of the several thousand Kennedy enthusiasts who were craning for a glimpse of him.

George Tames, 1919–1994
Gelatin silver print, 23.2 x 30.5 cm (9 ⅛ x 12 in.), 1962
Gift of Frances O. Tames
© The New York Times

On November 22, 1963, President John F. Kennedy arrived in Dallas, Texas, to mend political fences within his Democratic Party. With the late fall sun shining brightly down on his motorcade, and his vivacious wife seated next to him in their open car, the stage seemed to be particularly well set for the success of that mission. But the optimism of the moment was soon shattered as shots rang out and Kennedy suddenly slumped over. Within seconds, his presidential car was racing toward a nearby hospital, where shortly after its arrival Kennedy was pronounced dead.

Kennedy's assassination plunged the nation into a deep and profound grief not experienced since the death of Lincoln nearly a century before. And along with the grief came another phenomenon that harkened back to Lincoln's martyrdom. In the months following the Dallas tragedy, the public came to see Kennedy in increasingly idealized terms, and as his virtues became ever magnified in the popular imagination, his failings seemed to fade into insignificance.

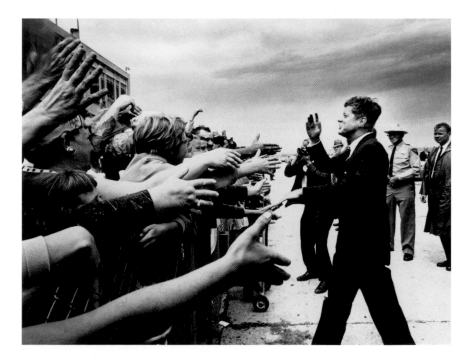

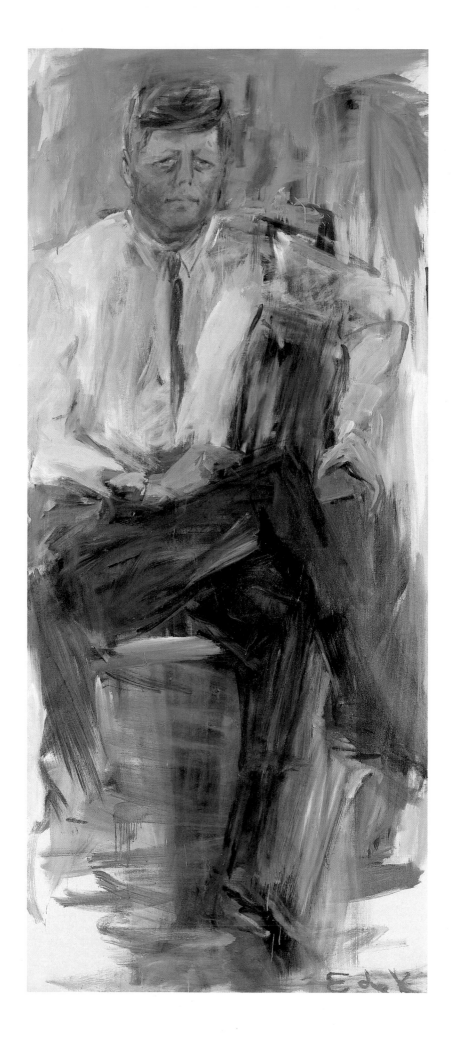

One of the series of portraits of John F. Kennedy by Elaine de Kooning

Normally Elaine de Kooning painted her sketchy, loose-brushed portraits quickly, and when the Harry S. Truman Presidential Library asked her to make a likeness of John F. Kennedy, she assumed that she would be able to finish the commission in short order. When she confronted Kennedy, however, in late 1962 at his family's home in Palm Beach, Florida, she soon concluded that this was not possible. Between the changeability of his appearance and a constant physical restlessness, his appearance altered radically and often during her seven informal sittings with him. As a result, one portrait did not seem sufficient, and in her effort to capture the full impact of Kennedy's presence and personality, de Kooning ended up making scores of drawings and some twenty-three finished paintings of him. The version here was done back in the artist's studio and was among the last oil likenesses to be derived from her many life studies.

Though clearly rooted in the representational tradition, de Kooning's portraiture owed much to Abstract Expressionism, the modernist school of painting of which her husband Willem was a chief proponent. Thus, the broad, restless brushwork in Kennedy's likeness clearly links it to the Abstract Expressionist credo, which placed a premium on the artist's gesture and subjective spontaneity.

Elaine de Kooning, 1918–1989
Oil on canvas, 259.7 x 111.8 cm (102 ¼ x 44 in.), 1963
© Elaine de Kooning Trust

The second-youngest individual to occupy the White House, he had come to office with a cocky and sometimes naive self-assurance that he and his advisers could do anything they set their minds to. But he quickly found that this was not the case. In giving the go-ahead, for example, to the utterly disastrous Bay of Pigs invasion of Cuba to overthrow Communist leader Fidel Castro in 1961, Kennedy had to accept responsibility for one of the country's most humiliating defeats in the history of the Cold War. At the same time, he had not proven particularly effective in dealing with Congress. As a result, his calls for, among other things, a far-reaching civil rights law, greater federal aid to education, and a national health-care program for the elderly failed to evoke positive responses.

But Kennedy had his successes as well. When the Soviet Union threatened the United States's security by installing missiles in Cuba in 1962, he quickly undertook to impose a naval blockade on Cuba and in the process forced the removal of the missiles. His administration also reached an agreement with the Soviet Union and Great Britain that promised to put an end to most nuclear testing. Finally, although Kennedy did not succeed in convincing Congress to enact most of his domestic programs, his dynamic leadership nevertheless helped to create a climate favorable to their eventual passage under his successor, Lyndon Johnson. Nowhere was this more apparent than in the area of civil rights, and there is little doubt that Kennedy's aggressive support for the struggle against racial discrimination was a major factor leading to the landmark Civil Rights Act of 1964.

The most positive aspect of Kennedy's presidency was not to be found in diplomatic agreements or new legislation. Rather, it lay in Kennedy's personal style. A man of enormous charm and wit, he injected the presidency with a cosmopolitan glamour that even his many critics found appealing. Perhaps more significant, however, was Kennedy's idealism, which, in tandem with his uncommon ability to articulate that idealism, often made it seem that a more equitable and peaceful world was indeed possible. Thus, as the Kennedy legend grew to heroic proportions after his assassination, it was not what he had done that explained this, but rather the promise of what he might have done, had he lived.

Lyndon B. Johnson

1908–1973

His critics found him abrasively crude and ruthless, and even his friends had to admit that on occasion there was more than a grain of truth in that unflattering characterization. Nevertheless, there was one compliment that neither ally nor foe could deny him: No one understood the mechanisms of American politics better than Lyndon B. Johnson, and no one could use those mechanisms to more effective advantage.

Having entered the political arena as a member of the House of Representatives in 1937, this tall, broad-shouldered Texas Democrat had by the mid-1950s become the majority leader of the Senate. More important, Johnson's mastery of the arts of political arm-twisting and flattery had made him one of the most formidable figures in Washington. It was universally acknowledged, by Democrats and Republicans alike, that no measure of consequence could pass through Congress without his blessing.

But Johnson's ascendance in Washington came temporarily to an end in 1961 when he became John F. Kennedy's Vice President, and like all the holders of that office before him, he found himself suddenly relegated to the nation's political backwaters. In speaking of his term in the vice presidency, he once remarked, "I detested every minute of it."

Johnson's unhappiness did not, however, erode his instincts for leadership, and when Kennedy's assassination placed him in the White House in 1963, it almost seemed that his time in vice-presidential limbo had increased his capacity for dominating. Thus, as Johnson brought his skills in political orchestration to bear on his presidential duties, he seemed to be almost infallible. By late 1965, his administration had pushed through Congress a body of legislation that could only be described as breathtaking. Perhaps the most notable of these measures was the far-reaching Civil Rights Act, which held the promise of finally putting an end to racial discrimination in American life. But there were other significant measures as well, among them federal health insurance for the elderly, generous funding for a "war on poverty," and the most comprehensive package of federal aid to education ever enacted.

The portrait that Lyndon Johnson rejected

The story of this portrait began in late 1964 when *Time* magazine named Lyndon Johnson its Man of the Year. To do his cover portrait for the occasion, the magazine called on the noted Southwestern artist Peter Hurd, and Johnson liked the resulting image so much that he decided that Hurd should paint his official White House portrait. This second phase in the Hurd-Johnson relationship, however, got off to a rocky start when Johnson promptly fell asleep at one of his sittings and would not sit still at another. But worse was yet to come. When Hurd brought his finished portrait to the Johnson ranch for a private showing, Johnson declared the picture "the ugliest thing I ever saw," and shortly thereafter it was shipped back to Hurd, who later gave it to the National Portrait Gallery. Meanwhile, the wags in Washington were saying that artists should be seen in the White House, but not Hurd.

One thing that Johnson approved of in Hurd's likeness was the angle at which he was painted. Convinced that his left side was his best, he was insistent through much of his presidency that at press conferences, photographers routinely should be confined to spots where it was possible to shoot only his left side.

Peter Hurd, 1904–1984
Tempera on panel, 121.9 x 96.5 cm
(48 x 38 in.), 1967
Gift of the artist

The ultimate goal of all these domestic programs, Johnson said, was the creation of a "Great Society" in which all Americans, regardless of race or birth, would be guaranteed a reasonable opportunity to partake in the enormous richness of their country's resources. To a large extent, Americans shared in that dream, and for a while Johnson's approval rating in the polls was running high. But even as his popularity soared, his commitment to protecting South Vietnam from a Communist takeover planted the seeds of his political destruction. In response to his administration's rapid buildup of American forces in Vietnam after 1965, public sentiment toward Johnson increasingly soured. Meanwhile, the costliness of his "Great Society" legislation and the failure of his civil rights policies to work their desired change as rapidly as some had hoped were also diminishing his reputation. While opponents of the Vietnam War vilified him for dragging the country into a war that was neither winnable nor justifiable, others accused him of fiscal irresponsibility and trafficking in false promises. Thus, by the end of his presidency, Johnson had gone from being one of the most widely approved Presidents in the twentieth century to one of the most disliked.

Richard M. Nixon

1913–1974

In late 1962, shortly after his defeat in the California gubernatorial election, Richard Nixon stood before an assemblage of news reporters and declared his intention to retire from politics. This announcement came as no surprise to his audience. In Congress, Nixon had not been known for warmth and easy likeability, and his sometimes unscrupulous efforts to undermine his political opponents had engendered considerable negative feeling. Nevertheless, during his eight years as Eisenhower's Vice President, he had performed admirably, both as acting President during Ike's several prolonged illnesses and as a representative of American interests abroad. But the failure of his own presidential candidacy in the election of 1960, followed by his unsuccessful bid for the California governorship, led many—including Nixon himself—to the conclusion that he had reached the end of the road politically.

Nixon's resolve to forswear politics did not, however, last long. Within a few years, he was once again taking an active role in promoting the Republican Party. In doing so, he was also reemerging as a serious White House contender. On presidential election day in 1968, he claimed the very prize that had eluded him in 1960 and that in 1962 he had publicly indicated he would never seek again.

On the domestic front, Nixon's presidency was not particularly notable for lasting achievements. And although he ultimately kept his campaign promise to end the bitterly controversial war in Vietnam, many were highly critical of the slowness with which he moved toward that goal. But in other respects, Nixon's accomplishments were substantial. While the efforts of previous administrations to ease Cold War tensions with the Communist world had never yielded many meaningful results, Nixon's attempts at peaceable rapprochement did. By the end of his first term, the United States was signing landmark agreements with the Soviet Union for mutual disarmament. More important, in partnership with Henry Kissinger, his foreign affairs adviser, Nixon finally

Richard Nixon on the eve of his presidency

Shortly after Nixon's election to the presidency, *Look* magazine hired the famed illustrator Norman Rockwell to make a portrait of him, and in December 1968 Nixon sat for the preliminary drawings for the likeness at New York City's Plaza Hotel. Rockwell later completed the final image, pictured here, back in his Stockbridge, Massachusetts, studio.

Rockwell once called Nixon "the hardest man I ever had to paint." He also admitted that in painting the *Look* portrait, he had consciously attempted to flatter by understating Nixon's prominent jowls and making his hair look thicker than it really was. The problem, according to Rockwell, was that Nixon fell into that troublesome category of "almost good-looking," and if the artist was going to err in his portrayal, he decided it should be in a positive direction.

Norman Rockwell, 1894–1978
Oil on canvas, 46.4 x 66.7 cm
(18 ¼ x 26 ¼ in.), 1968
Donated to the People of the United States of America by the Richard Nixon Foundation

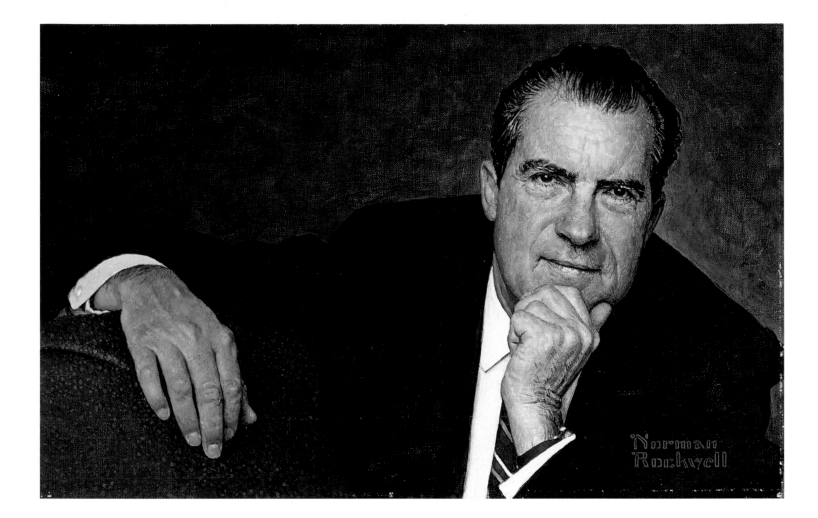

opened the way for American recognition of Communist China and a normalization of diplomatic relations with that country.

Unfortunately, Nixon never had time to savor these accomplishments and to enjoy his growing reputation as an architect of a more constructive and considerably less threatening international order. During his 1972 campaign for a second term, his reelection committee engaged in a number of illegal activities, the most notable being a conspiracy to wiretap Democratic Party offices at the Watergate complex in Washington. As the probes into this election-year malfeasance progressed, it became clear that many of Nixon's

closest advisers had been party to the wrongdoing. In the end, many of them went to jail. Worse yet, it was eventually found that while not directly involved in the crimes that had initiated the Watergate investigations, Nixon had participated in attempts to cover up the scandal. As a result, by mid-1974 his credibility as a leader had totally evaporated, and the House of Representatives was preparing articles of impeachment accusing him of intentionally blocking the Watergate inquiries and of abusing his presidential powers. Rather than face a Senate trial on those charges, Nixon became the only President in history to resign from office.

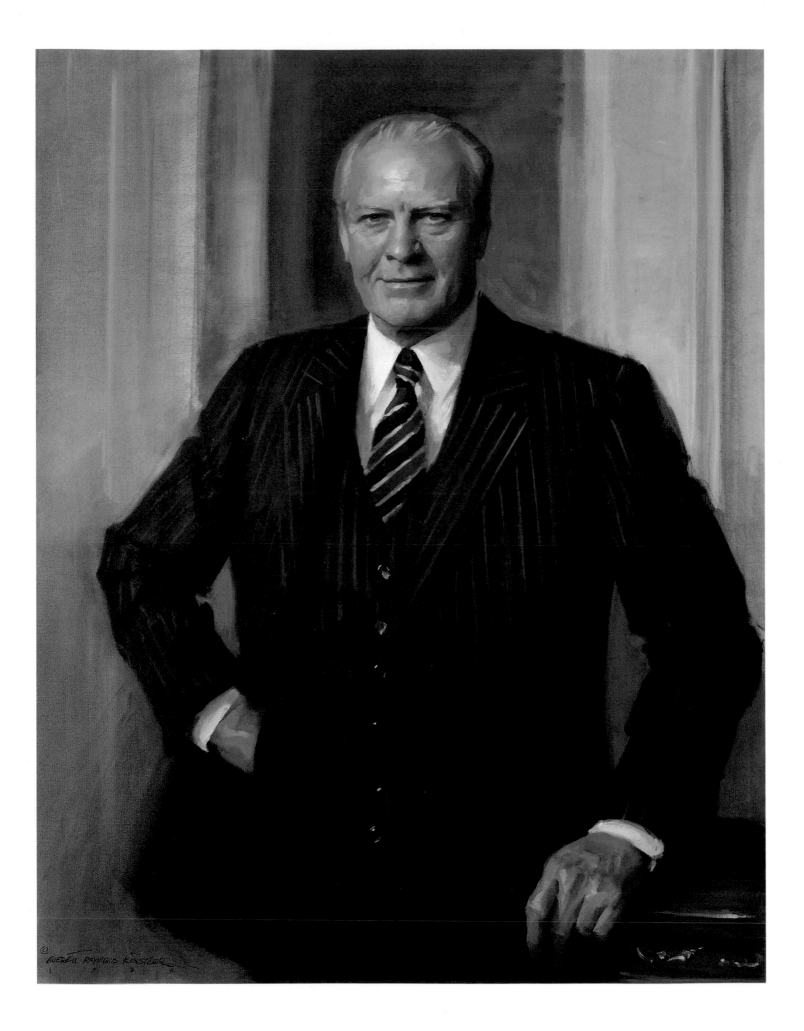

Gerald R. Ford

BORN 1913

Gerald Ford shortly after leaving office

Painted specifically for the National Portrait Gallery, this likeness was the work of Everett Raymond Kinstler, who began his career as an illustrator and, in the late 1950s, turned to portraiture. By the 1970s he had become one of the country's most sought-after portraitists. Completed in 1987, Ford's portrait was based on sketches that Kinstler had made ten years earlier when he was working on Ford's official White House likeness. At that picture's unveiling, Ford declared, "considering what Kinstler had to work with, he did very well."

Despite its pinstriped formality, Ford's likeness has a congenial warmth that bespeaks one of the main strengths of his presidency. If nothing else, Ford was steady, approachable, and easygoing—qualities that in themselves went a long way toward restoring credibility to the presidency, following Richard Nixon's resignation.

Everett Raymond Kinstler, born 1926
Oil on canvas, 111.8 x 86.4 cm (44 x 34 in.), 1987
Gift of the Gerald R. Ford Foundation

The annals of presidential history include a number of stories about men who reached the White House through unusual and sometimes irregular sequences of events. There was, for example, John Quincy Adams, who rose to the nation's highest office as a result of a deadlock in the electoral college and a political deal in the House of Representatives. And there was "dark horse" James K. Polk, who emerged seemingly from nowhere to claim the presidency in 1844. But if historians were asked to name the President who came to office under the most unexpectedly bizarre set of circumstances, there could be only one answer—the thirty-eighth President of the United States, Gerald R. Ford.

Among the elements that make the story of Ford's rise to the presidency so singular was that Ford himself had never entertained the slightest desire for that office. He had been quite content with his position as a member of the House of Representatives, and after his election in 1965 as Republican minority leader, his only other ambition was to one day become Speaker of the House. In the face of his party's chronic inability to gain a majority in the House, however, the goal eluded him. By the early 1970s, with the prospects for a change in the political situation as remote as ever, Ford had almost decided that the time had come to retire from public life. But just as he was starting to consider leaving politics, an incredible chain of events began conspiring to prevent it.

On October 10, 1973, after pleading *nolo contendere* to a charge of tax evasion, Spiro T. Agnew, Richard Nixon's Vice President, resigned from office. Shortly thereafter, Nixon appointed Ford to the vice presidency.

Then, just as the Senate began moving to confirm that appointment, Ford's political fortunes took yet another drastic turn; before he had fully settled into the vice presidency, it appeared that the mounting evidence of Nixon's involvement in the Watergate scandals might force the President to resign. Within another six months that possibility had become reality. On August 9, 1974, Ford became the only Vice President to succeed to the

presidency because of the resignation of his predecessor.

In many respects, Ford's White House tenure was not a success. In his response to a sagging economy and high inflation, he proved largely ineffective, and in his efforts to devise solutions to the energy crisis caused by the great rise in oil prices, he often found himself blocked by a balking Congress. As far as many contemporary observers were concerned, however, Ford's greatest sin was his issuing of a blanket pardon to Nixon for any part he may have had in the Watergate scandals. The anger inspired by this act was enormous, and in its wake, Ford's approval rating plummeted sharply.

Nevertheless, Ford performed one service that on balance exceeded his shortcomings: Having come to office because of a scandal that reduced public faith in the presidency to its lowest point in modern memory, Ford met his responsibilities with an honesty and openness that to a great extent restored that lost credibility. In so doing, he proved that, even under the most trying circumstances, Americans' pride in the orderly workings of the constitutional system was not misplaced.

Jimmy Carter

BORN 1924

Midway through Jimmy Carter's term as governor of Georgia, his mother teasingly asked him what he was going to do with himself when he was out of office. She was not expecting a serious answer. When Carter responded, "I'm going to run for President," she took it at first as a joke. But when she continued the joke by asking "President of what?" she realized from the thoughtful look on her son's face that upon leaving the governorship in 1975 he was indeed intent on running for President of the United States.

In achieving his White House ambitions, however, Carter had one seemingly insurmountable problem: Outside of his own state, he was a political unknown. As he began campaigning for the Democratic presidential nomination early in 1976, one of the most frequently heard quips on the campaign trail was "Jimmy who?" But the question soon lost its cynical bite. By summer, armed with iron determination, a gleaming smile, and an appealingly down-to-earth manner, Carter had sewn up the nomination and, by year's end, was staking his claim to the presidency.

Carter owed his unexpected rise to the White House to a unique blend of populism and conservatism that promised both innovation and caution. He also owed it to his success in convincing voters that as a man who had not been jaded by many years as a Washington insider, he had a truer understanding of the country's current needs and a healthier perspective on just how those needs should be met.

But although Carter's party held majorities in both houses, his inability to deal effectively with Congress made it difficult for him to live up to the high expectations that his campaign rhetoric had engendered. Thus, his attempts to promote such measures as tax reform, national health insurance, and changes in the country's welfare system met, for the most part, with failure, and in implementing a national energy policy in response to the oil shortages of the 1970s, he proved at best only partially successful. Worse yet, he never succeeded in coming to grips with the inflationary spiral that had been plaguing the United States since the early 1970s. By

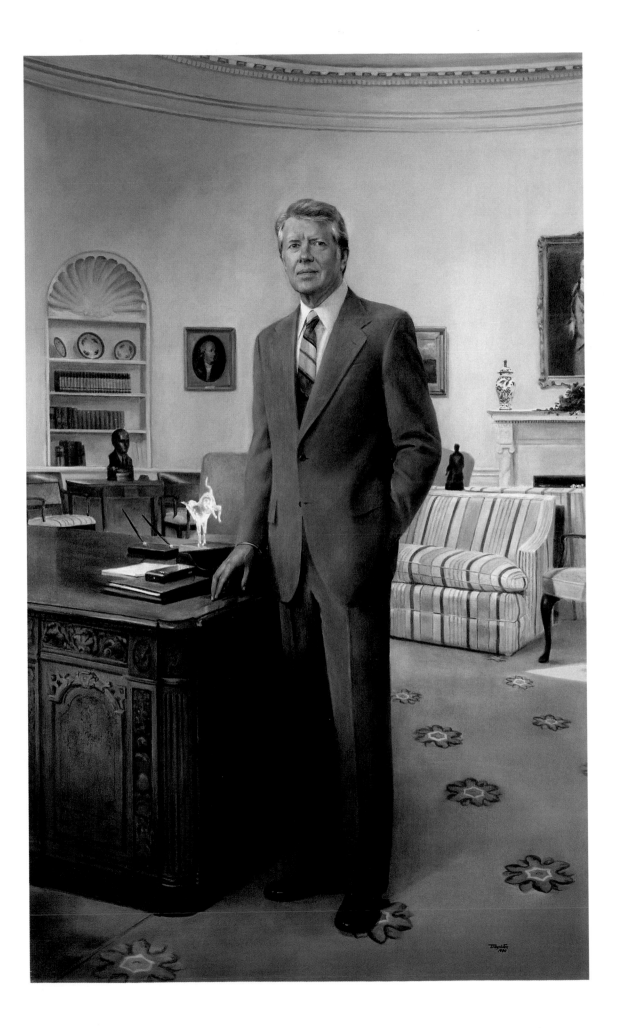

A portrait of Jimmy Carter begun in the final year of his presidency

While working on Jimmy Carter's portrait for the Georgia State Senate in 1979, artist Robert Templeton asked Carter how he would feel about posing for a full-length likeness set in his White House Oval Office. Carter was agreeable, and in the following year he made time for three sittings. Although the final picture is dated 1980, it was not actually finished until 1983.

In addition to creating a good likeness, Templeton was intent on re-creating the Oval Office as it was furnished during Carter's administration. On the desk is a statuette of the Democratic donkey, which was given to Carter by the Democratic National Committee, and in the distance is a bust of Harry Truman, a White House predecessor whom Carter greatly admired.

Robert Templeton, 1929–1991
Oil on canvas, 235 x 142.2 cm (92 ½ x 56 in.), 1980–1983
Partial gift of the 1977 Inaugural Committee

Gold version of Jimmy Carter's inaugural medal

Julian Hoke Harris, 1906–1987. 7 cm
(2 ¾ in.), 1976
Gift of Bardyl Tirana

early 1980, the nation's annual inflation rate was hovering around 16 percent.

Carter's administration did, however, manage to achieve some of its major objectives, among them the deregulation of the banking and air transportation industries and civil service reform. It was also largely due to Carter's intercession that Egypt and Israel finally negotiated an end to the state of war that had so long existed between them.

Unfortunately, these and other triumphs were not enough to counteract the widespread popular perception that Carter was not up to the job of leading the country. When, late in 1979, anti-American feeling in Iran climaxed with the taking of fifty-two hostages at the American embassy, and when Carter's efforts to free the hostages continually met with failure, that perception deepened even further. By mid-1980, his approval rating in the polls had reached an unprecedented low. Consequently, although the Democrats nominated him for a second term that year, enthusiasm for his candidacy, even among many party faithful, was far from wholehearted. Well before the election in November, it seemed clear to many that Carter's "political miracle" of 1976 would not repeat itself.

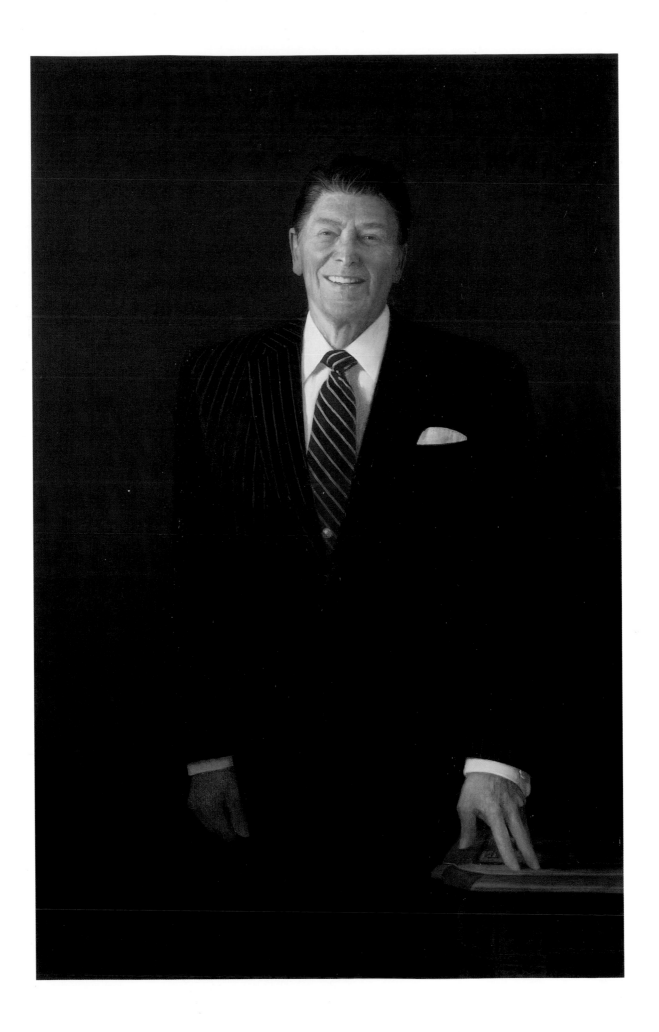

Ronald Reagan

BORN 1911

Portrait of Reagan from the final months of his presidency

This portrait is based on some thirty studies that artist Henry Casselli made of Ronald Reagan over four days at the White House in November 1988. Commissioned with the National Portrait Gallery in mind, the finished picture was brought to the White House the following January for inspection by Reagan and his wife. When Reagan saw it, he exclaimed, "Yep! That's the old buckaroo."

Reagan was approaching his seventy-ninth birthday when he posed for this portrait, and he had been President for nearly eight years. Yet the portrait depicts him with the same warm buoyancy that he had when his presidency began.

Henry Casselli, born 1946
Oil on canvas, 127 x 81.3 cm (50 x 32 in.), 1989
Gift of Herman Chanen, Tom Chauncey, and other friends of President and Mrs. Reagan
© Henry C. Casselli, Jr.

In the 1940s if anyone had claimed that a moderately successful screen actor named Ronald Reagan had the makings of a President, he or she would have been laughed at. By 1964, however, Reagan had become a spokesman for the Republican Party's more conservative elements, and in the wake of his spellbinding televised speech that year in support of Republican White House hopeful Barry Goldwater, such an assertion no longer seemed so implausible. Although Reagan's masterful performance was not enough to make Goldwater President, it nevertheless demonstrated Reagan's own remarkable powers as a vote-getter. Almost overnight, a movement to put this onetime actor into public office was afoot, and two years later he won election to the California governorship.

For Reagan's backers, this was only a beginning. No sooner had he settled into the governorship than his supporters were contemplating strategies for making him a presidential candidate. Initially these strategies proved unsuccessful; after he failed to win the Republican nomination in 1976, it almost seemed that Reagan's political career was at an end. In 1980, however, in the face of mounting distrust of the federal bureaucracy's capacity to deal with such problems as rampant inflation and a stagnating economy, Reagan's call for reducing the government's role in American life had great appeal to voters. Consequently, Reagan came to the Republican convention that year virtually unopposed for his party's presidential nomination. Six months later he was sworn in as President.

Reagan's disengaged White House style, which often manifested itself in a poor mastery of the details of his administration, did not augur well for a productive presidency. Yet he had two strengths that more than made up for that detachment: He seemed to know what he wanted, and he had an almost magical ability to sell the American people on the rightness of his stated views. By the end of his two terms in office, his program to cut back on government regulation of the economy, substantially reduce taxes, decrease federal spending on social services, and

drastically increase the country's military strength had been largely successful. His only major failure was his disregard for achieving a balanced budget.

Falling short in that respect produced record annual deficits, which by the late 1980s were running into the trillions of dollars—a development that observers found increasingly worrisome. Also disturbing were indications that many of Reagan's advisers had used their positions for private gain and the revelations that his administration had conspired to circumvent a congressional ban on supplying military aid to anti-Communist forces in politically troubled Nicaragua.

For most Americans, such things did not seem to matter much as they enjoyed the prosperity that resulted from Reagan's tax reforms and his loosening of federal controls over the economy. In addition, there was a widely shared perception that Reagan's great military buildup in the name of curbing Communist influence in the world might have played a part in the demise of the confrontational politics of the Cold War shortly after he left office. With a thriving economy and an easing of international tensions, the faults of Reagan's presidency paled, and when he left the White House in 1989, he commanded a popularity that few other outgoing Presidents have enjoyed.

George Bush

BORN 1924

By the early 1960s George Bush was presiding over a multimillion-dollar oil business in Houston, Texas. Had he remained in that line of work, he might well have become a billionaire. But the prospect of building a modest fortune into an immense one did not hold much interest for this transplanted New Englander, and in 1962 he turned his attention to politics. Four years later, after a stint as a Republican Party county chairman and an unsuccessful bid for a seat in the United States Senate, he was elected to the House of Representatives, where he eventually served two terms and earned a reputation as a comer in the Republican Party.

Bush's defeat in his second try for the Senate in 1970 represented a setback in his political rise, but it was only temporary. By the decade's end, his successes as ambassador to the United Nations, national chairman of the GOP, envoy to China, and director of the Central Intelligence Agency had begun to make him look vaguely presidential.

In Bush's attempt to gain his party's White House nomination in 1980, he lost out to Ronald Reagan. Nevertheless, he emerged from the competition with a valuable consolation prize when Reagan tapped him to be his running mate. In face of the immense popularity of Reagan's presidency, that prize proved substantial. In 1988 Bush's eight years of identification with Reagan's successes became the springboard for his own election to the presidency.

Commenting on Bush's enjoyment of his presidential responsibilities one year into his administration, one observer said, "He works as hard at the job as Carter did, yet wears the office as lightly as Reagan." In the first half of his White House tenure, that combination of toil and ease produced some fairly impressive results, including a significant overhaul of the Clean Air Act, landmark legislation ensuring the civil rights of the disabled, and a budget package that represented a promising start in curbing the nation's runaway deficit spending. But Bush's most formidable presidential accomplishments were in foreign policy, where his sure-footedness led one expert to hail him as a master "of timing

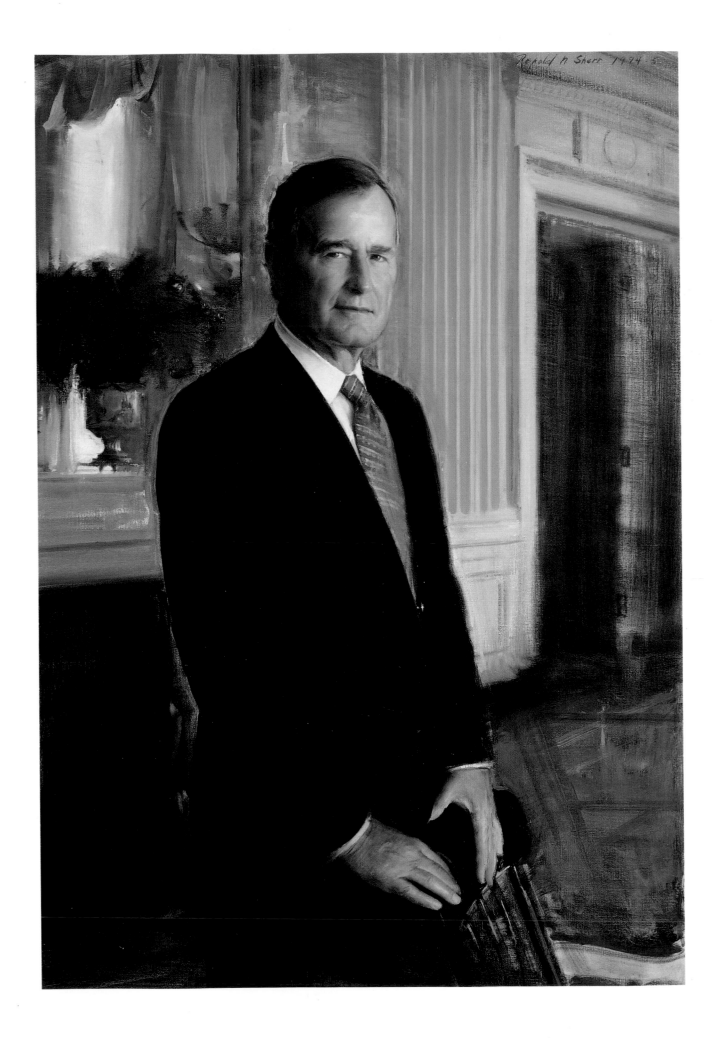

Portrait of George Bush made several years after leaving the White House

Artist Ron Sherr based the figure in this portrait on five sittings with George Bush at Bush's home in Kennebunkport, Maine. The backdrop, however, is the East Room of the White House. Sherr found Bush amazingly cooperative and was especially gratified by his cheerful willingness to maintain his standing pose for long periods of time.

When Sherr does a portrait, he likes to consider the place where it will hang and plan his composition accordingly. Since he knew this picture was destined for the National Portrait Gallery, where it was apt to be viewed at short distances, he heightened its approachability by investing it with an intimate warmth.

Ronald N. Sherr, born 1952
Oil on canvas, 127 x 85.7 cm (50 x 33 ¾ in.), 1994
Gift of Mr. and Mrs. Robert E. Krueger

and substance." More widely traveled than any other President before him, he managed well the policy transitions necessitated by the collapse of the Soviet empire and the end of the Cold War. More impressive, however, was his adroit response to the occupation of Kuwait by Iraq's Saddam Hussein in 1990. In forming the international alliance of disparate interests in opposition to Hussein, his diplomatic skills became the adhesive that kept it together long enough to liberate Kuwait.

The triumph over Hussein sent Bush's approval rating soaring to 91 percent. Unfortunately, he seemed unwilling to capitalize on all that popular goodwill with new initiatives, and the second half of his administration went into a largely reactive mode. That passivity inevitably hurt him, and was a crucial factor in his defeated bid for a second term in 1992.

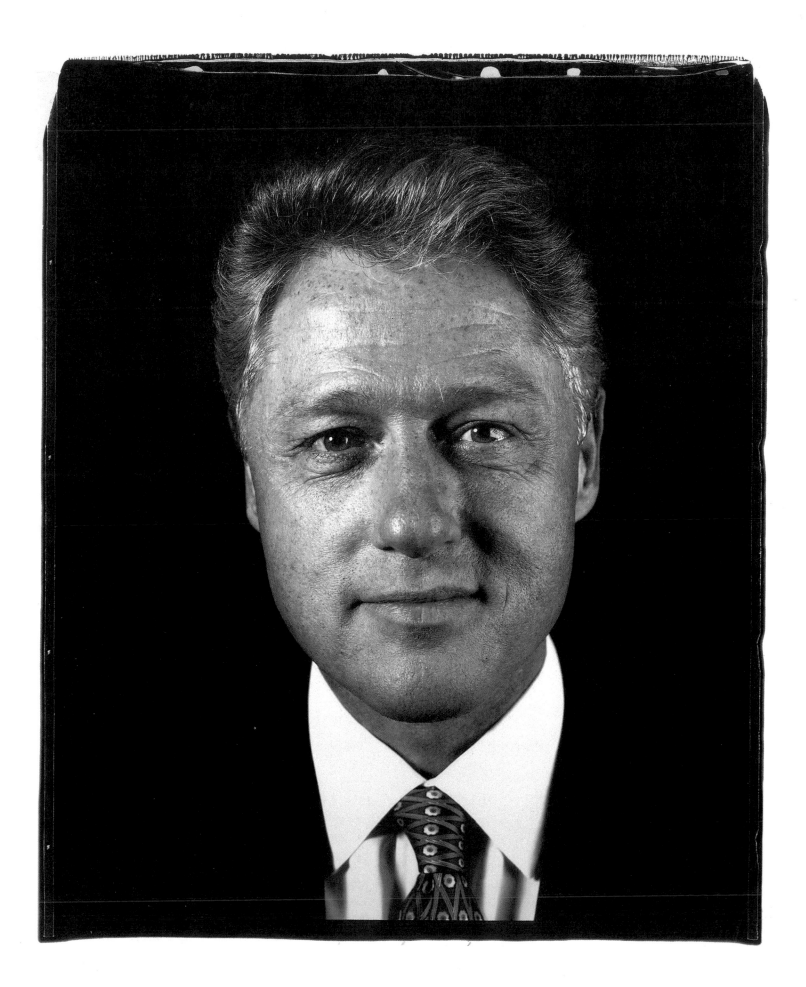

William J. Clinton

BORN 1946

Bill Clinton in the year of his reelection

While most modern-day portraitists still pattern their likenesses on compositional conventions that trace their roots to such artists as Titian, Hals, or Velázquez, Chuck Close takes the inspiration for his likenesses from quite a different source—the mug shot. Combining that composition with a scale that is larger than life, his images often carry an impact that is at once overwhelming and riveting.

Close produced his likeness of Clinton to raise money for the Artists for Freedom of Expression during the election of 1996. In anticipating his meeting with Clinton at the White House to take the Polaroid shot that would be the basis for the final enlarged ink-jet print, Close was afraid that his busy subject would lose patience and walk out before he had gotten what he wanted. With the camera stationed disconcertingly close to Clinton's face, the situation did indeed produce some tense moments, but ultimately Clinton became fascinated with the process and gave Close as much time as he needed.

Chuck Close, born 1940
Giclée print on Somerset paper, 119.1 x 88.3 cm (46 7/8 x 34 3/4 in.), 1996

The first of the post–World War II baby boomers to sit in the White House, William Clinton had his first taste of the political life as a high schooler, when he came to Washington, D.C. as a delegate to Boys' Nation. During his stay, he met President Kennedy at the White House and Senator J. William Fulbright from his native Arkansas. The encounters changed Clinton forever: Having toyed with being a minister or a musician, he now wanted only one thing—to go into politics.

And that was exactly what he did. Soon after receiving his law degree at Yale in 1973, he ran for Congress. Although he lost, he was not deterred, and in 1978, at age thirty-two, he claimed the Arkansas governorship. His bid for reelection two years later failed. But in 1982, he bounced back to win again and proceeded to tally up a record of accomplishments that would keep him in office for ten years.

Among the more outstanding of Clinton's political traits was a never-failing resilience, borne by his unflappable affability and uncanny skill in reading the popular mood. That trait became his salvation when he ran for the presidency in 1992. The stories from his past, brought to light during the campaign, about such things as evading the draft during the Vietnam War and a prolonged extramarital affair, would have been enough to stop anyone else's candidacy dead in its tracks. But not Clinton's. He not only survived to capture the Democratic nomination but to claim victory in November as well.

In his presidency, that resilience continued to be his mainstay. For one of the most noteworthy aspects of Clinton's two administrations was the stream of revelations, legal suits, and investigations related to his extramarital affairs—both alleged and admitted—and to his and his wife's alleged pre-presidential involvements in deceptive land development schemes in Arkansas. Yet despite all the damaging disclosures, Clinton managed to maintain his credibility with the electorate. In fact, when his alleged lying under oath about his affair with White House intern Monica Lewinsky led to a Senate impeachment trial, he not only

avoided being ousted from office, his popularity rating in the polls actually increased.

The most ambitious initiative of Clinton's presidency was an attempt to overhaul the nation's health care system. That effort failed, but Clinton could claim accomplishments on other fronts, including a role in reshaping the nation's public welfare system. His administration also played a crucial part in curbing the massive federal spending deficits that had soared out of control in the 1980s, and during his second term, there was a surplus in government revenues for the first time since the late 1960s. It may be, however, that Clinton's most significant legacy is his pragmatic brand of liberal centrism, which has substantially diminished expectations of the role that the federal government can play in solving the nation's problems.

WILLIAM J. CLINTON

Notes on Sources

Introduction

John Adams, "Had I been chosen President again," in "Presidents on the Presidency," *American Heritage* 15, no. 5 (August 1964): 112. Thomas Jefferson, "Unceasing drudgery," in John P. Foley, ed., *The Jefferson Cyclopedia*, vol. 2 (New York: Russell & Russell, 1967), p. 717. John Quincy Adams, "the four most miserable years," in "Presidents on the Presidency," *American Heritage* 15, no. 5 (August 1964): 112. Abraham Lincoln, "If it wasn't for the honor," in Emanuel Hertz, *Lincoln Talks: A Biography of Anecdote* (New York: Viking, 1939), pp. 258–59. Grover Cleveland, "My little man," in Kenneth S. Davis, *FDR: The Beckoning of Destiny* (New York: Putnam, 1972), p. 63. Theodore Roosevelt, "No one ever enjoyed," in Albert Bushnell and Herbert Ronald Ferleger, *Theodore Roosevelt Cyclopedia* (Oyster Bay, N.Y.: Theodore Roosevelt Association, 1989), p. 467. Henry Clay, "I would rather be right," in Robert V. Remini, *Henry Clay: Statesman for the Union* (New York: Norton, 1991), p. 527. Webster on Andrew Jackson, "When he comes, he will bring a breeze," in Charles Wiltse, ed., *Papers of Daniel Webster*, vol. 2 (Hanover, N.H.: University Press of New England/Dartmouth College, 1976), p. 388.

Presidential Likenesses at the National Portrait Gallery

"Boiled in his own oils," *Time*, January 19, 1962, p. 6. "Either a strong likeness or a fine picture," in Andrew Oliver, *Portraits of John Quincy Adams and His Wife* (Cambridge, Mass.: Harvard University Press, Belknap Press, 1970), p. 231. "When they talk about," in Joel Porte, ed., *Emerson in His Journals* (Cambridge, Mass.: Harvard University Press, Belknap Press, 1982), p. 301. "A small, hatchet-faced, colorless man," in Claude M. Feuss, *Calvin Coolidge: The Man from Vermont* (Hamden, Conn.: Archon Books, 1965), p. 285. "The Chief Executive in virtually every mood," in John Beardsley, "Framing the Presidents," *Museum & Arts Washington* 5, no. 1 (January/February 1989): 48.

George Washington

"The Scourge and misfortune," in *The American Heritage Pictorial History of the Presidency of the United States*, vol. 1 (New York: American Heritage Publishing Co., 1968), p. 28. "He was indeed," in Foley, *Jeffersonian Cyclopedia*, vol. 2, p. 928. Caption: "steady as a clock," in Dorothy Clarke Wilson, *Lady Washington* (New York: Doubleday, 1984), p. 342.

John Adams

"The most insignificant office," in John Bartlett (Emily Morison Beck, ed.), *Familiar Quotations* (Boston: Little, Brown, 1980), p. 381. "Since some sin, unknown to me," in Page Smith, *John Adams*, vol. 2 (Garden City, N.Y.: Doubleday, 1962), p. 1069.

Thomas Jefferson

"I think this is the most extraordinary collection," in Anne H. Lincoln, *The Kennedy White House Parties* (New York: Viking, 1967), p. 98. "The splendid misery," in Foley, *Jeffersonian Cyclopedia*, vol. 2, p. 716.
Caption: "Deemed the best," in Alfred L. Bush, *The Life Portraits of Thomas Jefferson* (Charlottesville: Thomas Jefferson Memorial Foundation, 1962), p. 76.

James Madison

"Every Person seems to acknowledge," in Ralph Ketchum, *James Madison: A Biography* (New York: Macmillan, 1971), p. 201.
Caption: "Delight of every social board," in ibid., p. 636.

John Quincy Adams

"A nun taking the veil," in Marie B. Hecht, *John Quincy Adams: A Personal History of an Independent Man* (New York: Macmillan, 1972), p. 490.
Caption: "Pinchingly poor," in Oliver, *Portraits of John Quincy Adams*, p. 119.

Martin Van Buren

"Lily-fingered" and "let Van from his coolers," in Lillian Miller et al., *"If Elected . . .": Unsuccessful Candidates for the Presidency, 1796–1968* (Washington, D.C.: Smithsonian Institution Press, 1972), p. 128.

William Henry Harrison

"My friends are not worth the powder," in Miller et al., *"If Elected . . . ,"* p. 131. Caption: "Striking head," in Monroe Fabian, "A Portrait of William Henry Harrison," *Prologue* (winter 1969): 31; *Boston Transcript*, May 22, 1841.

John Tyler

"Reptile-like," in Robert Seager II, *And Tyler Too: A Biography of John & Julia Gardiner Tyler* (New York: McGraw Hill, 1963), p. 162.

James K. Polk

Caption: "It is, I think," in Milo Milton Quaife, ed., *The Diary of James K. Polk* (Chicago: A. C. McClurg & Co., 1910), vol. 1, pp. 318–19.

Zachary Taylor

"I would not be a candidate" and "harmonize conflicting interests," in Holman Hamilton, *Zachary Taylor: Soldier in the White House* (Hamden, Conn.: Archon Books, 1966), pp. 40, 158.

Franklin Pierce

"It took a romancer to do it," in Haviland Miller, *Salem Is My Dwelling Place: A Life of Nathaniel Hawthorne* (Iowa City: University of Iowa Press, 1991), p. 381. "Imbecility," in Mark Van Doren, *Nathaniel Hawthorne* (New York: W. Sloane Associates, 1949), p. 195.

James Buchanan

"If you are as happy on entering," in "As One President to the Next," *American Heritage* 11, no. 5 (August 1960): 106.

Abraham Lincoln

Captions. "Anything but agreeable," in Harold Holzer and Lloyd Ostendorf, "Sculptures of Abraham Lincoln from Life," *Antiques* 113 (February 1978): 382. "The animal himself," in Leonard Volk, "The Lincoln Life-Mask and How It Was Made," *Century Illustrated Magazine* 23 (December 1881): 228. "Good looking whether the original should justify it," in Harold Holzer, "Out from the Wilderness: Little-Known Contemporary Paintings of Abraham Lincoln," *The Connoisseur* 199 (October 1978): 125.

Andrew Johnson

"His mind had one compartment," in Michael Les Benedict, *The Impeachment and Trial of Andrew Johnson* (New York: Norton, 1973), p. 3.

Rutherford B. Hayes

"His Fraudulency," in Richard Kenin and Justin Wintle, eds., *The Dictionary of Biographical Quotation of British and American Subjects* (New York: Knopf, 1978), p. 368.
Caption: "A man of power," in W. D. Myers to Solon Humphries, September 15, 1876, NPG curatorial files.

James A. Garfield

"I am a Stalwart," in Theodore Clark Smith, *The Life and Letters of James A. Garfield*, vol. 2 (Hamden, Conn.: Archon Books, 1968), p. 1184.
Caption: "Voice took on," in ibid., p. 705.

Chester A. Arthur

"I have but one annoyance," in George Frederick Howe, *Chester Arthur: A Quarter Century of Machine Politics* (New York: F. Ungar Publishing Co., 1957), p. 244.
Caption: "Trimmed to the perfection point," in Thomas C. Reeves, *Gentleman Boss: The Life of Chester Alan Arthur* (New York: Knopf, 1975), p. 271.

Grover Cleveland

Caption: "As for my ugly mug," in *Letters of Grover Cleveland, 1850–1908*, ed. Allan Nevins (Boston: Houghton Mifflin, 1933), p. 513. "A great deal of supplemental work," in ibid.

Benjamin Harrison

"He is narrow," in Harry J. Sievers, *Benjamin Harrison: Hoosier President*, vol. 3 (Indianapolis, Ind.: Bobbs-Merrill, 1968), p. 43. "No sting," in Miller et al., *"If Elected . . . ,"* p. 271.

William McKinley
"You shall not crucify mankind," in H. Wayne Morgan, *From Hayes to McKinley: National Party Politics, 1877–1896* (Syracuse, N.Y.: Syracuse University Press, 1969), p. 504.

Theodore Roosevelt
Captions: "I really enjoyed having painted," in Elting E. Morison, ed., *The Letters of Theodore Roosevelt*, vol. 6 (Cambridge, Mass.: Harvard University Press, 1952), p. 995. "I can be President," in Nathan Miller, *Theodore Roosevelt: A Life* (New York: William Morrow, 1992), p. 432.

William Howard Taft
Caption: "But I am pudgy, Alice," in Archie Butt, *Taft and Roosevelt: The Intimate Letters of Archie Butt* (New York: Doubleday, Doran & Co., 1930), vol. 1, p. 159.

Calvin Coolidge
"In politics, one must meet people," in Donald McCoy, *Calvin Coolidge: The Quiet President* (New York: Macmillan, 1967), p. 9. "The chief business of the American people," in Feuss, Calvin Coolidge, p. 358.
Caption: "Man absorbed by duty," in *New York Sun*, January 31, 1929.

Franklin D. Roosevelt
Captions: "The hands of a farmer," in David Meschutt, "Portraits of Franklin Delano Roosevelt," *American Art Journal* 18, no. 4 (1986): 39. "Just going to be plain, ordinary Mrs. Roosevelt," in Joseph Lash, *Eleanor and Franklin* (New York: Norton, 1971), p. 355. "I sometimes acted as a spur," in Anna Eleanor Roosevelt, *This I Remember* (New York: Harper & Row, 1949), p. 349.

Harry S. Truman
"Here lies Jack Williams," in Robert Polley, ed., *The Truman Years: The Words and Times of Harry S. Truman* (Waukesha, Wis.: Country Beautiful, 1952), p. 98.

Dwight D. Eisenhower
Caption: "By golly, I'd like to try that!" in NPG curatorial files. "The best artist that you could get," in Louis Galambos, ed., *The Papers of Dwight David Eisenhower*, vol. 11 (Baltimore: Johns Hopkins University Press, 1985), p. 946.

Lyndon B. Johnson
"I detested every minute of it," in Robert Dallek, *Flawed Giant: Lyndon Johnson and His Times, 1961–1973* (New York: Oxford University Press, 1998), p. 44.
Caption: "The ugliest thing I ever saw," in Hugh Sidey, "The One L.B.J. Likes and the One He Doesn't Like," *Life*, February 14, 1969, p. 4.

Richard M. Nixon
Caption: "The hardest man I ever had to paint," in Joanne Omang, "Rockwell Leaves Old for New," in *Washington Star*, March 2, 1969.

Gerald R. Ford
Caption: "Considering what Kinstler had to work with," in Donnie Radcliffe, "Gerald Ford Makes a Comeback," in *Washington Star*, May 25, 1978.

Jimmy Carter
"I'm going to run for President," in *Time*, January 3, 1977, p. 14.

Ronald Reagan
Caption: "Yep! That's the old buckaroo," in John R. Kemp. "Portrait Painter at Home with Reagan," *New Orleans Times-Picayune*, February 2, 1992.

Selected Bibliography on Presidential Portraiture

Barber, James G. *Andrew Jackson: A Portrait Study.* Washington, D.C.: National Portrait Gallery and Tennessee State Museum, in association with the University of Washington Press, 1991.

Blaisdell, Thomas C., Jr., et al. *The American Presidency in Political Cartoons, 1776–1976.* Berkeley, Calif.: University Art Museum, 1976.

Bolton, Theodore. "The Life Portraits of James Madison." *William and Mary Quarterly*, 3d ser., 8 (1951): 25–47.

Bush, Alfred L. *The Life Portraits of Thomas Jefferson.* Charlottesville: Thomas Jefferson Memorial Foundation, 1962.

Cunningham, Noble E., Jr. *The Image of Thomas Jefferson in the Public Eye: Portraits for the People, 1800–1809.* Charlottesville: University Press of Virginia, 1981.

————. *Popular Images of the Presidency from Washington to Lincoln.* Columbia: University of Missouri Press, 1991.

Eisen, Gustavus. *Portraits of Washington.* 3 vols. New York: R. Hamilton & Associates, 1932.

Hamilton, Charles, and Lloyd Ostendorf. *Lincoln in Photographs: An Album of Every Known Pose.* Dayton, Ohio: Morningside House, 1985.

Holzer, Harold. "Out from the Wilderness: Little-Known Contemporary Paintings of Abraham Lincoln." *Connoisseur* (October 1978): 124–31.

Holzer, Harold, Gabor S. Boritt, and Mark E. Neely Jr. *The Lincoln Image: Abraham Lincoln and the Popular Print.* New York: Scribner's, 1984.

Holzer, Harold, and Lloyd Ostendorf. "Sculptures of Abraham Lincoln from Life." *Antiques* (February 1978): 382–93.

Langston-Harrison, Lee A., ed. *Images of a President: Portraits of James Monroe.* Fredericksburg and Charlottesville, Va.: James Monroe Museum and Memorial Library, Mary Washington College, and Ash Lawn–Highland, 1992.

MacNeil, Neil. *The President's Medal, 1789–1977.* New York: Clarkson Potter, in association with the National Portrait Gallery, 1977.

Meschutt, David. "Portraits of Franklin Delano Roosevelt." *American Art Journal* 18, no. 4 (1986): 2–50.

Miles, Ellen G. *George and Martha Washington: Portraits from the Presidential Years.* Washington, D.C.: National Portrait Gallery, in association with the University Press of Virginia, 1999.

Morgan, John Hill, and Mantle Fielding. *Life Portraits of Washington and Their Replicas.* Philadelphia: privately printed, 1931.

Oliver, Andrew. *Portraits of John and Abigail Adams.* Cambridge, Mass.: Harvard University Press, Belknap Press, 1967.

————. *Portraits of John Quincy Adams and His Wife.* Cambridge, Mass.: Harvard University Press, Belknap Press, 1970.

Prucha, Francis Paul. *Indian Peace Medals in American History.* Lincoln: University of Nebraska Press, 1976.

Wick, Wendy C. *George Washington, an American Icon: The Eighteenth-Century Graphic Portraits.* Washington, D.C.: Smithsonian Institution Traveling Exhibition Service and the National Portrait Gallery, 1982.

Wilson, Rufus R. *Lincoln in Portraiture.* New York: Press of the Pioneers, 1935.

Index of Artists